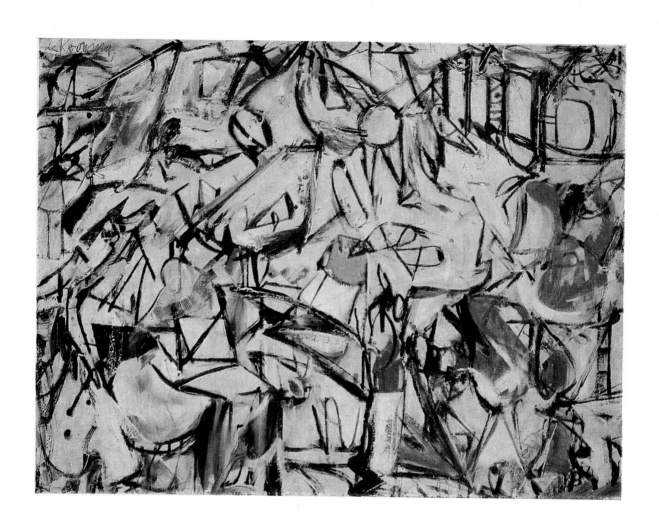

Willem de Kooning

by Thomas B. Hess

The Museum of Modern Art, New York

Distributed by New York Graphic Society Ltd.,
Greenwich, Connecticut

Published by The Museum of Modern Art
11 West 53 Street, New York, N. Y. 10019
All rights reserved, 1968
Library of Congress Catalogue Card Number 68-54925
Designed by Susan Draper Tundisi
Printed in The Netherlands by
Koninklijke Drukkerij G. J. Thieme N.V. Nijmegen

frontispiece: *Painting.* (*ca.* 1950).
Oil and enamel on cardboard, mounted on composition board, $30^{1}/_{8} \times 40$ inches.
Collection Mrs. H. Gates Lloyd, Haverford, Pennsylvania

Acknowledgments

This is Willem de Kooning's exhibition. He made an initial selection of pictures that he thought would best represent him. Whenever possible this was followed. I have chosen a number of works I felt he had overlooked and also the pictures done after 1963 and the drawings.

The late René d'Harnoncourt and Wilder Green laid the first plans for this exhibition along with Waldo Rasmussen who prepared its European tour under the auspices of the Museum's International Council. I am grateful to them, and to James Thrall Soby, for having asked me to direct it. De Kooning's lawyer, Lee V. Eastman, also helped to prepare the way.

Alicia Legg of the Department of Painting and Sculpture, and her assistants, Jane Necol and Richard Lanier, were of invaluable help in research and in taking care of all the thousands of details and crises that the securing of loans entails. Stephen Gillaugh, Howardena Pindell, and Nancy Sage handled the physical details concerned with each work of art.

William S. Lieberman, A. James Speyer, and Alberto Ulrich have been very helpful in facilitating several important loans.

Barnett Newman, Phillip Pavia, and Harold Rosenberg gave me the benefit of their knowledge on certain points of documentation.

Xavier Fourcade of M. Knoedler & Co. was of great assistance at almost every stage of the game.

My thanks go to all the collectors, and I appreciate their reluctance to part from their paintings, in many cases for well over a year.

Finally I wish to thank Audrey Hess for putting up so graciously with the intolerable situation of having a husband at work on several jobs at once.

T. B. H., July 1968

Lenders to the Exhibition

Mary Abbott, American Broadcasting Company, John Becker, Mr. and Mrs. Donald M. Blinken, Susan Brockman, Mr. and Mrs. Daniel Brustlein, Elise C. Dixon, Edward F. Dragon, Virginia Dwan, Mr. and Mrs. Lee V. Eastman, Ruth Stephan Franklin, Peter Fried, Mr. and Mrs. Gianluigi Gabetti, Mr. and Mrs. Milton A. Gordon, Joseph and Mildred Gosman, Wilder Green, Mrs. Albert M. Greenfield, Isobel and Donald Grossman Collection, Mr. and Mrs. Ben Heller, Mr. and Mrs. Thomas B. Hess, Joseph H. Hirshhorn Collection, Joseph H. Hirshhorn Foundation, Inland Steel Company, Martha Jackson, Elaine de Kooning, Willem de Kooning, Carol Bettman Lazar, Mr. and Mrs. Boris Leavitt, Mrs. H. Gates Lloyd, D. and J. de Menil Collection, Robert and Jane Meyerhoff Collection, Hermine T. Moskowitz, Mr. and Mrs. Roy R. Neuberger, Muriel Newman, Alfonso A. Ossorio, Mr. and Mrs. Stephen D. Paine, Betty Parsons, Mr. and Mrs. Gifford Phillips, John and Kimiko Powers, Mr. and Mrs. Seymour Propp, Nelson A. Rockefeller, Dr. and Mrs. Israel Rosen, Mrs. Arthur C. Rosenberg, Mr. and Mrs. Harold Rosenberg, Mr. and Mrs. Robert C. Scull, Mr. and Mrs. Stanley K. Sheinbaum, Norton Simon Foundation, Mr. and Mrs. David M. Solinger, Saul Steinberg, Mr. and Mrs. Allan Stone, Mr. and Mrs. Reuben Tam, Marie Christophe Thurman, Paul and Ruth Tishman Collection, Mrs. Samuel Weiner, Mr. and Mrs. Frederick R. Weisman, Mr. and Mrs. Richard L. Weisman, Mr. and Mrs. Bagley Wright.

Stedelijk Museum, Amsterdam; The Baltimore Museum of Art; Albright-Knox Art Gallery, Buffalo; The Art Institute of Chicago; Wadsworth Atheneum, Hartford; Nelson Gallery – Atkins Museum, Kansas City, Missouri; Solomon R. Guggenheim Museum, New York; The Metropolitan Museum of Art, New York; The Museum of Modern Art, New York; Whitney Museum of American Art, New York; Museum of Art, Carnegie Institute, Pittsburgh; Washington University Gallery of Art, St. Louis; The Phillips Collection, Washington; National Collection of Fine Arts, Smithsonian Institution, Washington.

James Goodman Gallery, New York; The J. L. Hudson Gallery, Detroit; Martha Jackson Gallery, New York; M. Knoedler & Co., Inc., New York, Paris, London; Allan Stone Gallery, New York.

Contents

Willem de Kooning

Hans Namuth: Willem de Kooning, East Hampton, 1963

Introduction

As I write these lines of introduction to Willem de Kooning's most comprehensive exhibition, he is hard at work in his new studio (it is almost finished; it probably will never be finished) at The Springs, Long Island.

I have not seen the latest paintings; a friend who visited him a week ago says that they are still on the Woman in the Country theme, but now he has keyed up the colors – lighter and brighter. Also he has invented a new way to stretch large canvases, on reinforced styrofoam panels weighing only a few pounds, instead of on a wood chassis that weighs about fifty; this makes it easier to maneuver the paintings around.

About a dozen major oils, three times that many sketches, plus a stack of drawings have been completed since January 1, 1967 – the cut-off date of this exhibition, making it satisfactorily incomplete and open-ended. In the past he has turned down a number of bids for retrospectives. "They treat the artist like a sausage," he once said, "tie him up at both ends, and stamp on the center 'Museum of Modern Art,' as if you're dead and they own you." He became reconciled to this project three years ago, at first because it was going to be in Amsterdam and London, and probably not come to New York; later because his good friend the poet Frank O'Hara, who was a curator at the Museum, was going to organize the New York show; and finally, and decisively, because his own work is going so well that he cannot be petrified into a memorial.

This, then, is a look at the artist in mid-career, beginning with his first mature works in the mid-1930's and emphasizing pictures that have seldom if ever been shown in public. It defines neither his œuvre nor its development, but certainly offers enough to demonstrate why many artists, critics, and collectors are convinced that Willem de Kooning has been and remains the most important painter at work in the middle of our century.

I Willem de Kooning was born in Rotterdam, April 24, 1904. When he was about five years old, his mother and father were divorced. The court assigned his older sister to his mother, and Willem to his father, probably because of the extremely warm relationship between them. His mother, however, fought the decision, at first simply by grabbing up the child and taking him home with her, later through a successful appeal to the court. Both parents remarried and had other children. The father, Leendert de Kooning, became a successful distributor of wines, beers, and soft drinks. He was preoccupied with his growing business and new family and had little time for Willem. The mother, Cornelia Nobel, today a spry nonagenarian still living in Rotterdam, was a bartender in a café largely patronized by sailors. I touch on these details because, as will be indicated, they supply possible clues to de Kooning's magisterial Woman of the early 1950's – an image which has become a totem and icon of the times.

At the age of twelve Willem was sent to work for his living, apprenticed to a firm of commercial artists and decorators, Jan and Jaap Gidding. Because the boy showed exceptional aptitude, the latter urged him to enroll for the full course of evening classes at the Rotterdam Academy of Fine Arts and Techniques, where he worked for the next eight years.

The academies inaugurated in seventeenth-century Holland were very different from those that flourished under royal patronage in the rest of Europe – as Nikolaus Pevsner points out in his book on these maligned institutions. Most academies were founded as centers of Renaissance humanist ideas about science, philosophy, education, and the arts and led in the fight against the vestiges of the medieval guilds, with their craft traditions, ap-

prenticeship system, local monopolies, and belief in the artist's fixed role in a homogeneous, hierarchical society. The academies fought for the artist's right to become a cosmopolitan, intellectual professional – a peer of jurists, generals, and bishops. They were usually backed by the state (notably the efforts of Colbert and Mazarin in France) through its emergent, nationalist government, which understood that the emancipated artists of the academies could improve the design of exports, attract tourists, and, most of all, give regal forms to the authority of a centralized monarchy. The guilds fought tenacious rear-guard actions, often in alliance with feudal nobles and the urban petty merchant and working classes, who also wanted to protect their franchises and social prerogatives against the "New Thought" of a new age. The academies of course won. The guilds were reduced to craftsmen's trade unions. And one of the results was that the modern artist became, for the first time, a classless intellectual with a deep nostalgia (often alternating with an aristocratic disdain) for the working classes, with their simpler values and deeper roots.

The single notable exception to this pattern, however, was Holland: perhaps because its prosperous middle class was already so advanced that it had taken over and identified itself with the nation without periods of civil war or intellectual revolution; perhaps because the small, homogeneous country had enough interior strength to withstand the tensions and fragmentation inherent in modernity; perhaps because the feudal structure had never been deeply a part of the Lowlands, dotted with harbors and populated with explorers and import-export tycoons.

In any event, the Dutch institutions established for art education were blends of the feudal guilds (which made no distinction between fine and applied arts, both being part of the same ladder, with the apprentice grinding pigments at the bottom rung and the great master executing his masterworks at the top, each producing an honest day's labor worthy of its hire) and of the seventeenth-century academies, which considered the Fine Arts as pure, intellectual: a *causa mentale*, in the phrase of the founder of the first Renaissance academy, Leonardo da Vinci.

Thus de Kooning was taught guild and academy disciplines and philosophies simultaneously. He remembers that, first, there was lettering, copying inscriptions; at the end of the year each student was supposed to make one masterful sign (a guild idea, and one that has stuck with the artist; a number of his paintings of the mid-1940's and the mid-1950's are clued to scattered letters; walking down the Boulevard des Capucines at night, on his first visit to Paris – January 1968 – his initial impression was that "the French have very neat, crisp lettering"). Then there were perspective (an academy discipline) and proportion (again the academy – perspective and proportion were considered to be purely intellectual subjects and thus free from any guildish taint of manual work). The students were given brass models "which looked like Constructivist sculptures" and told to render them from various angles neatly on paper. There were also drawing from casts and the model (academy) and training in wood-graining and marbleizing (guild). There were lectures on art theory and history, from the Egyptians through the Renaissance. Sometimes guild and academy ideas were fused into one project. A carefully arranged still-life setup was presented to the students as an exercise in foreshortening, modeling, rendering light and shadow, etc., all academic principles, but de Kooning recalls that it had to be finished with a series of minute conté crayon dots and

Dish with Jugs. (ca. 1921).
Charcoal on gray paper,
 19³/₄ × 25³/₈ inches.
Private collection

points, to give a textureless, *trompe-l'œil* illusion – a guild "secret" (above).

The issue of originality was never raised because both guild and academy understood that originality is the one thing that cannot be taught. Standards of quality were so obvious that they were irrelevant. "Everybody knew," de Kooning remembers, "who were the best students." They were the quickest and deftest – and that was that. The guild tradition of an artist as a man in the world, a part of society, was dominant, and had become reinforced in the 1920's by the brilliant de Stijl group in Holland, which, under the leadership of Mondrian and van Doesburg, agitated for the new creed of the modern artist as a revolutionary social engineer. Inspiration was considered to be a piece of archaic sentimentality: "Show me Inspiration," sneered the de Stijl artists, just as, half a century before, Courbet had challenged the Romantics to show him a man with wings growing out of his back. In an interview with David Sylvester for the B.B.C. de Kooning said, "When we went to the Academy – doing painting, decorating, making a living – young artists were not interested in painting *per se*. We used to call that 'good for men with beards.' And the idea of a palette, with colors on it, was rather silly. At that time we were influenced by the de Stijl group. The idea of being a modern person wasn't really being an artist in the sense of being a painter."[1]

For a number of reasons, most of them beyond his control, de Kooning did not choose to become a full-time, totally committed Artist with a capital A until 1934. Up until then he was an artist, but also a "modern person" in the "real world" – a skilled professional: carpenter, designer, house painter, portraitist, a man who could execute a commission with dispatch. And he has kept this contact, physically and metaphysically, with life outside of the studio. He designed his own house, starting with the steel framework and going down to details of tables, benches, drawers. He works on it as he does

14

on a painting: tearing walls down, moving cabinets around. A number of young artists have been hired to be his helpers. They were nicknamed "de Kooning's Peace Corps." One visitor rummaging around came across a drawer fitted with small, neat compartments. "What is it for?" De Kooning said, "Why, collar studs." When asked if he owned so many studs, he admitted that a particular carpenter he employed was good at, and enjoyed, making little wood compartments.

It is as if whenever he moves into something new, such as becoming an Artist, he refuses to let it replace what was there before, in this case the guild-plus-de Stijl idea of the artist as a Jack-of-all-crafts. Which brings us to the central issue in de Kooning's art: his creative use of ambiguity, his will to work within the dialectical tensions of a syllogism without synthesis. That is:

Thesis: The worker, the man on the job; his responsibilities, his values, his dignity.

Antithesis: The artist, the man in the studio; his aesthetic concepts, commitment to his identity in art; his metaphysics (inspiration, genius, magic, symbolizing power, call it what you will).

Synthesis: – and here de Kooning balks. He will choose neither antinome nor accept their opposition within a closed system. He is open to any concept except that of exclusivity.

In 1949, de Kooning wrote a paper that was read on February 18 to a group of his fellow artists and their friends:

My interest in desperation lies only in that sometimes I find myself having become desperate. Very seldom do I start out that way. I can see of course that, in the abstract, thinking and all activity is rather desperate. When an idea is given, one is stuck with it. You cannot help seeing it and even using it as a possibility.

In Genesis, it is said that in the beginning was the void and God acted upon it. For an artist that is clear enough. It is so mysterious that it takes away all doubt. One is utterly lost in space forever. You can float in it, fly in it, suspend in it and today, it seems, to tremble in it is maybe the best or anyhow very fashionable. The idea of being integrated with it is a desperate idea.

In art, one idea is as good as another. If one takes the idea of trembling, for instance, all of a sudden most of art starts to tremble. Michelangelo starts to tremble. El Greco starts to tremble. All the Impressionists start to tremble. The Egyptians are trembling invisibly and so do Vermeer and Giacometti and all of a sudden, for the time being, Raphael is languid and nasty; Cézanne was always trembling but very precisely.

The only certainty today is that one must be self-conscious. The idea of order can only come from above. Order, to me, is to be ordered about and that is a limitation.

An artist is forced by others to paint out of his own free will. If you take the attitude that it is not possible to do something, you have to prove it by doing it.

Art should *not* have to be a certain way. It is no use worrying about being related to something it is impossible not to be related to.

Style is a fraud. I always felt that the Greeks were hiding behind their columns. It was a horrible idea of van Doesburg and Mondrian to try to force a style. The reactionary strength of power is that it keeps style and things going.

It is impossible to find out how a style began. I think it is the most bourgeois idea to think one can make a style beforehand. To desire to make a style is an apology for one's anxiety. Anyhow, I think innovators come at the end of a period. Cézanne gave the finishing touches to Impressionism before he came face to face with his "little sensation."

Whatever an artist's personal feelings are, as soon as an artist fills a certain area on the canvas or circumscribes it, he becomes historical. He acts from or upon other artists.

15

An artist is someone who makes art too. He did not invent it. How it started – "to hell with it." It is obvious that it has no progress.

The idea of space is given him to change if he can. The subject matter in the abstract is *space*. He fills it with an attitude. The attitude never comes from himself alone.

You are with a group or movement because you cannot help it.[2]

Implicit in this statement is the syllogism:

Thesis: All art comes from art, relates to other art, is about art, influences subsequent art.

Antithesis: The imperatives of style and historical necessity are frauds; the artist today must work from zero, from the void within himself.

Synthesis: – again de Kooning refuses any conclusion that would close the argument.

The perfect anti-Hegelian, he will have it both ways and work within the contradictions.

De Kooning does not identify with his friends the American artists who claim a Wild West parthenogenesis. He does not share the New World idea of the New, the innocent eye, the virgin forest – the slightly swami rhetoric that began in Stieglitz' circle, turned into stump speeches with the Regionalists in the 1930's, and still is heard among the followers of Pollock and Still (although both these artists were far too intelligent to indulge in their followers' exaggerations). De Kooning has called it "making art out of John Brown's body . . . standing all alone in the wilderness."

He is scholarly, hypersensitive to traditions; the Metropolitan Museum is a part of his landscape. But still, after a quick look at Michelangelo's *Last Judgment*, he ducked out of the Sistine Chapel saying, "You know I'm no art lover." And in the early 1940's he said to his wife, "When I go through the subway turnstile, I expect the bell to clang a little louder."

It seems probable that the school in Rotterdam, with its humane mixture of guild and academic practices and ideals – a good day's work superimposed on the *beau idéal* – provided a basis for, or reinforced a predisposition to, de Kooning's revolutionary sense of ambiguity.

In 1920, he moved from the Giddings' to work under Bernard Romein, art director of a large department store. He still attended night classes at the Academy, but during the day learned more about the latest modern arts in Holland, Germany, and Paris. In 1924, he made a trip to Belgium with some friends, supporting himself with odd jobs at sign painting and window display. He saw some of the local Belgian Expressionists' work, but there is no evidence that he was at all influenced by them. In fact, the trip was not an art tour, but a dry run for his emigration, a testing of his ability to be independent. He returned to Holland in 1925 and the next year embarked for America.

It took six tries, three of them "legal" (he attempted to get hired as a deck hand by the Holland-America line, with the idea of jumping ship in the U.S., but evidently this plot was written all across his 21-year-old face, and the hiring clerk adamantly refused to take him on). The next three tries were "illegal." He got a little money from his father, enough to give the sailors' union their required fee. His father wished him good luck, but told him not to come back for any more money. They said good-bye. The first try misfired when the contact did not show up. The second time, he was smuggled aboard, only to be told that there was a mistake, and the ship was bound for Buenos Aires. Feeling a touch of excitement, de Kooning said, "Let's go to Buenos Aires!" But his friend who supervised these maneuvers, Leo Cohan, dragged him off. On the third try, he made it. De Kooning

was hidden in the crew's quarters, and when the ship landed at Newport News, slipped off; he then got hired by a coaler going to Boston, was able to leave her with proper landing papers, and finally went to Hoboken, where Leo Cohan had arranged for him to stay. (Some thirty years later, the statute of limitations on illegal entry having long since expired, de Kooning re-entered the U.S. from Canada on the quota. He has since completed the formalities of becoming a citizen.)

Why America? He had read Whitman, studied Frank Lloyd Wright (who had strongly influenced the de Stijl architects), read about cowboys and Indians. He told David Sylvester, "... the shield, the medieval shield they have with the stars on top and the stripes on the bottom, almost like the heraldic period of the Crusaders, with the eagle; as a child I used to be absolutely fascinated by this image."

But he has also said he came because he thought you could make money in America. He wanted to get rich, then paint in his free time. And he had seen photographs of long-legged American girls.

Maybe it is that way with all emigrants: they know they want to leave, but move toward something vague and imaginary. In any event, de Kooning quickly became one with the only kind of true Americans this country ever has known: America is a European idea; it is the "aliens" who choose the U.S. who can grasp its reality.

First came the disillusionments. "I had thought everything would be so fine," de Kooning remembered, "with linoleum even in the kitchen; but when I got to the Hoboken rooming house, what did I see – Congoleum!" He told an interviewer, "The only word I knew was 'Yes.'"[3]

He told David Sylvester:

I was here only about three days when I got a job in Hoboken as a house painter. I made nine dollars a day, which was quite a large salary, and after being around four or five months doing that, I started looking for a job doing applied art-work. I made some samples and I was hired immediately. I didn't even ask them the salary because I thought if I made nine dollars a day as a house painter, I would make at least twenty dollars a day being an artist. Then at the end of two weeks, the man gave me twenty-five dollars and I was so astonished I asked him if that was a day's pay. He said, "No, that's for the whole week." And I immediately quit and went back to house painting.

He made excursions into Manhattan and in 1927 moved into a studio on 42nd Street, supporting himself with commercial-art jobs, department-store displays, making signs, carpentry.

Visiting museums and galleries he met John Graham, the brilliant connoisseur-artist, and Arshile Gorky, who was to be a close friend for the next twenty years. Graham was a catalyst: he had lived in Paris, knew Picasso, and could testify that the art world was real. Gorky was studiously re-working the history of modern art, beginning with Cézanne; he read all the Paris art magazines, was a devotee of Ingres and the Le Nains, and could testify that art was real.

In 1935, de Kooning spent a year on the Federal Art Project and for the first time in his life was able to commit all his energies to painting. He told Irving Sandler, "I had to resign because I was an alien, but even the year I was on gave me such a terrific feeling that I gave up painting on the side and took a different attitude. After the Project I decided to paint and do odd jobs on the side. The situation was the same, but I had a different attitude."[4]

In his year on the W.P.A. de Kooning was assigned several mural projects, but none of them was finally commissioned. A 20 by 14 inch study for a 14 by 9 foot mural for the Williamsburg Federal

Housing Project, Brooklyn, was exhibited in a survey of Federal Art Project works directed by Holger Cahill at The Museum of Modern Art in 1936. This was de Kooning's first public appearance. The picture, titled *Abstraction*, went unnoticed and was subsequently destroyed; apparently no photograph of it exists. In 1937 he designed a mural for the New York World's Fair Hall of Pharmacy, but did not execute it on the wall himself. He made a precarious living, sold a few pictures, gave a few private lessons.

The Depression years usually are considered the bleak, sad time in modern American history – and in the arts, which were dominated by Regionalism and Social Realism. For older people, it was harsh indeed: they had lost their money, their sense of being able to cope with life, their belief in themselves and in the future. It was equally painful for children who watched their parents mourn for lost businesses, worry about the next month's rent, talk endlessly about money. But for the young men and women of the decade, especially the artists, writers, and their friends, it was a tremendously gay period. The whole question of money suddenly disappeared and everybody could do as he pleased. David Smith told me that parties were never as wonderful as in the 1930's, when everyone chipped in for whiskey and all the girls were beautiful. De Kooning and Gorky, both violent anti-Stalinists, cheerfully built May Day floats for the Party on the orders of Stuart Davis, whom they revered as the senior American modernist. Harold Rosenberg remembers demonstration parades for the Workers; contingents of artists carried cardboard palettes, writers brandished big cardboard pens, one young writer carried a sign proclaiming, "WE WANT BON-VIVANT JOBS!" In this ebullient atmosphere, New York painters and sculptors laid the framework for their social milieu. The Communists and dedicated Social Realists worked mostly apart from the rest, but groups intermingled. A long, chaotic, brilliant, funny conversation about art began in the mid-1930's and continued for more than twenty years. It was one of those rare moments in history when nothing interfered with the discussion; there were no sales, exhibitions, careers. The Impressionists in the Café Guerbois days, when they were all unknown or despised, must have had a similar moment. Some artists changed styles easily from year to year; others carefully studied the latest issues of *Cahiers d'Art*. A sense of colleaguality and mutual respect marked the community; ideas could be debated seriously with respect for different opinions. The artists at first may have huddled together in Greenwich Village out of a sense of mutual protection, but they stayed together because they found that they could become their own audience. They lived in lofts, had their favorite park benches in the spring and cafeteria tables in the winter. They belonged. It was out of this lively community that came the great flowering of postwar American art.

In 1938 de Kooning met a young art student, Elaine Fried, and began to paint his first series of Women, a theme that has preoccupied him ever since. In 1943 he married Elaine, who had been studying with him for over a year. She was to become well known as a painter in her own right and during the 1950's as an influential writer on American art. She sometimes articulated concepts that she and de Kooning had discussed together, but scrupulously avoided any mention of his work in her criticism.

De Kooning's first gallery appearance was in a group exhibition chosen by John Graham for McMillan, Inc., a decorating firm, in January 1942; Graham also picked Picasso, Braque, Matisse, and Stuart Davis, and gave two other Americans their

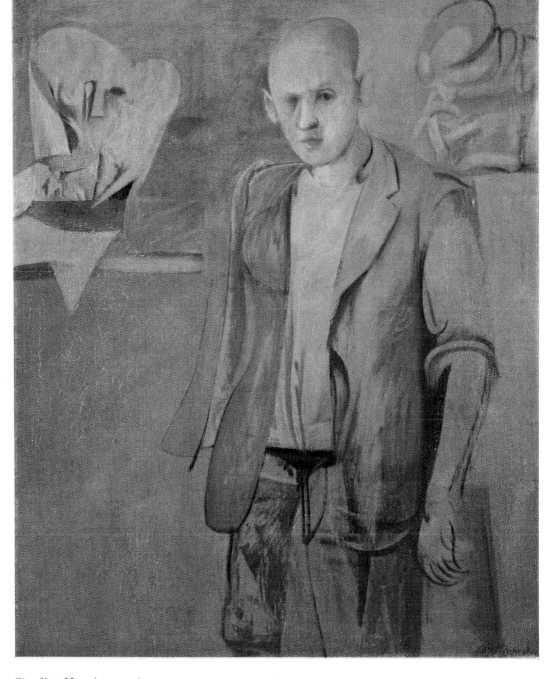

Standing Man. (*ca.* 1942).
Oil on canvas, 41¹/₈ × 34¹/₈ inches.
Wadsworth Atheneum, Hartford, The Ella Gallup Sumner
and Mary Catlin Sumner Collection

public debuts: Jackson Pollock and Lee Krasner. The following year, de Kooning was included by Georges Keller in a group show at the Bignou Gallery; he exhibited a drawing of Elaine (page 37), *Pink Landscape* (page 28), and *Elegy* (page 29), which was bought by Helena Rubenstein. He did not exhibit again until his first one-man show at Egan in 1948, although around 1945 he was asked to exhibit at Peggy Guggenheim's Art of This Century Gallery, where Hofmann, Pollock, and Motherwell were showing.

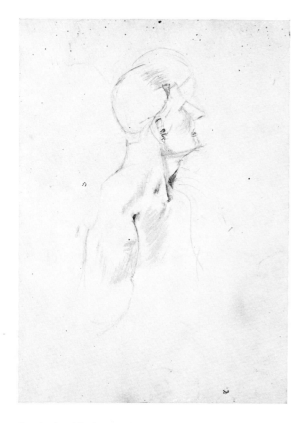

Study for *Glazier* (Self-Portrait?). (*ca.* 1940). Pencil, 14¹/₈ × 11 inches. Owned by the artist

De Kooning's works of the late 1920's and early 1930's are largely destroyed, and the few minor examples that have survived or were recorded in photographs are interesting mainly as indications of the sources and influences available to the young artist. He left a few student drawings in Holland in the 2:00 A.M. rush to catch the ship to America; they show the precocious talent of a natural draftsman and have some Art Nouveau-Symbolist elements similar to those in the early Mondrian. In America in the 1920's he experimented with every style that came along: you find Mondrian, Lurçat, and Miró, Mexican Social Realism, and de Chirico perspectives. But by the early thirties two themes became dominant and mark the beginnings of his mature development: the first (pages 27–31) is a series of abstractions, most of them with an objects-in-an-interior or still-life space, but a few of them based on figure motifs; the second (pages 19, 32–35) is a series of figures, all of them Men, sitting or standing.

The Men have a sad, exiled look; they wear work clothes that fall into elegant pleats and creases (as well-worn dungarees do); they stare out at an angle, focussing behind the viewer; their dark flat eyes echo the colors of the background, giving them a hollow, tragic air – as if you could see right through their heads to the wall behind them (they antedate by some years T. S. Eliot's description of the unemployed as "hollow men," but the parallel is striking). Sometimes there are two men, and one drawing is titled *Self-Portrait with Imaginary Brother* (page 36): probably an imaginary older brother; perhaps a dream father? Certainly the psychological tension in the paintings of Men seems to suggest losses: lost father, lost country, lost in a new world. And in that brave new country, the Depression was making every man feel the poignancy of losses. So the Men can also be read as re-

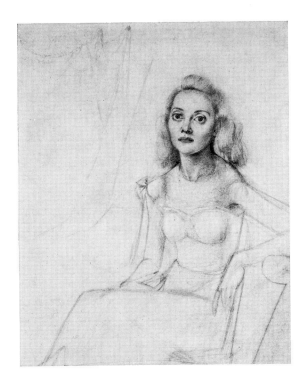

Portrait. (*ca.* 1940).
Pencil, $16^1/_2 \times 11$ inches; $10^1/_2 \times 8^3/_8$ inches (comp.).
Owned by the artist

flections of the Depression years. They are the idle. Any hint of self-pity is wiped out by the athletic inner strength, self-reliance, even protest of these tough heroes.

Most of the Men look a bit like the artist, who worked from drawings made at the mirror, but none of them are self-portraits. Some of them look like the poet Edwin Denby, who met de Kooning in 1934. (Denby was attracted by the sounds of Stravinsky blaring from a loft near his own, and, dropping in, found an immaculate studio, bare of every amenity except a fine record player. They have been close friends ever since, and Denby, along with the photographer Rudolph Burckhardt,

became the first serious collector of de Kooning's work.)

Each of the Men paintings attacks specific pictorial problems. *Glazier* (page 34), for example, is the result of hundreds of studies on how to paint a shoulder. Once de Kooning had "got" it, he went on to the next "impossible" question. *Two Men Standing* (page 32), among other things, picks up a concept from Louis Le Nain: the gaze from each figure moves along the legs of a triangle projecting into the room, and these lines in turn suggest a reverse perspective that widens as it enters the picture and locks open on the roughly indicated rectangles in the background. Other paintings of Men are concentrated observations of the topology of creases in a pair of pants (de Kooning had a clothed manikin in his studio, Rudolph Burckhardt remembers, and carefully fixed each fold in its properly casual spot by painting it with glue). There is allusion here, obviously, to Cézanne's disordered tablecloth, which is also a mountain. In *Standing Man* of 1942 (page 19) drawings pinned to and curling off the studio wall are flattened out into abstract still-life objects, which become the invented attributes or properties of the figure.

Of course the painting is not an excuse for a project. Rather, the difficulty, the "impossible" element, is attacked within the context of a complete work, and when it is "solved," or, to put it more accurately (there are no solutions), when an answer suggests itself that permits the painting to continue, de Kooning moves on to the next picture, often abandoning or destroying the previous one.

This gave him a reputation, which still persists in certain quarters, for never finishing a painting. In the late thirties and in the forties, both de Kooning and Gorky were established leaders in the art world (largely underground and known only to the artists themselves). Their subterranean fame also

made them a number of enemies, whose line of attack was: Gorky is brilliant, but completely derivative, and de Kooning is the genius who can never complete a picture.

Looking at Gorky's early pictures it is hard to see why they once appeared so damagingly dependent on his sources in Cézanne, Picasso, Miró, Matta, etc. Today they seem pure Gorky: incisive statements of a uniquely lyric, intellectual vision.

For de Kooning, however, the fact is that until around 1947 he did not "finish" very many paintings, and until around 1953, the paintings he did stop work on were as apt to be destroyed as they were to be left alone. Most of the surviving works of that decade are those that were taken away from the artist, sometimes, you could almost say, "untimely ripp'd." A friend would come in and buy a picture for the then princely sum of a few hundred dollars – Denby or Burckhardt, Fairfield Porter or Max Margulis, or Janice Biala and Daniel Brustlein – or someone would drop by and admire a canvas that the artist was about to wipe out, and persuade him to give it away. Some pictures were lent to friends and never returned. A few simply disappeared and only surfaced again twenty years later.

It must be remembered that in those days American art by such men as de Kooning and Gorky was a "product" for which no demand existed. Collectors, exhibitions, careers, articles, fame, all were so remote from the downtown New York art world as to be nonexistent.

But why did de Kooning make a practice of wiping out his paintings? His colleagues carefully saved their unsaleable works. A number of answers suggest themselves.

There was in the back of his mind the example of Frenhofer, the heroic old artist in Balzac's *The Unknown Masterpiece*. Frenhofer was obsessed with the "perfect painting," an "absolute" masterpiece that would combine every secret he had learned from his Northern Mannerist master, Mabuse, with the High Renaissance and Venetian aesthetics of light and volume (a fusion of guild with academy ideals). He wanted to stuff all knowledge, history, and perception into his culminating picture, an imaginary portrait of Catherine Lescault, "the beautiful courtesan." "My painting is not painting," he explains to Pourbus and the young Poussin, who, in the last chapter, visit his studio, "it is a feeling, a passion!" But invited to look at Frenhofer's Woman, Poussin exclaims that all he can see is "a confused massing of colors held in place by strange lines which form a wall of paint." The young artists leave the studio, touched by this example of *hubris*, of overreaching ambition. Frenhofer goes mad, destroys his paintings, then dies. But our generation can add a final joke. The sixteenth-century master, created by Balzac in 1845, painted a de Kooning almost exactly 100 years before the fact.

The book did not "influence" de Kooning, but reinforced and put words to attitudes he already held (just as he also has been affected by Dostoevsky, Faulkner, Gertrude Stein, and Kierkegaard). Like Frenhofer, he did not want to finish his pictures because they always could be improved. Elaine de Kooning remembers that after stopping work on one magnificent painting, the artist reluctantly admitted that it was "pretty good" but decided that it had to be moved "two inches to the left." Instead of cutting down the right side and piecing out some space to the left, he proceeded to paint over the whole image, meticulously shifting each element – and in the process lost the whole image.

Because de Kooning wanted to put everything into his painting, each thing he got into it not only

had its own presence, but represented the absence of something else. If this second element was then added, bringing new ambiguities and contradictions into the arena of the painted surface, the integrity of the first was weakened and a third was absent – and so forth. To finish meant to settle for the possible at a given moment, to abandon an effort and continue it elsewhere. But continuity itself then became an issue. Once a painting is left alone, and rests with its face to the wall in a corner of the studio, a new image must be started from scratch, and each move the artist makes can be inhibited by the existence of the record – by the testimony of his previous work. But if the painting is destroyed, its destruction opens the way to a fresh beginning.

When de Kooning attacked certain problems that obsessed him – such as how to paint the joint that connects an arm to a torso ("half-orchid, half-tumor," in Edwin Denby's poem *The Shoulder*, which alludes to de Kooning's pictures of Men), or how to invent his own series of abstract shapes, or how to bring up certain colors into violent contrasts that would still set flatly contiguous, emphasizing the structure of the canvas plane – and as he found his way out, the paintings reveal the paths he took. Like many of his friends, he was reacting strongly against the aesthetics of the then dominant School of Paris, and one of the Parisian characteristics the new American artists threw away was the concept of "finish" – the highly refined, balanced, nuanced confections of, for example, Borès or Marchand, which in pre-World War II New York were accepted as culture symbols of the Parisian hegemony.

De Kooning, like Pollock, omitted the last stages of "finish." The picture exposed the obstacles and how the artist had tried to overcome them.

Clement Greenberg has written that the history of modern painting is that of "the growing rejection of an illusion of the third dimension."[5] It would be more accurate to suggest that the history of modern painting is of an increasing revelation of the artist's means, both technical and conceptual. Both statements are of course wildly oversimplified, but at least the latter suggests that there is something more to art than its skin – painting is not stuffed derma, and there are some physical and metaphysical bones beneath the *illusion* of two dimensions.

Starting with Manet, moving through the Impressionists, Pointillists, Cézanne, Cubists, and all the Isms, on to any young artist of today who we can agree is worthy of their company, there is a progressive stripping away of technical disguises and masks for content. As the history of modern art proceeds on its erratic, illogical course, we are shown more and more openly what the artist was after and how he went about getting it. In 1885, if there is to be a bright sky, the strongest blue in the palette is used to evoke it. In 1914, if there is to be a play between reality and illusion, a bit of reality itself – say, a newspaper clipping – is introduced into the tilting planes. When a dashing attack is made on the surface in 1946, the drips that trail from the brush are left as witness to the artist's intent. A painter of 1965 who wants an opalescent field of color does not hesitate to use the undisguised effects of a power spray gun. It is not that painting has been getting "flatter," although artists who are interested in such a concept obviously would reveal their interest in this illusion. Rather the intent and means of modern painting have been made increasingly available to the spectator – revealed as functional parts of the image, and often becoming inextricably mixed with the content of the image itself.

Thus de Kooning's "unfinished" paintings in a

sense were finished as soon as they exposed in physical paint his insight or mood or glimpse of reality or pictorial stumbling block. The symbolizing quality of this kind of art is reduced to a minimum – the shoulder does not *stand for* a kind of humanity; it *is* de Kooning's invention for a link between the arm and the torso.

Two considerations, more problematic, should also be mentioned in connection with de Kooning's reluctance to finish his paintings. The first is the simple human problem encountered by an artist using the awesomely complicated methods that he had evolved. The constant addition of ambiguities and contradictions, the packing of the painting with shapes, allusions, actions, and counter-actions, the high ambition to achieve a triumphant work, all set up tremendous tensions and frustrations. Harold Rosenberg remembers visiting de Kooning in the early 1950's and seeing *Woman, I* almost finished (in fact perfectly finished, if the artist would only leave it alone); de Kooning picked up a wide loaded brush and slapped it across the canvas.

The second consideration is more doubtful. De Kooning was miserably poor in those days (his pictures did not begin to sell with any regularity until 1956); he ate in dingy cafeterias; he ducked landlords; once he received a message to telephone The Museum of Modern Art and found that he did

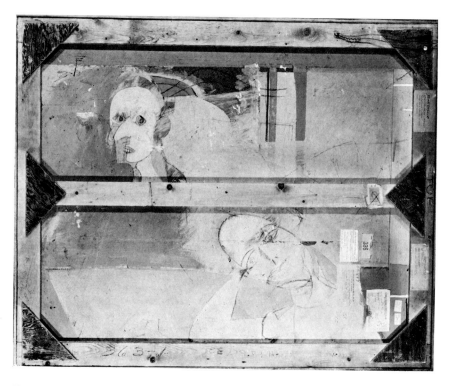

Reverse of *Black Friday*, 1948, with unfinished heads, *ca.* 1943

not have the nickel. At the same time, in the underground artists' world he was famous, revered, lionized. It is the classic position of the modern genius – of Rimbaud and van Gogh, the *maudits*. Did he see himself as an existentialist hero engaged in an absurd struggle for survival against a hostile world? And if so, was the auto-vandalism a psychic weapon in his fight?

Certainly the American middle class and its institutions (including museums) were viciously opposed or aggressively indifferent to all the best in American modern art. Collectors who in 1968 have redecorated their hip salons, taken down the Pop and put up Minimal and Funk, in the 1940's and 1950's were buying Dufy, Utrillo, and maybe – greatly daring – a Dubuffet. Professors of art history and enlightened curators, who now dismiss a Rothko or a Motherwell as overfamiliar classics, were deeply involved in Chagall and Bérard. No wonder the American artists became a bit cranky: refused to lend to group exhibitions, wrote open letters to the newspapers, complained endlessly about "the situation."

Were de Kooning's unfinished and wiped-out paintings a way of punishing society for his neglect? A Coriolanus arrogance? Certainly some of de Kooning's disciples thought so, and they re-enacted his dilemma with melodramatic verve. But de Kooning himself stayed aloof and cool. If he felt he was a hero, he kept it to himself. He was as much a professional as a Prometheus. Examples of his unfinished works, fragments of which can be examined today on the backs of existing paintings (page 24), indicate that many of them were tentative. And if a painfully large number of fully accomplished paintings were scraped away, a very respectable number has survived, especially for an artist so well known for his inability to finish a picture.

Finally, there is no doubt that de Kooning by temperament dislikes conclusions almost as much as he hates systems. As I mentioned at the beginning of this essay, his house in The Springs, a major undertaking that has lasted about six years to date, will probably always be building. One month a gazebo rises on the lawn; then the fireplace is reshaped; next a portico is threatened. It is the unfinished masterpiece, and de Kooning can say with Nietzsche, "When we have finished building our house we realize that we have inadvertently learned something which we should have known before we ever started to build. This everlasting, baleful 'too late' – The melancholy of all that is *finished*."[6]

As might be expected from an artist who makes ambiguity a hypothesis on which to build, he has never belonged to a team and rejects the commands of various ideologues who want everybody to pick sides. By the 1930's, abstract art was a Cause, opposed to and sometimes in actual conflict with all forms of figuration (including Surrealism). De Kooning and Gorky were associated with the abstract artists socially and intellectually, but they both did figurative pictures along with their abstractions. De Kooning would spend weeks drawing with a needle-sharp 8-H pencil from a carefully posed nude and at the same time be at work on a non-objective composition in which every trace of nature had been carefully erased.

In his abstractions (pages 27–31), the space is a flat, slippery, metaphysical surface, related to that of some Mirós of the middle thirties; there are also recollections of Arp. The forms are based on the stripe (usually vertical, related to Mondrian) and circles that have been forced into pointed or bulging ovals by the irregular pressures between shapes. This lateral pushing and pulling is held flat to the surface by bright colors (often keyed to blue and

25

pink with parallel grays and ochers); their values are so close that, in Fairfield Porter's phrase, they make "your eyes rock."

In the abstractions there are neither backgrounds nor foregrounds; the surface is continuous. In the figure paintings, the Men are positioned in a shallow "stage," but they tend to melt into a background whose forms aggressively move up to the level of their bodies. The early Women (pages 38–43) inhabit an even more distorted space, and the chairs, tables, and windows indicating the volume that is supposed to contain them take on the independent intensity of abstract forms and often seem to push in front of the figures.

These counterbalancing actions in de Kooning's pictures might seem to relate to Clement Greenberg's *ipse dixit* concerning "the growing rejection of an illusion of the third dimension." But in de Kooning, as in so much of the best of modern art, the opposite is the case: a sense of the two-dimensionality of the physical surface is recreated by complex series of interacting illusions in depth.

For those of us fortunate enough to have two eyes, physical two-dimensionality, i.e., pure flatness, is illusion. We see everything in a complicated elliptical field of vision in which objects are foreshortened, dimmed, brought into focus, and twisted every which way to make a mosaic of sensations that our culture has taught us to interpret along certain conventional tracks. One of the conventions is the monocular illusion of flatness, which can only be suggested by elements taken out of the reality of the three-dimensional world in which we live and transformed into pictorial metaphors. "Flatness" is not "there," on the canvas, simply and easily exposed for what it is, but is a metaphysical quality, which, like a vision, can be revealed, but not proved.

De Kooning's abstractions and figures were "flattened" through a development of illusions and equilibriums. He did not make distinctions between the genres, nor has he since. The spheroids from an abstraction appear as fruit on a Woman's crazy hat. Windows and shelves become "unreadable" nests of rectangles.

De Kooning's work can be divided into types for purposes of convenience, and in order to follow a motif through its various developments. A suggested breakdown would be:

1 Early high-key color abstractions, 1934–1944.
2 Early figures (Men), 1935–1940.
3 Early figures (Women), 1938–1945.
4 Color abstractions, 1945–1950.
5 Largely black with white abstractions, 1945–1949.
6 Largely white with black abstractions, 1947–1949.
7 Women, series II, 1947–1949.
8 Women, series III, 1950–1955.
9 Abstract urban landscapes, 1955–1958.
10 Abstract parkway landscapes, 1957–1961.
11 Abstract pastoral landscapes, 1960–1963.
12 Women, series IV, 1960–1963.
13 Women, series V, since 1963.
14 Women in the country, since 1965.
15 Abstract countryside landscapes, since 1965.
 (All dates are tentative.)

The point is that unlike Picasso, for example, whose "periods" follow each other in a chronological sequence (Blue, Pink, African, Analytical Cubist, Synthetic Cubist, Neo-Classic, etc.) de Kooning keeps as many possibilities going at the same time as he can, each feeding the other, each in a sense inhabiting the other. So a division of his work into types could result in the ultimate parody of art-historical periodicity in which there are as many periods as there are pictures.

The artist keeps himself open, available to all possibilities and any contradictions.

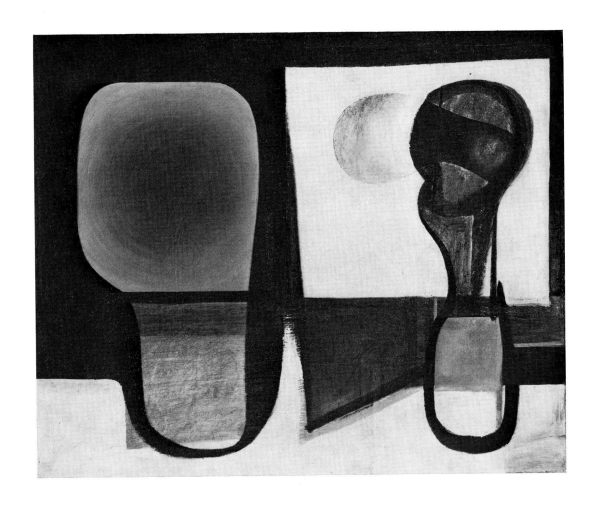

Untitled. (*ca.* 1934).
Oil on canvas, 36 × 45¹⁄₃ inches.
Collection John Becker, London

opposite above: *Pink Landscape. (ca. 1938).*
Oil on composition board, 24 × 36 inches.
Collection Mr. and Mrs. Reuben Tam, New York

opposite below: *Abstract Still Life. (ca. 1938)*.
Oil on canvas, 30 × 36 inches.
Collection Mr. and Mrs. Daniel Brustlein, Paris

above: *Elegy. (ca. 1939).*
Oil and charcoal on composition board, 40¹/₄ × 47⁷/₈ inches.
Private collection. Courtesy Pasadena Art Museum

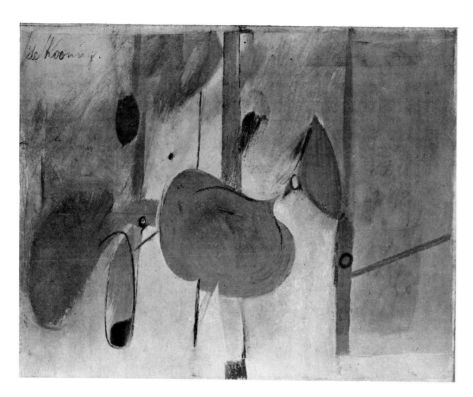

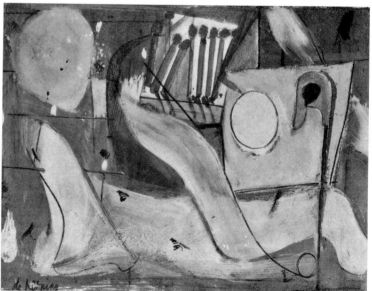

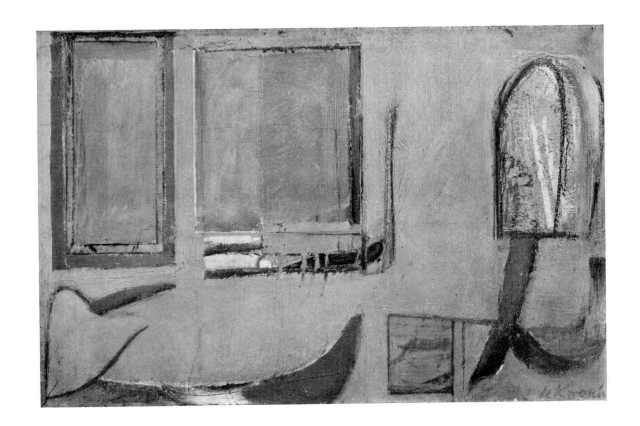

opposite above: Untitled. (1941–1942).
Oil on paper, 5⅝ × 7⅜ inches.
Allan Stone Gallery, New York

opposite below: Untitled (*Matchbook*). (*ca.* 1942).
Oil and pencil on paper, 5½ × 7½ inches.
Collection Mr. and Mrs. Stephen D. Paine, Boston

above: Untitled. (*ca.* 1944).
Oil and charcoal on paper, mounted on composition board,
 13½ × 21¼ inches.
Collection Mr. and Mrs. Lee V. Eastman, New York

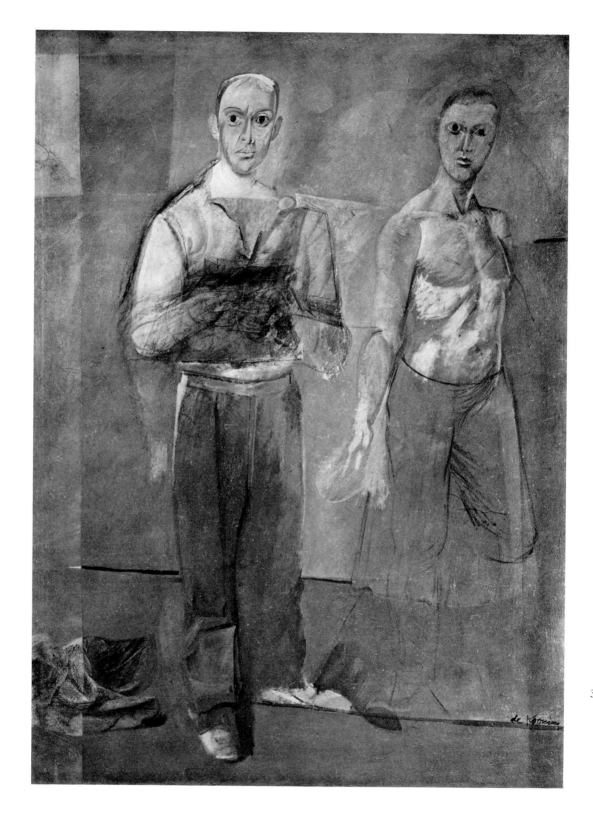

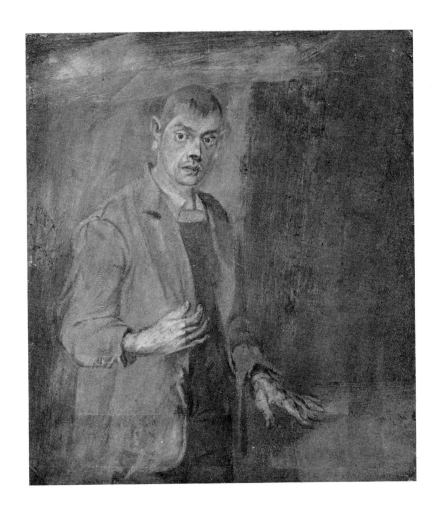

opposite: *Two Men Standing.* (*ca.* 1938).
Oil on canvas, $61^1/_8 \times 45^1/_8$ inches.
Private collection

above: *Man.* (*ca.* 1939).
Oil on paper, mounted on composition board, $11^1/_4 \times 9^3/_4$ inches.
Private collection

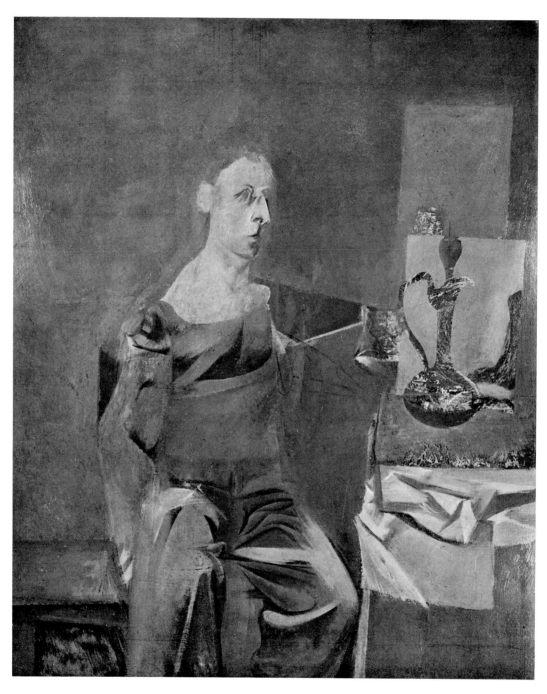

Glazier. (*ca.* 1940).
Oil on canvas, 54 × 44 inches.
Private collection

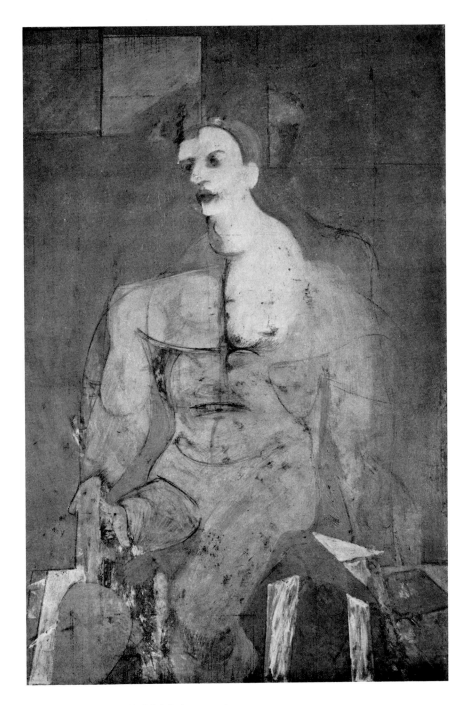

35

Seated Figure (Classic Male). (*ca.* 1940).
Oil and charcoal on plywood, 54³/₈ × 36 inches.
Private collection

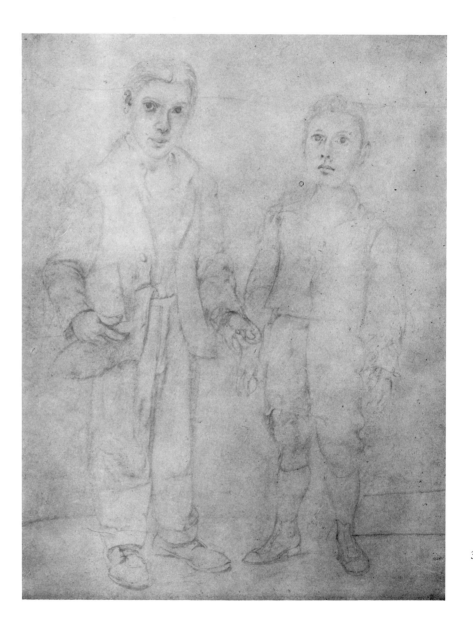

36

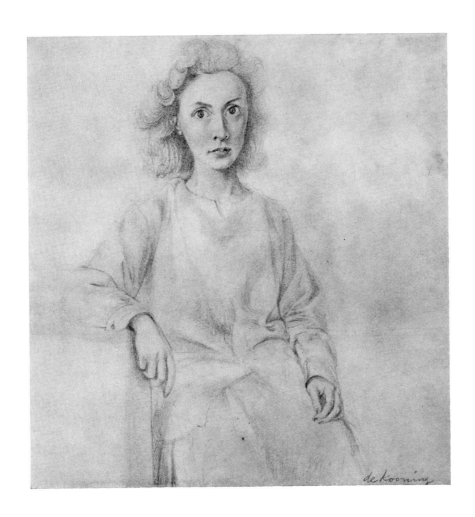

opposite: *Self-Portrait with Imaginary Brother.* (*ca.* 1938).
Pencil, $13^{1}/_{8} \times 10^{1}/_{4}$ inches.
Collection Saul Steinberg, New York

37 above: *Elaine de Kooning.* (*ca.* 1940–1941).
Pencil, $12^{1}/_{4} \times 11^{7}/_{8}$ inches; $9 \times 8^{7}/_{8}$ inches (comp.).
Collection Hermine T. Moskowitz, New York

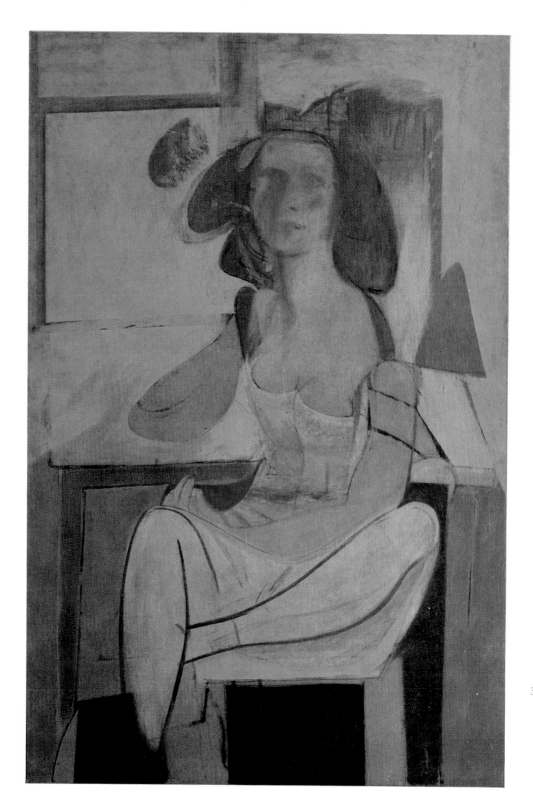

38

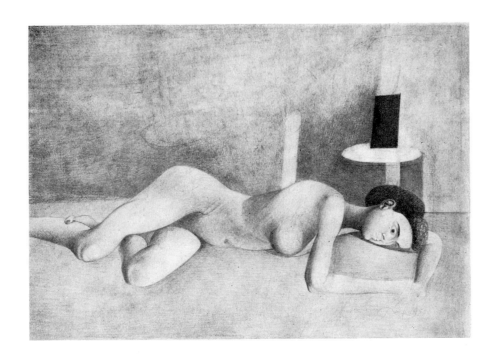

opposite: *Seated Woman*. (*ca.* 1940).
Oil and charcoal on composition board, 54 × 36 inches.
Collection Mrs. Albert M. Greenfield, Philadelphia.

above: *Reclining Nude*. (*ca.* 1938).
Pencil, 10^1/$_2$ × 13 inches; 7^3/$_8$ × 10^5/$_8$ inches (comp.).
Owned by the artist

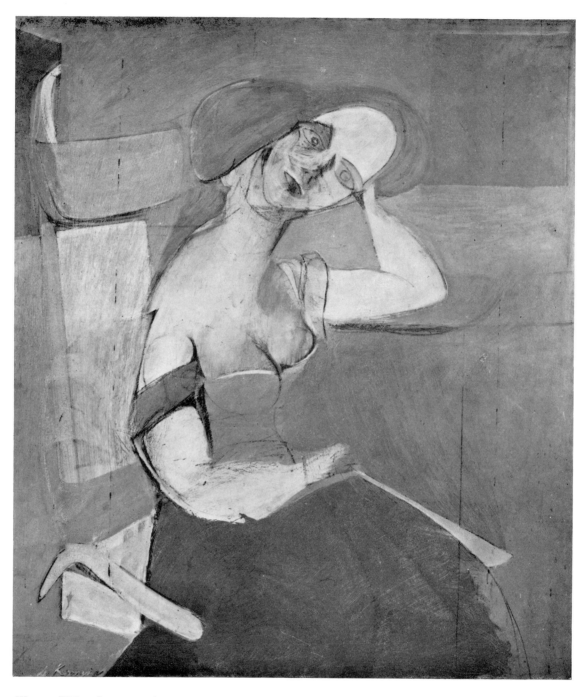

Woman Sitting. (1943–1944).
Oil and charcoal on composition board, 48¹/₄ × 42 inches.
Collection Mr. and Mrs. Daniel Brustlein, Paris

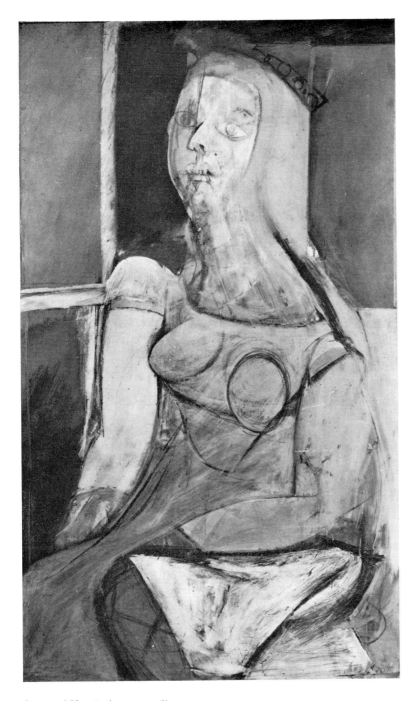

Queen of Hearts. (1943–1946).
Oil and charcoal on composition board, 46 × 27¹/₂ inches.
Joseph H. Hirshhorn Foundation

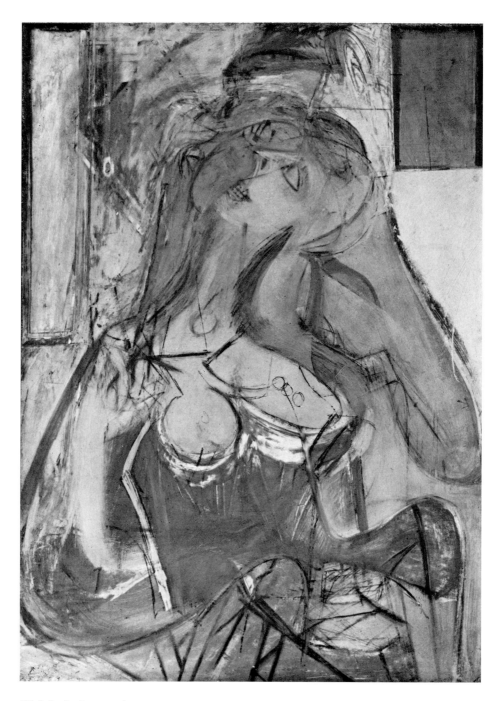

Pink Lady. (*ca.* 1944).
Oil and charcoal on composition board, 48³/₈ × 35⁵/₈ inches.
Collection Mr. and Mrs. Stanley K. Sheinbaum, Santa Barbara, California

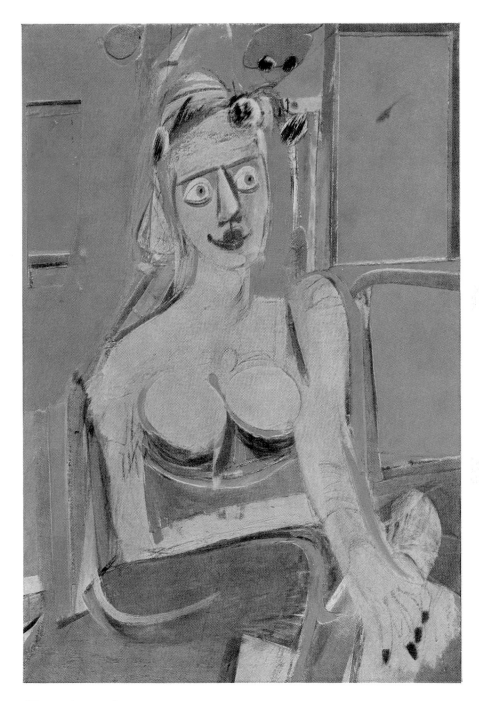

43

Woman. (ca. 1944).
Oil and charcoal on canvas, 46 × 32 inches.
Private collection

II

In 1940, with Paris sealed off from the world by the German army, groups of well-known European artists and writers began to arrive in New York, increasing the already rich concentration of emigré intellectuals who had been coming to the U.S. since 1933. The Europeans were welcomed and appropriately fêted and followed; but, perhaps by coincidence, their arrival also marked the moment of the American artists' final and definitive rejection of School of Paris aesthetics. The concept of the well-made picture – the sensitized touch and refined composition – had become too attenuated to be of any further use to the younger Americans. They did not react *against* Picasso, Léger, or Miró; these masters simply had nothing left to offer. (Later, when Matisse's 1946–1948 paintings and drawings were shown in New York, a number of Americans returned to Paris sources through him – often following the guidance of Hans Hofmann.)

With the immediate past cut away, American artists faced a crisis: what to do, where to go, even how to begin, were put in question. Surrealism, despite its apparently old-fashioned reliance on subject matter, had something to offer in the idea of automatism, which was reinforced by the New York artists' experience with the early improvisational Kandinskys exhibited at the Guggenheim, then called the Museum of Non-Objective Art. Social Realism was abandoned simultaneously with the liquidation of ideologies, although its sense of urgent commitment and ambition for a direct communication with a wide audience remained influential. A tradition of Western art seemed to have ended, and with the disappearance of its imperatives there also came a sense of joyful release. The whole past suddenly was available, open to radical reinterpretation and re-use. Mondrian and Bonnard seemed more relevant than Picasso or Braque. Courbet, Monet, Seurat, Pissarro appeared

44

as new artists. Almost anything could seem new: a study of myths and the unconscious, a revival of monumental scale, geometry, anarchy, even art for Art's sake.

What had happened was that the New York artists – many working independently, some helping each other in small groups, others influenced by certain leaders – changed the basic hypothesis of art. It can be described (in a simile) as a shift from aesthetics to ethics; the picture was no longer supposed to be Beautiful, but True – an accurate representation or equivalence of the artist's interior sensation and experience. If this meant that a painting had to look vulgar, battered, and clumsy – so much the better.

Of course the cruel trick that history plays is to transform revolutions into continuities. The violent drip paintings of Pollock that once shocked the public, or Still's sooty trowelings, or de Kooning's scarred and clotted pigment now, twenty years later, look as beautiful as Manets. And the "new" hypotheses of the Americans were probably not very different from those that engaged Cézanne and Matisse – only the New Yorkers expressed the idea more sharply (they had, after all, the example of Dada), and in their own idiom. But if the great opening moves of the new American art now seem to be clothed in historical inevitability, that is also the fault of History, which insists on being read backwards. At the time, the future looked black; it *was* a revolution.

The powers-that-be in the art world were almost unanimously against the new ideas. They had read their history books backwards and were waiting for an allegorical, perhaps religious or symbolic, realism to consolidate the efforts of Surrealism and Neo-Romanticism. Abstract art was considered a dead end, with Mondrian its blind wall. The American artists were attacked, dismissed, and left to themselves and to four or five galleries, which showed their works with a dedication replying to that of the artists themselves.

Some of these artists arrived at their styles within the developing concepts of their art: you might call them "continuers," and they include de Kooning, Gorky, Pollock, Hofmann, etc. Others changed their styles radically, sometimes in a matter of weeks, sometimes over a period as long as two years; you might call them "converts" (like Saul, who, suddenly on his way to Damascus, became Paul); they include Kline, Newman, Rothko, Gottlieb, etc.[7] Both "continuers" and "converts" were equally fervent believers in their new visions, but the latter in a sense had wiped out the past, and many of them even today exhibit old pictures with reluctance – not of course from any sense of shame but because the earlier pictures might seem misleading and inapplicable. With the "continuers," on the other hand, it is difficult to pinpoint where a drastic change occurred, if any did – especially in the case of de Kooning. (With Pollock, on the other hand, there is the "invention" of drip paintings; and with Gorky, the adaptation of floating, thinned washes of color – although the "new" images were based firmly on the artists' previous ideas about content and formal construction.)

Reinforcing the breakaway from traditional Paris aesthetics was the general feeling that after the War something new, better, more human, would have to replace the old customs and systems in political and social as well as cultural life. Such a spirit is probably the product of all deeply troubled times. Trotsky felt it when, as an exile, he visited the Prado in 1916; he wrote in his notebook that there could never be "a simple return to the old form, however beautiful – to the anatomic and botanic perfection, to the Rubens thighs (though thighs are apt to play a great role in the new post-

war art, which will be so eager for life). It is difficult to prophesy, but out of the unprecedented experiences filling the lives of almost all civilized humans, surely a new art must be born."[8] Commissar Trotsky nevertheless helped to suppress some of the best art to appear after World War I. And in Europe and America between the wars, many of the best artists turned to consolidation and away from radical experiments (with some exceptions, notably Dada and de Stijl). But during and after World War II, as the center of international power moved to America, expressing itself most directly in America's capital city, New York, a new art was born, and eventually it would include even the Rubens thighs that Trotsky had so poignantly envisioned.

The evolution of de Kooning's postwar style was, as I have said, a continuous process – a gradual, logical, steady development, marked by hundreds of insights, but no blinding revelation. His friend Franz Kline changed from small-scale, mild, lyrical realism to giant, roaring, epic black-and-white abstraction in a matter of weeks. The changes in de Kooning's art have a secret drama. Compare an abstraction of about 1938 (page 28) with *Pink Angels* of about 1945 (page 52), and you see that an image of sweeping, passionate gestures has replaced a calmer, harmonious balance (which nevertheless has its inner quiverings). Or, to narrow the dates down a bit, compare *Seated Woman*, 1940 (page 38), with a 1944 figure (page 43). Many of the elements are similar: the pose of the legs (only American girls, Raoul Hague once explained to de Kooning, sit on one buttock), a window in the corner, an armchair, a hat. But the 1944 painting is bursting with a new energy; the colors have been tuned up so intensely that the framed rectangle on the right seems to glow – as if de Kooning had pre-

dicted the television set; it is only a step from here to *Woman, I* of 1952 (page 91). Likewise, *Pink Angels* prefigures *Light in August*, 1946 (page 54), a full expression of the style that Harold Rosenberg named Action Painting in 1952,[9] but that by 1950 already was becoming internationally famous.

Conversely, when you look at these same pictures within the larger body of de Kooning's work, their similarities are as emphatic as their differences: similar themes of Pompeian color – blue, pink, ocher, alluding to the Boscoreale frescoes in the Metropolitan as well as to Broadway neon – similar hooking forms and flickering contours, tie the works so closely together that the whole idea of a "breakthrough" seems a bit juvenile – like an advertising agency's gimmick to sell History.

But between 1942 and 1944 a shift did take place, and a stronger passionate force, a greater control of more ambitious means, marked de Kooning's work. Very few works seem to exist that can be dated with any certainty to 1943. It was the year in which de Kooning remodeled his studio in preparation for his marriage; he produced a few pictures of elegantly dressed, aristocratic ladies, in hopes of getting commissions from some of the fashion magazines, but abandoned the project as fruitless and distracting. It was probably also the year of stepping back in order to leap.

To describe how the new work evolved it must be analyzed, and in analysis the point of the work, its essential wholeness, is lost. It is a trap into which always falls that system of translation by metaphors we call "art criticism." But perhaps pointing out that we are in a trap gives us a precarious freedom – at least enough to "continue the conversation," as Wittgenstein advised art critics.

"There are three toads at the bottom of my garden, Line, Color and Form," de Kooning once wrote. Let us start with Line. De Kooning is a

46

natural draftsman, fully aware of the dangers of virtuosity. Until the 1960's he seldom made a "finished" drawing, or drawings for drawing's sake. The moving pencil, charcoal, brush, or knife is the way he thinks (as such different temperaments as Degas, Cézanne, and van Gogh thought). Some drawings are done almost absent-mindedly, like humming a song. Some attack a problem directly and are as analytical as an equation. But usually the drawing is a search for shapes or lines or divisions or connections or a sense of light that will be used in painting.

De Kooning developed his shapes from fairly realistic motifs (a shutter, a belfry, fingers, a matchbook with a match sticking out along the bottom) to abstract ones.[10] No iconography or key to the abstraction can result from investigating his method: a belfry shape near a woman shape does not stand for a woman in a church. But a morphology can be indicated: how the artist picked a motif and refined it until it became part of his own supply of forms.

"Even abstract shapes must have a likeness," de Kooning once said. Likeness is a mysterious quality. Raphael's and Ingres' portraits convince us they are speaking likenesses, even though we have never seen the sitters. In other portraits we see mainly the artist's style; the sitter could have been an apple, but a likeness comes through – the psychology of an individual man (Roland Penrose, sitting in a café, recognized the dealer Uhde from a Picasso portrait that is largely an arrangement of faceted Cubist planes). Portraits without likenesses usually are representations of an official style or a power, like the sumptuous representations of Louis XIV, which so overwhelm us with the concepts of divine right and national grandeur that we forget the two men – the artist and the sitter.

For an abstract shape to have likeness, then, it must first of all be the artist's; then it must be accurately tuned to something outside his art while retaining the quality of his insight; finally it must establish an equilibrium between the "inside" and the "outside," and within that tension express the fusion of both elements.

De Kooning is one of the great inventors of forms of the twentieth century, and the fascination his drawings present, apart from their intrinsic qualities, is their revelation of this part of the creative act. He will do drawings on transparent tracing paper, scatter them one on top of the other, study the composite drawing that appears on top, make a drawing from this, reverse it, tear it in half, and put it on top of still another drawing. Often the search is for a shape to start off a painting, and in *Attic* (page 65) you can still see signs of the sliced drawings that supplied the motif. Other drawings do not search for ideas about form, but are about interstices, connections, edges. Some drawings have nothing to do with line, but indicate how two shapes will meet with a crunch on a surface. And others, reassembled and torn, indicate how one passage can jump to the next one.

In de Kooning's works of 1945–1956, shapes do not meet or overlap or rest apart as planes; rather there is a leap from shape to shape; the "passages" look technically "impossible." This is a concept which comes from collages, where the eye moves from one material to another in similar impossible bounds. De Kooning often paints "jumps" by putting a drawing into a work-in-progress, sometimes painting over part of it and then removing it, using it as a mask or template, sometimes leaving it in the picture. An assembly of sliced pieces of paintings thumb-tacked together in 1950 (page 69) is the prototype of the technique of collage-painting that has been very widely adapted, first in America, now internationally.

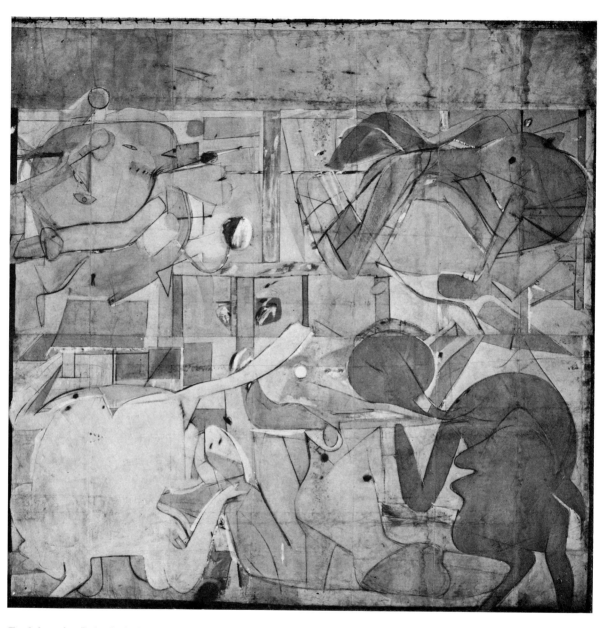

Backdrop for *Labyrinth*. (1946).
Calcimine and charcoal on canvas, 16 feet 10 inches × 17 feet.
Allan Stone Gallery, New York

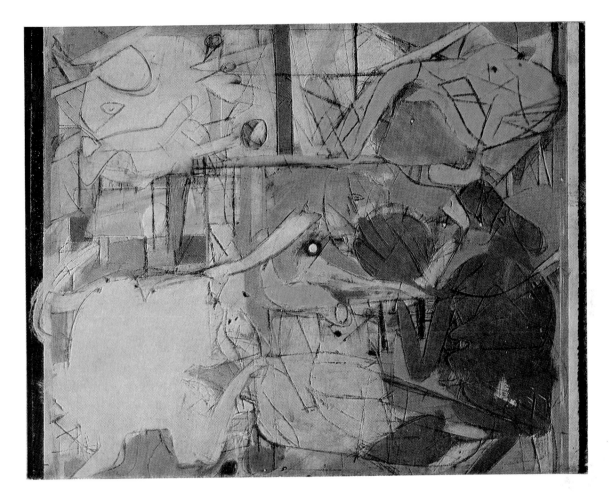

Study for backdrop *(Labyrinth)*. (1946).
Oil and charcoal on paper, $22^1/_8 \times 28^1/_2$ inches.
Private collection

De Kooning had two experiences with theatrical design.
Through his friend Edwin Denby he was commissioned to do
sets and costumes for Nini Theilade's ballet *Les Nuages*,
which was presented by the Ballet Russe de Monte Carlo
at the Metropolitan Opera on April 9, 1940. Unfortunately
no record of this event survives. In the spring of 1946
he was asked to make a backdrop for a dance recital by
Marie Marchowsky. He painted a sketch and enlarged it on a
17 foot square canvas with the help of Milton Resnick.
The dance was performed April 5, under the title *Labyrinth*;
the backdrop was found in 1959 rolled up in Miss Marchowsky's
apartment.

De Kooning also draws in and on his paintings. He will trace a section of a work with charcoal on wrapping paper in order to test a form in several positions, or to keep a record of a part of the painting that is about to be wiped out. He also draws with heavy charcoal directly into the paint, and often there are traces of it in the finished work – perhaps symbolizing the unfinished dreams of Frenhofer, certainly adding an ambiguity of tentative indications that might or might not be replaced by strokes of the brush. In a number of pictures there is a charcoal X, like a belly button, often indicating the pivot from which the forms swing – a kind of memorandum from the artist to himself that he purposely forgot to throw away.

The move from drawing to painting could be as natural, at the inception of a painting, as the shift from black ink to black paint. De Kooning began painting some of his abstractions in the 1940's by drawing an object chosen at random, sometimes his own thumb, with a long, supple liner's brush whose hairs bend into an S as it distributes pigment on the surface, moving in a quick razor-thin line or, when an edge is flipped down, distributing streaks or crescents five inches wide.

At other times he would begin a painting by scattering letters on the picture, sometimes at random, sometimes spelling simple words like "ART" or "RAPT" (page 56).

Pollock was making a similar use of what he called "simple stenographic notations" in the early forties, but he preferred to put in his ampersands, numerals, and other signs as the work was nearing completion. De Kooning usually began with letters and then painted them out. Both artists were looking for shapes that could be quickly and easily "read," but had no strong associative meanings. Pollock abandoned his stenographic signs rather quickly, but de Kooning kept using letters in paintings until 1956. *Easter Monday* of that year (page 109) was titled from its day of completion (just in time for his show at the Janis gallery), but it is also, perhaps coincidentally, strewn with E's.

Drawings and paintings fed off each other in the forties, until de Kooning created a new kind of painting, or perhaps a new kind of drawing, in a series of black-and-white abstractions (pages 54–60), which were exhibited in his first one-man show at the Egan gallery in 1948.

They are not drawings because the black-on-white or white-on-black shapes, no matter how thin, act as pictorial forces: in other words, there are no lines. Neither are there backgrounds nor foregrounds. The blacks and whites push in front of and slip behind each other. Everything moves at a uniform velocity; the material has a consistent body. There is an extraordinary lucidity – and ambiguity. It is as if two philosophers were having a discussion about Black and White, but each property could only be cited in terms of its opposite.

Why black and white? Barnett Newman has said that when an artist moves into black, it is to clear the table for new hypotheses (and this was certainly true for Franz Kline). But de Kooning did not make a *tabula rasa*. The idea for these paintings started in his high-keyed color abstractions; then ochers gradually dominated; finally the color was drained out – but slowly; patches of color still appear as late as *Light in August* and *Black Friday* (pages 54, 55).

Another suggestion has been that de Kooning, very poor at the time, could not afford colors. The pigments used in these works are a zinc white and a house painter's black enamel, Ripolin, the gloss sometimes toned down with an admixture of pumice. The pictures are done on large sheets of pa-

per, then mounted on masonite with zinc white as an adhesive – the cheapest possible materials. But this romantic interpretation (the black of despair) ignores the fact that even when de Kooning was so broke that he did not have a nickel to return Dorothy Miller's call from The Museum of Modern Art, if he wanted the best (and only the best) tube colors, he always found a way to get them. In 1949, his financial position had not improved, but he began a series of abstractions with bright colors set like crushed jewels between the muscular white and black forms.

The answer seems to be a simple one: in cutting down to black and white, the artist was able to achieve a higher degree of ambiguity – of forms dissolving into their opposites – than ever before; he pushed along this line until, with *Attic* and *Excavation* (pages 65, 70–71) he had painted himself "out of the picture."

The black-and-white abstractions and the colored ones that were done alongside them are packed to bursting with shapes metamorphosed from drawings of women which had been cut apart, transposed, intermixed until they were abstract, but always with a "likeness" and a memory of their source and its emotive charge. Interchangeability is a plastic quality, as negative and positive spaces swiftly reverse and then resume their positions, and also an element of the content, as the parts of the body engage in a similar dance of shifting identities. This will become a major theme in de Kooning's Women of 1950–1953. Here it adds a joyous eroticism to the sense of exuberance and liberation from aesthetic constraint.

Untitled. (1945).
Pastel and pencil,
12 × 13⁷⁄₈ inches (irregular).
Allan Stone Gallery, New York

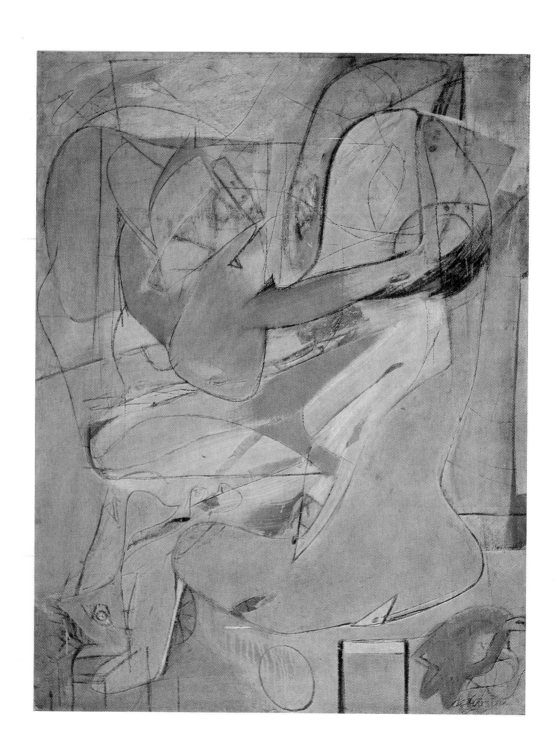

52

opposite: *Pink Angels*. (*ca.* 1945).
Oil and charcoal on canvas, 52 × 40 inches.
Collection Mr. and Mrs. Frederick R. Weisman, Beverly Hills, California

above: *Still Life*. (*ca.* 1945).
Pastel and charcoal, 13³/₈ × 16¹/₄ inches (sight).
Collection Betty Parsons, New York

53

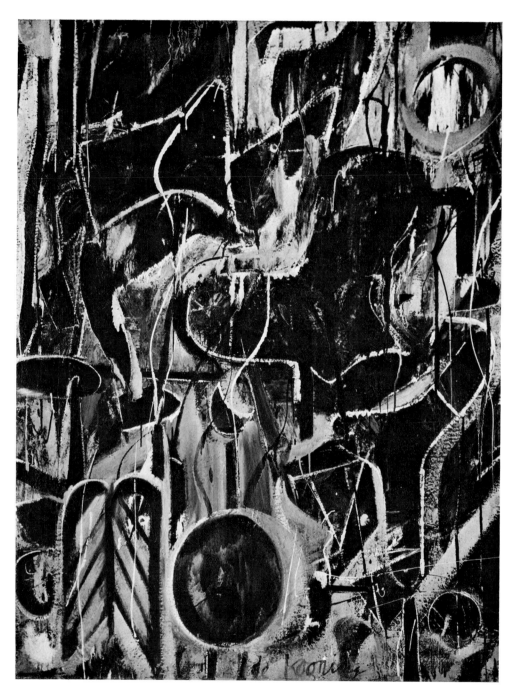

Light in August. (*ca.* 1946).
Oil and enamel on paper, mounted on canvas, 55 × 41 ½ inches.
Collection Elise C. Dixon, Scottsdale, Arizona

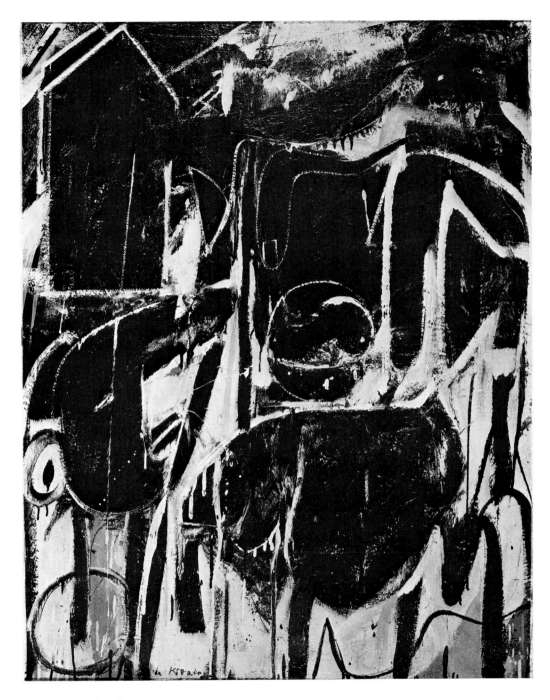

55

Black Friday. (1948).
Enamel and oil on composition board, 48 × 38 inches.
Collection Mrs. H. Gates Lloyd, Haverford, Pennsylvania

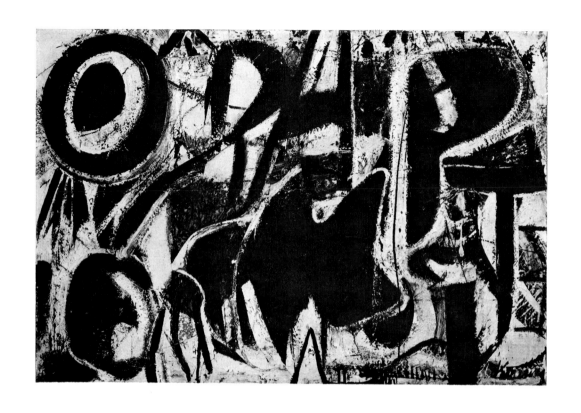

opposite: *Orestes*. (1947).
Enamel on paper, mounted on plywood, 24^1/$_8$ × 36^1/$_8$ inches.
Collection Ruth Stephan Franklin, New York

below: *Painting*. (1948).
Enamel and oil on canvas, 42^5/$_8$ × 56^1/$_8$ inches.
The Museum of Modern Art, New York. Purchase

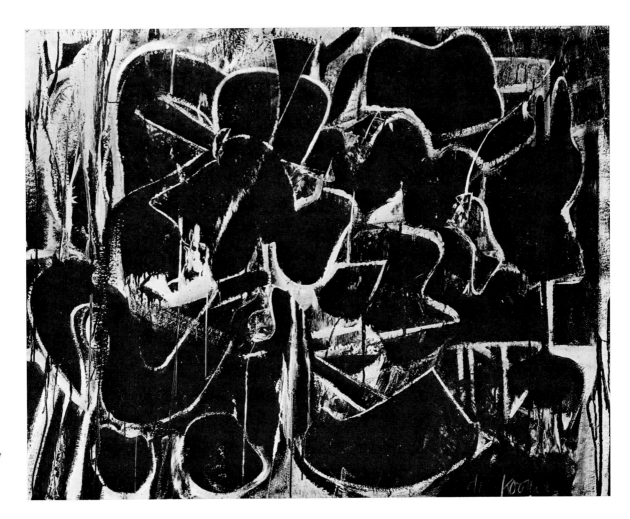

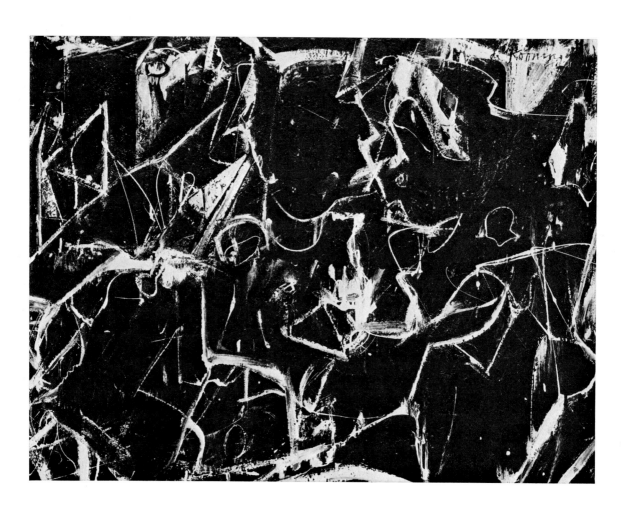

58

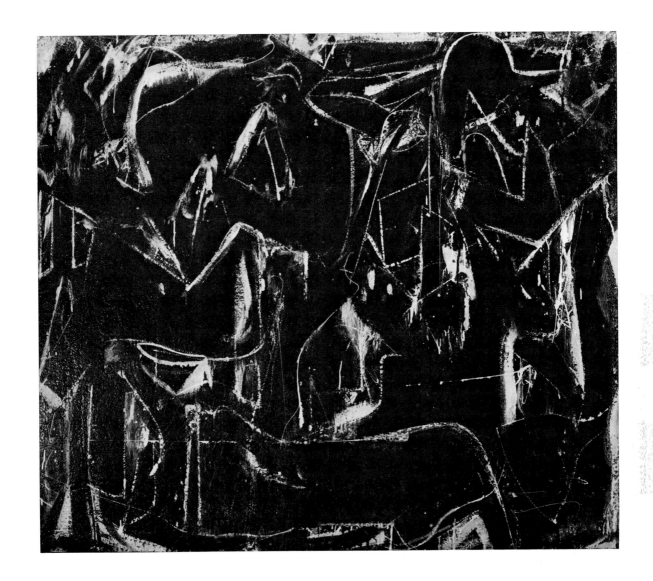

opposite: *Night Square.* (*ca.* 1949).
Enamel on cardboard, mounted on composition board, 30 × 40 inches.
Collection Martha Jackson, New York

above: *Dark Pond.* (1948).
Enamel on composition board, $46^3/_4 \times 55^3/_4$ inches.
Collection Mr. and Mrs. Richard L. Weisman, New York

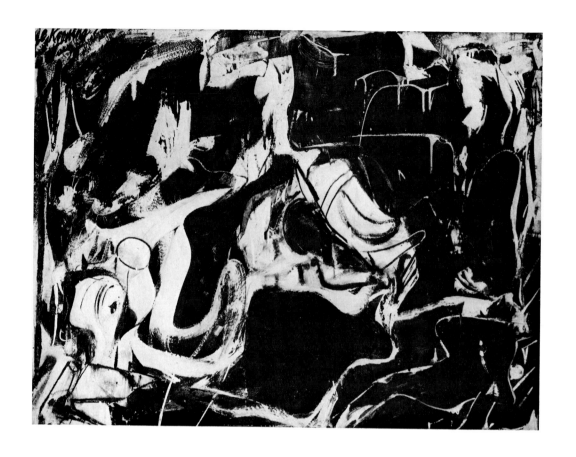

above: Untitled. (1948).
Enamel and oil on paper, mounted on composition board, 30 × 40 inches.
Collection Mr. and Mrs. Thomas B. Hess, New York

opposite above: Untitled. (1949).
Enamel on graph paper, 21$^1/_2$ × 29$^1/_2$ inches.
Collection Mr. and Mrs. Harold Rosenberg, East Hampton, New York

opposite below: Untitled. (1950). Enamel, 18$^7/_8$ × 25$^1/_2$ inches.
Joseph H. Hirshhorn Collection

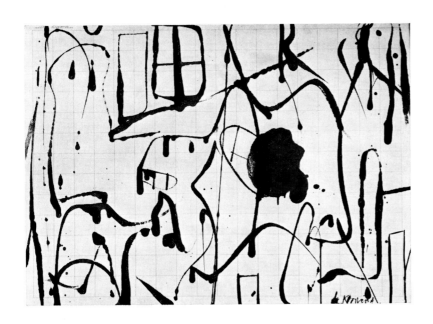

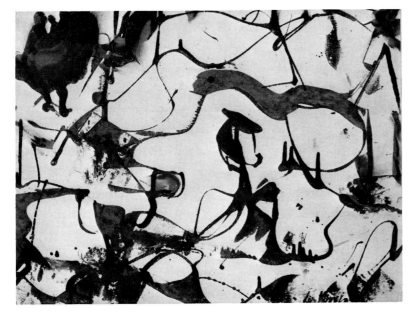

opposite above: Untitled. (1948).
Oil and enamel on paper, 18⁷/₈ × 23 inches.
Collection Mary Abbott, New York

opposite below: *Town Square.* (1948).
Oil and enamel on paper, mounted on composition board,
 17³/₈ × 23³/₄ inches.
Collection Mr. and Mrs. Ben Heller, New York

above: *Mailbox.* (1948).
Oil, enamel, and charcoal on paper, mounted on
 cardboard, 23¹/₄ × 30 inches.
Collection Nelson A. Rockefeller, New York

63

below: *Attic Study*. (1949).
Oil and enamel on buff paper, mounted on composition board,
 18⁷/₈ × 23⁷/₈ inches.
D. and J. de Menil Collection

opposite: *Attic*. (1949).
Oil on canvas, 61³/₈ × 80¹/₄ inches.
Collection Muriel Newman, Chicago

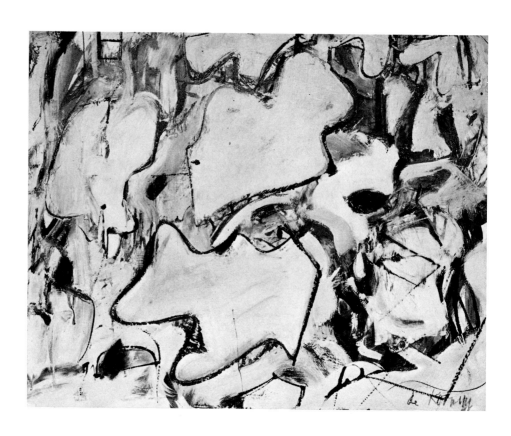

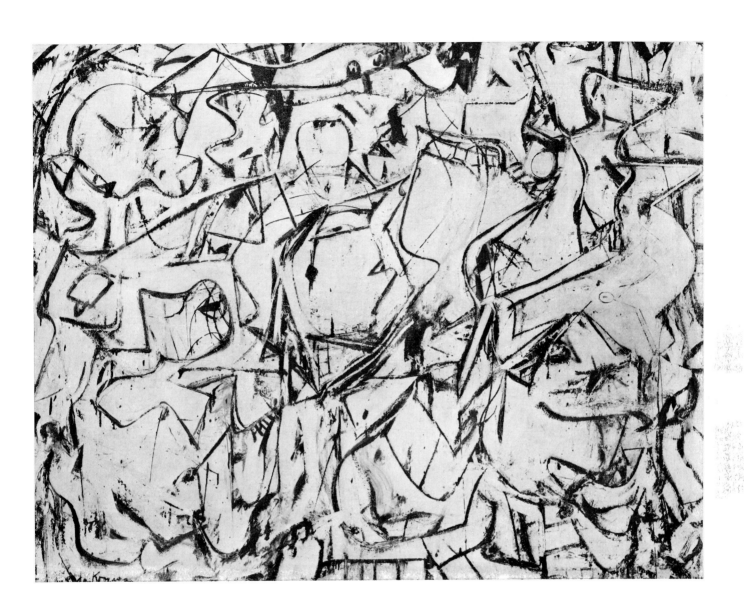

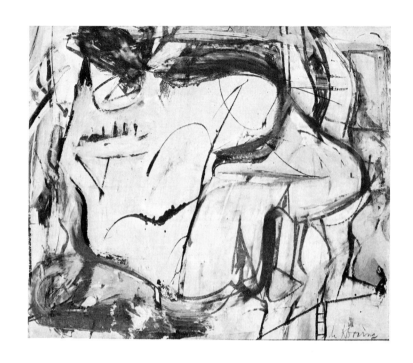

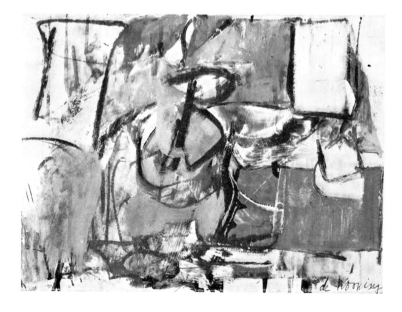

right above: Untitled (*Woman, Wind, and Window*). (1950).
Oil and enamel on paper, $16^1/_2 \times 20$ inches.
Collection Alfonso A. Ossorio, East Hampton, New York

right below: *Boudoir*. (1950).
Oil and enamel on paper, $15 \times 20^3/_4$ inches.
Collection Mr. and Mrs. Allan Stone, New York

opposite above: *Warehouse Manikins*. (1949).
Oil and enamel on buff paper, mounted on cardboard, $24^1/_4 \times 34^5/_8$ inches.
Collection Mr. and Mrs. Bagley Wright, Seattle, Washington

opposite below: *Woman, Wind, and Window*. (1950).
Oil and enamel on buff paper, mounted on composition board, $24^1/_8 \times 36$ inches.
Collection Mr. and Mrs. Ben Heller, New York

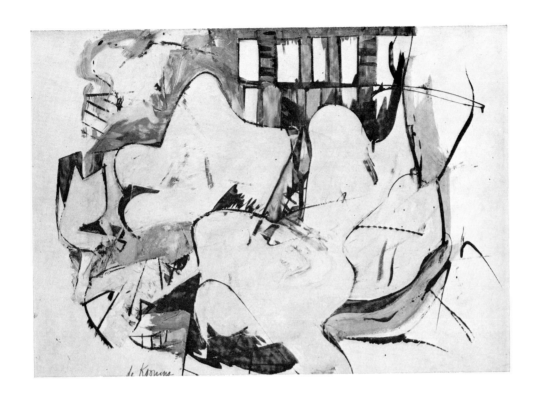

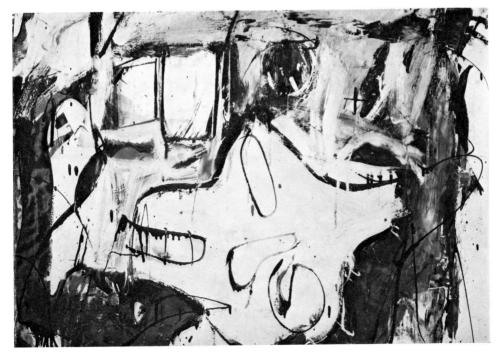

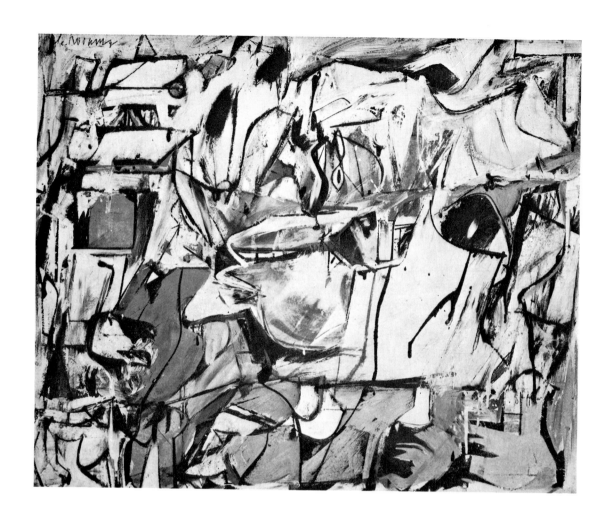

opposite: *Asheville*. (1949).
Oil and enamel on cardboard, mounted on composition board, $25^5/_8 \times 32$ inches.
The Phillips Collection, Washington, D.C.

below: *Collage*. (1950).
Oil, enamel, and metal (thumbtacks) on cut papers, 22×30 inches.
Collection Mr. and Mrs. David M. Solinger, New York

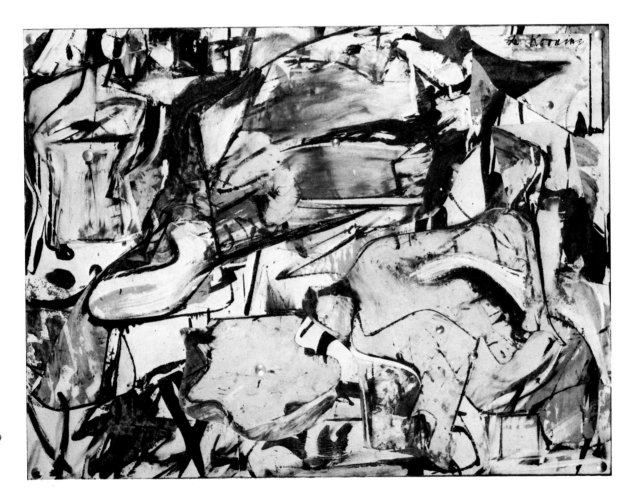

Excavation. (1950).
Oil and enamel on canvas, 6 feet 8$^1/_8$ inches × 8 feet 4$^1/_8$ inches.
The Art Institute of Chicago. Mr. and Mrs. Frank G. Logan
 Purchase Prize; Gift of Mr. Edgar Kaufmann, Jr.
 and Mr. and Mrs. Noah Goldowsky

III

De Kooning's one-man show, April 1948, marked his emergence from the artists' underground world; it was widely accepted by the artist public, which in turn influenced a growing number of the public public. Clement Greenberg in *The Nation* called it a "magnificent first show" and later, when he took part in a round table on modern art organized by *Life* magazine, chose the largest black-and-white abstraction at the Egan gallery (page 57) as evidence of the importance of the new American painting. Renée Arb in *Art News* and Robert Goldwater in the *Magazine of Art* were also early champions of the artist.

In the summer of 1948, de Kooning taught at Black Mountain College, then headed by Josef Albers, where he renewed his friendship with composer John Cage and universal designer Buckminster Fuller. Elaine audited one of Fuller's courses and remembers that one day he showed the class two irregularly shaped solids and said they could be fitted into a perfect cube. Everybody attempted to do it, but no one could. De Kooning dropped in, and Fuller asked him to try; he looked at both sections for a few seconds, then jammed them together, and they clicked into position. Fuller said to the class that this demonstrated how "genius" can visualize forms in space. Later de Kooning explained to his wife that, knowing Fuller, he just chose the two most impossible-looking aspects – the areas that could never join – and pushed from there. But in a sense Fuller was right; joining impossibles is a de Kooning method.

By the end of the 1940's the situation of the American artist had not greatly changed. Sales were still so remote as to be almost unthinkable. There had been some attempts by dealers to advance their painters a bit of money, but the arrangement did not work out in the short run, and none of the dealers was in a position to think about

72

long hauls. Most museums and critics were still violently opposed to anything new in American art since Ben Shahn and Morris Graves.

A number of the artists who lived downtown became tired of the old cafeterias, where nice points of aesthetic or erotic scholarship were apt to be violently interrupted by sick bums and belligerent drunks. So they decided to form a "club," passing the hat to rent a loft at 31 East 8th Street, and fixing up a place for their conversations. De Kooning was one of the founding members, along with Kline, Conrad Marca-Relli, Phillip Pavia, Milton Resnick, and Landès Lewitin. The Friday evening talks initiated at the Subject of the Artist School (and later carried on in the same quarters under the name Studio 35) were adopted by the Club, but round-table discussions soon replaced them and became a popular form of debate. De Kooning and Franz Kline participated in many of these events, and along with Phillip Pavia, Harold Rosenberg, and others gave a form and sense of intellectual excitement to the very informal gatherings of artists and artists' friends. Barnett Newman would debate issues; Ad Reinhardt would denounce his colleagues; Ibram Lassaw and Aaron Siskind would look wise; Adolph Gottlieb and Robert Motherwell put in less frequent appearances. Jackson Pollock would stay around the corner at the Cedar bar until the talking was over and then climb the stairs to join the post-symposium party.

The Club in its Eighth Street days was a slightly distorted mirror-image of the New York art world, but it also focussed and concentrated the social milieu. It was the closest approximation New York ever had to the Paris café life of previous generations, and as a place to articulate and exchange ideas, it was even more efficient.

In the winter of 1950/51, de Kooning commuted to Yale and taught at the Art School, where Josef Albers recently had become director. Albers referred to de Kooning's studio as "the genius shop," but the students seemed pleased to get out from under the old Bauhaus master's dicipline for awhile, and de Kooning became a popular teacher. Perhaps too popular: he found the work drained his energy, and after this experience never taught again.

In 1950 he was invited to have one of six small one-man shows, along with Gorky (who had died in 1948), Pollock, Lee Gatch, Hyman Bloom, and Rico Lebrun, around a large Marin retrospective at the Venice Biennale. De Kooning finished his largest work, *Excavation*, in June 1950, just in time for it to be included in his Venice representation, along with *Attic*, which had been hung in the main landing of the Whitney Annual the previous January. Matisse won the grand prize in Venice that year. The Americans were generally disparaged by European critics, who saw them condescendingly as representing the "extreme effect attained by European formulae on the virgin American spirit." Douglas Cooper in *The Listener* called Pollock "merely silly."

In April 1951, de Kooning had his second one-man show at Egan; the pictures were abstract, many of them in color. Also included were a series of black-and-white palette-knife drawings in enamel. In June, the New York artists held the first of their co-operative "salons," in a whitewashed store on Ninth Street. Pollock, Kline, Hofmann, Motherwell, Esteban Vicente, Jack Tworkov, David Smith, Reinhardt, and many others showed works in the style the artists had made famous among their colleagues. De Kooning, however, showed a Woman of 1949 (now owned by the University of North Carolina, Greensboro). No one seemed to find this strange, although de Kooning had become categorized as an "abstract" artist. That same

month, *Excavation* was the climax in the installation of The Museum of Modern Art's *Abstract Painting and Sculpture in America*, and in October 1951 the painting won first prize in the sixtieth annual of the Chicago Art Institute, which put the $2,000 prize money toward the $5,000 purchase price.

In February 1951, de Kooning was invited by The Museum of Modern Art to write a paper for a symposium titled *What Abstract Art Means to Me;* the Museum published the statement in its *Bulletin* (Vol. XVIII, no. 3), and it has since been frequently quoted and misquoted. But while considered a spokesman for the new American abstract art, de Kooning was engaged in a very different enterprise. Almost as soon as *Excavation* left his studio in 1950, he tacked a seventy-inch-high canvas to his painting wall and began to paint *Woman, I* (page 91); it was not finished until two years later, having been abandoned after about eighteen months' work, then retrieved at the suggestion of de Kooning's friend the art historian Meyer Schapiro, and finally finished along with five other Women (pages 91–95). They were exhibited in the artist's third one-man show, at the Janis gallery, in March 1953.

Most of those who knew de Kooning's work and had followed his heroic struggles with *Woman, I* felt it was a triumph. Many younger artists, already in reaction to the rigorously intellectual climate of Abstract Expressionism, considered it a permission to revive figure painting. But the public was scandalized by de Kooning's hilarious, lacerated goddesses. And the more doctrinaire defenders of abstract art were equally severe. Clement Greenberg once had told de Kooning, "It is impossible today to paint a face," to which de Kooning had replied, "That's right, and it's impossible not to."[11]

A comic climax of a sort was supplied by the French abstractionist Georges Mathieu, who cabled the Artists' Club grandly protesting American recidivism and betrayal of the high cause of abstract painting.

De Kooning's financial situation remained much the same – that is, terrible – even though *Woman, I*, bought from the exhibition by The Museum of Modern Art, soon became one of the most widely reproduced works of the 1950's. Popular surveys that used to be subtitled, "From Altamira to Picasso," now were billed as, "From Lascaux to de Kooning." But American collectors continued to shy away. One day de Kooning explained to Harold Rosenberg: "Janis wants me to paint some abstractions and says he can sell any number of black and whites, but he can't move the Women. I need the money. So if I were an *honest* man, I'd paint abstractions. But I have no integrity! So I keep painting the Women." In 1955 he sold a large group of pictures, many of them three to six years old, for about $6,000 to Martha Jackson; she exhibited a selection of them in November. Several were sold to West Coast dealers who would henceforth show him in the Los Angeles area.

In the interview with David Sylvester, de Kooning said:

It's really absurd to make an image, like a human image, with paint, today, when you think about it.... But then all of a sudden it was even more absurd not to do it.... It [painting *Woman, I*] did one thing for me: it eliminated composition, arrangement, relationships, light – all this silly talk about line, color and form – because that was the thing I wanted to get hold of. I put it in the center of the canvas because there was no reason to put it a bit on the side. So I thought I might as well stick to the idea that it's got two eyes, a nose and mouth and neck.... When I think of it now, it wasn't such a bright idea. But I don't

think artists have particularly bright ideas. . . . Or the Cubists – when you think about it now, it is so silly to look at an object from many angles. . . . It's good that they got those ideas because it was enough to make some of them great artists.

The black-and-white abstractions, the white-and-black abstractions leading up to *Attic*, the color abstractions that climaxed with *Excavation*, are, among many other things, covert celebrations of orgiastic sexuality. They are also, if you will, inter-actions of pure shape, evocations of a bird's-eye landscape (de Kooning once said that one of the black-and-white abstractions reminded him of a seventeenth-century Dutch engraving of a naval battle), experiments in high-velocity forms. Or all together: the strength of de Kooning's ambiguity is its inclusivity. He also includes orgies.

It is instructive to compare Pollock's and de Kooning's pictures of the 1940's from the view-point of their overt and covert erotic content. Both use emphatic male and female symbols; in both the act of lovemaking is the main drama. For Pollock, the big subject is the orgasm, which is to say he is concerned with release – as Louis Finklestein has pointed out.[12] De Kooning, as usual, is more ambiguous; he is involved with preludes, climaxes, and postludes – he wants release and control. But there are more similarities than differences in their approaches. The intellectual decision to focus on sex also distinguishes them from practically all of their colleagues in the first generation of Abstract Expressionism.

In deciding to paint Woman overtly and to keep at work on one canvas until he could complete it, he was following his own fiercely independent log-ic, as the quotation cited above indicates, but he was also going back to a classical subject in art (as he has said, ''the idol, the Venus, the nude'') which he had invoked off and on from 1938 to 1949. One

can also suggest a psychological reason: perhaps he wanted to bring out into the open his feelings about Woman, realizing that they had played a large, if secret, role in his abstractions.

The new American painting was (and remains) deeply involved with a discovery of self, with the identity of the artist. Harold Rosenberg based his Action Painting thesis upon his sharp perception and analysis of this characteristic. And the enthu-siasm and dismay with which Rosenberg's essay was immediately greeted demonstrated the accu-racy of his diagnosis (''Action'' became a part of the language in the fifties as fast as ''Happening'' did in the sixties). Traditionally, European artists were more concerned with the discovery of Art. They knew who and where they were. Americans were sure of neither.

In two years of work on one rectangle of canvas, *Woman, I* was completed then painted out literally hundreds of times. De Kooning paints fast and could cover the whole surface in a matter of hours. But then would follow weeks of analysis, dissec-tion, drawing sections of the figure, moving the drawing to overlay another area.

There were also hundreds of studies, drawings, small oils, a magnificent series of pastels executed in East Hampton, Long Island, in the summer of 1952 (pages 86–87). In the studies de Kooning of-ten expressed his enchantment with American girls: they are beautiful, bright, charming; some of these figures closely resemble his wife Elaine. But on the big canvas, Woman remained regal, fero-cious.

She represents many things, but one of her as-pects, surely, is that of the Black Goddess: the mother who betrays the son, gets rid of the father, destroys the home. Facing this image and getting beyond it, perhaps, was one the reasons that it took so many months to finish *Woman, I*, and why

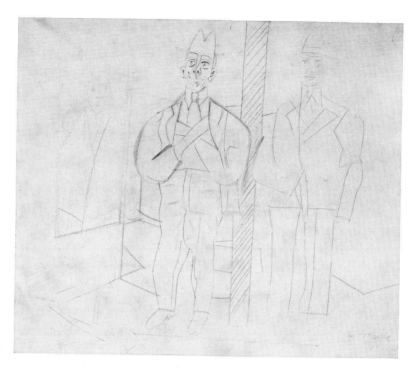

Manikins. (ca. 1942).
Pencil, 13⁷/₈ × 16⁷/₈ inches.
Owned by the artist

it was immediately afterwards destroyed, only to be resurrected through the intercession of an admired friend.

De Kooning has made the same complaint about the reception of the Women series as Joyce did about critical attacks on *Ulysses:* nobody even noticed that it was funny. There is something comical about the evocation of a Black Goddess anyhow – like a fifty-year-old man complaining that when he was five his mother broke his bow and arrows. He still may feel the punishment, but he has to laugh at the same time. Hilarity is a balance to horror – and so is banality.

The concept of the American banal has always intrigued de Kooning: advertising, commercial art, giant industries for such intimate things as deodorants and toilet paper. He found it romantic, vulgar, and in its own way poignant. In order to slow the drying of the paint in such pictures as *Attic* and *Gotham News* (pages 65, 108), de Kooning placed sheets of newspaper over the surface, peeling them off the next day. They left offset images of columns of type and advertisements in the paint and, where de Kooning did not rework, he let the ghostly images remain (page 77). They are scattered across the pictures haphazardly – here a bathing beauty, there a column of want ads – and he decided he liked this intrusion of the art of the streets into his work. The random accumulation of news and advertising images supplied a direct precedent for Rauschenberg's compositional formats – although this in no way detracts from the younger artist's completely original approach.

De Kooning was always fascinated by store-window manikins (above), comic-strip characters, and billboard figures: humanoids with the capabil-

ity of a whole range of ersatz expressions made by modest artists and anonymous craftsmen. Hannah Arendt's phrase "the banality of evil" was epitomized years before the trial of Eichmann in a huge sign that dominated lower Fourth Avenue near Cooper Union: a saintly depiction of Trujillo, with his silky little Hitler mustache and delicately modeled jowls, it presided over de Kooning's Tenth Street neighborhood as a reminder that there was a style of big art for a big audience. Woman is also conceived in these terms. And de Kooning was thinking about the American female idols in cigarette advertisements (in one study, page 78, he cut the mouth from a "Be kind to your T-zone" Camel ad and pasted it on the face), the girls whose photographs are paraded through the city on the sides of mail trucks, pinup girls with their extraordinary breasts (a particularly lush example usually hung in his studio). Thus Woman's iconic presence was modified by his understanding of our modern icons; the Black Goddess has a come-hither smile.

The direct influence of de Kooning's Women on the Pop artists of the sixties, who presented their banal idols straight, seems undeniable. Of course their assumptions are very different. And if de Kooning had never done his Women, the American Pop artists probably would have evolved pretty much as they did. At any event, after the Women of 1953–1955, de Kooning lost interest in the billboard effects—although the idea of the All-American Girl and the comic-strip creature would recur in his pictures of the sixties.

If the Black Goddess image was subconscious, the artist worked consciously with a number of highly developed plastic concepts, two of which should be mentioned in some detail.

The first involved his invention of forms out of which to make a body for Woman: the process was similar to his development of abstract elements working in paintings and drawings and collages and mixtures of all three media to find a shape with the "likeness" he wanted. De Kooning's metaphor for his concept was "intimate proportions." He described it as "the feeling of familiarity you have when you look at somebody's big toe when close to it, or a crease in a hand, or a nose, or lips, or a necktie."[13] And when parts are seen "intimately," they become interchangeable: as when you hold the joint of your thumb close to your eye, it could just as well be a thigh.

It is not a "system" of proportions, of course, but a way of achieving relationships without any system beyond the exhaustive exploration of all

Detail from *Attic*, 1949, with offset newspaper advertisement (see page 65)

above: *T-Zone*, detail from Camel
cigarette ad, back cover of *Time*
magazine, January 17, 1949;
below: Detail from Study for
Woman, 1950, with collage mouth
(see page 83)

possible forms. Anatomy opens up to as many per-
mutations as there are parts of the body.

"Intimate," however, is the clue word. It was
and still is an ideal among many of the postwar
American artists, including Pollock, Rothko,
Kline, and Newman. They planned very big pictures
because they worked "close" to the painting (phys-
ically and metaphysically) and the size could
embrace them – and the spectator. "Intimate"
meant breaking through the aesthetic barriers of
style and establishing a direct flow between the
artist and his work, between the work and the
viewer. It could be expressed in a reduced scale,
too; Motherwell once told me that a large brush
mark across a small format can make the "big"
point.

De Kooning's insistence on intimacy as a quality
of his Women must have added to his difficulties.
He had set up a context for an idol. Then he made
the idol hilarious, contemporary, and banal. These
attributes all seem consistent, more or less. But to
add intimacy–to connect the idol directly to the
solar plexus, so to speak, is to set up an "impos-
sible" condition.

But de Kooning's specialty always has been the
impossible condition. And he did achieve his "inti-
mate proportions," perhaps not in *Woman, I*,
which is a noble battlefield rather than a complet-
ed painting, but triumphantly in the Women that
followed immediately thereafter and in those
which were to come in the sixties, some of which
are still wet on the artist's easel.

Another concept that de Kooning developed in
his long struggle with *Woman, I* he has called, in
another metaphor, "no environment"–the Ameri-
can urban scene and its lack of specificity. He used
to keep pinned near his easel a *Daily News* photo-
graph of a huge crowd at a sports event; you could
not tell whether it was being held indoors (at

Madison Square Garden) or outdoors (at Yankee Stadium), although a number of architectural clues were visible–piers, girders, balconies, etc. Here an increase in size and quantity destroyed the identity and special quality of the context.

And in the city, a detail from a skyscraper could be the corner of a dentist's reception room; a huge rectangular grid could be the baffles around a water tank on top of an office building or a part of a subway station. Everything has its own character, but its character has nothing to do with any particular place. Nor with any scale: strips of steel and glass can be piled up for a building five or a hundred stories high.

As in his concept of anatomy, and in his experiments with drawings cut apart and refitted together, the parts of the city are envisioned as interchangeable. This meant that the environment for *Woman, I* would be both specific, as is appropriate to a pinup queen, and general, fit for a Queen of the Night. The visual clues to her location are kept purposefully ambiguous. There are indications of a window, but you cannot tell whether she is in a room or in front of a house. In later Women, the environmental elements are even more problematical. They suggest a city landscape, but as in the city itself, the suggestions are as equivocal as the glimpse of a neon sign or the crest of a skyscraper's tower looming over a used-car lot.

These landscape elements played an increasingly large part in his painting as the Women series pro-gressed, and finally took over the image as de Kooning returned, in 1956, to abstractions. As the sense of a landscape grew stronger, however, the environmental forms tended to develop a likeness to the intimate proportions of the Women's anatomy.

De Kooning told David Sylvester that after making the little study with the mouth from a Camel ad stuck to it:

I cut out a lot of mouths. First of all I felt everything ought to have a mouth. Maybe it was like a pun, maybe it's even sexual, or whatever it is, but I used to cut out a lot of mouths and then I painted those figures [i.e., *Woman, I*] and then I put the mouth more or less in the place where it was supposed to be. It always turned out to be very beautiful and it helped me immensely to have this real thing. I don't know why I did it with the mouth. Maybe the grin – it's rather like the Mesopotamian idols.

To judge from photographs of the work-in-progress,[14] the grin is more shark than idol, and it was echoed in a number of the later Women, even becoming a necklace of teeth for *Woman and Bicycle* (page 96). But apart from this detail, the Women that followed the first version are gentler creatures. If there had been a Black Goddess, de Kooning had exorcised her. The girls who followed are tragicomic heroines. They have the power of de Kooning's extraordinary art; you could name a hurricane after any one of them. But like hurricanes they are an intimate part of our climate.

left: Untitled. (*ca.* 1947).
Oil on paper, 20 × 16 inches.
Private collection

below: *Pink Lady* (study), (*ca.* 1948).
Oil on paper, 18¹/₂ × 18¹/₂ inches.
Collection Mr. and Mrs. Donald M. Blinken, New York

opposite: *Woman*. 1948.
Oil and enamel on composition board, 53¹/₂ × 44/¹₂ inches.
Joseph H. Hirshhorn Foundation

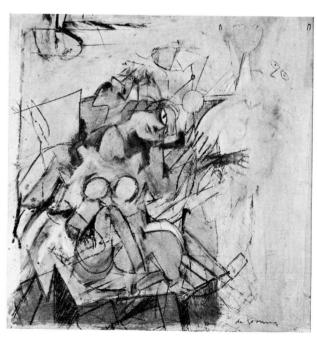

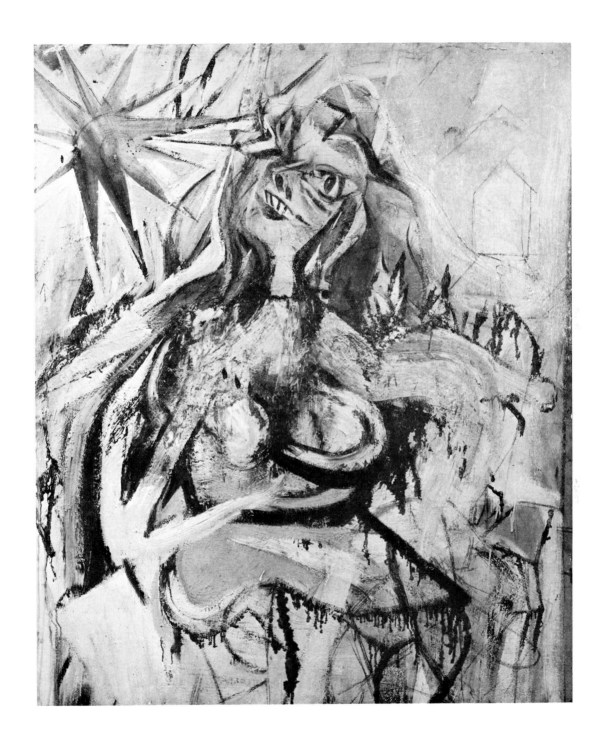

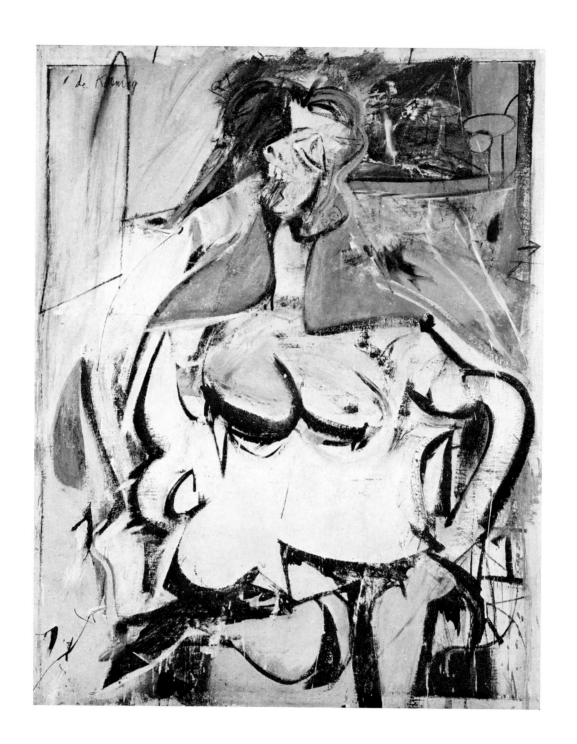

82

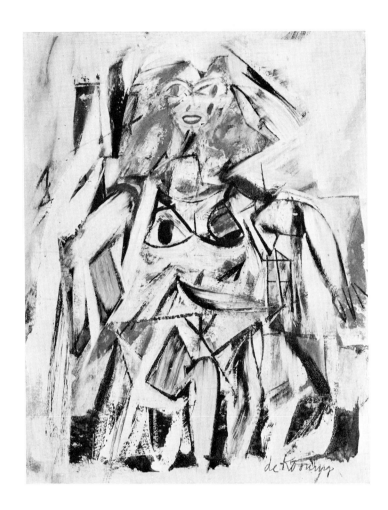

opposite: *Woman*. (1949).
Oil, enamel, and charcoal on canvas, $60^1/_2 \times 47^7/_8$ inches.
Collection Mr. and Mrs. Boris Leavitt, Hanover, Pennsylvania

above: Study for *Woman*. (1950).

83 Oil and enamel on paper, with pasted color photoengraving,
$14^5/_8 \times 11^5/_8$ inches (sight).
Collection Mr. and Mrs. Thomas B. Hess, New York

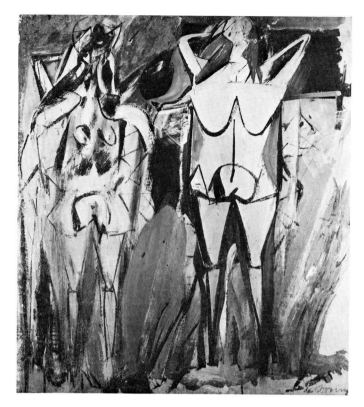 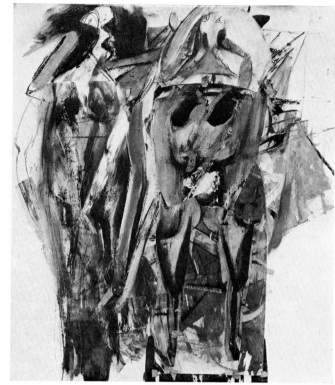

above left: *Two Standing Women.* (1949).
Oil, charcoal, and enamel on paper, mounted on
 composition board, 29¹/₂ × 26¹/₄ inches.
Norton Simon Foundation

above right: *Two Women on a Wharf.* (1949).
Oil, enamel, and pencil on cut-and-pasted papers,
 24¹/₄ × 24¹/₄ inches.
Collection Edward F. Dragon, East Hampton, New York

opposite: *Figure and Landscape, II.* (*ca.* 1950).
Oil and enamel on cardboard, mounted on
 composition board, 32³/₄ × 15¹/₄ inches.
Joseph H. Hirshhorn Collection

84

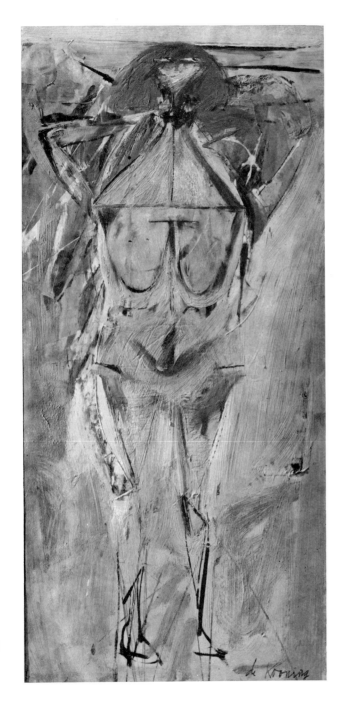

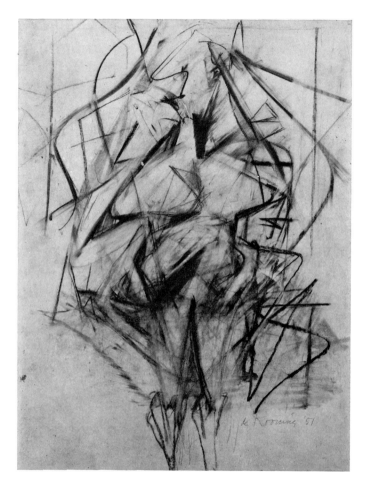

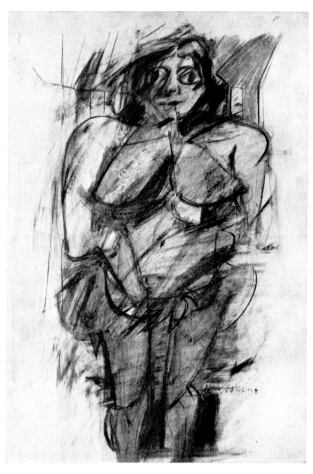

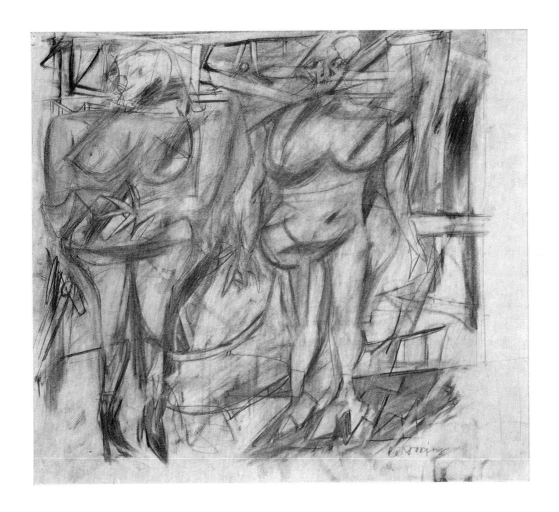

opposite left: *Woman*. 1951.
Charcoal, pastel, and crayon, $21^1/_2 \times 16$ inches.
Paul and Ruth Tishman Collection, New York

opposite right: *Woman*. (1952).
Pastel and pencil, 21×14 inches.
Collection Mr. and Mrs. Stephen D. Paine, Boston

above: *Two Women, IV*. (1952).
Charcoal and pastel, $16^1/_2 \times 20^1/_4$ inches; $15^1/_2 \times 17^1/_2$ inches (comp.).
Private collection

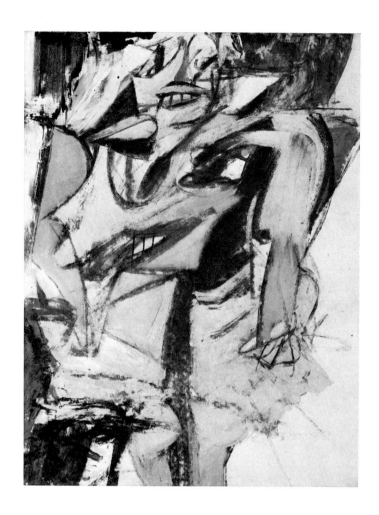

left: *Woman*. (1953).
Oil and charcoal on paper, mounted on
 canvas, $25^1/_2 \times 19^3/_4$ inches.
Joseph H. Hirshhorn Collection

below: *Woman*. (*ca.* 1952).
Charcoal and crayon on cut-and-pasted papers,
 mounted on canvas, $29^1/_2 \times 19^3/_4$ inches.
Collection Elaine de Kooning, New York

opposite: *Two Women*. 1952.
Charcoal, 22×29 inches.
Robert and Jane Meyerhoff Collection, Baltimore

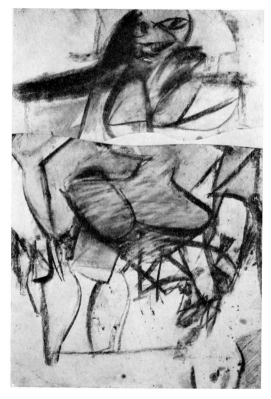

89

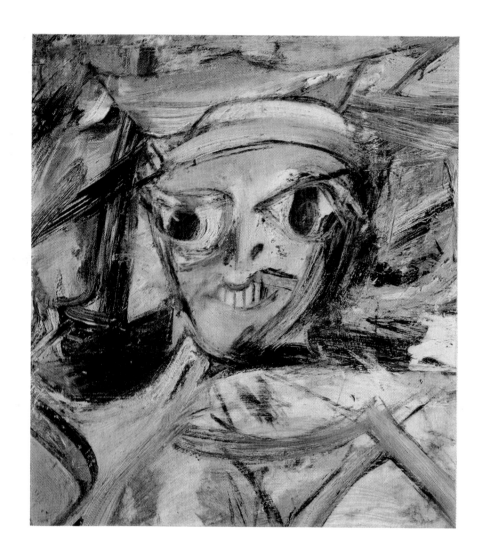

above: Detail from *Woman, I,* 1950–1952.

opposite: *Woman, I.* (1950–1952).
Oil on canvas, $75^7/_8 \times 58$ inches.
The Museum of Modern Art, New York. Purchase

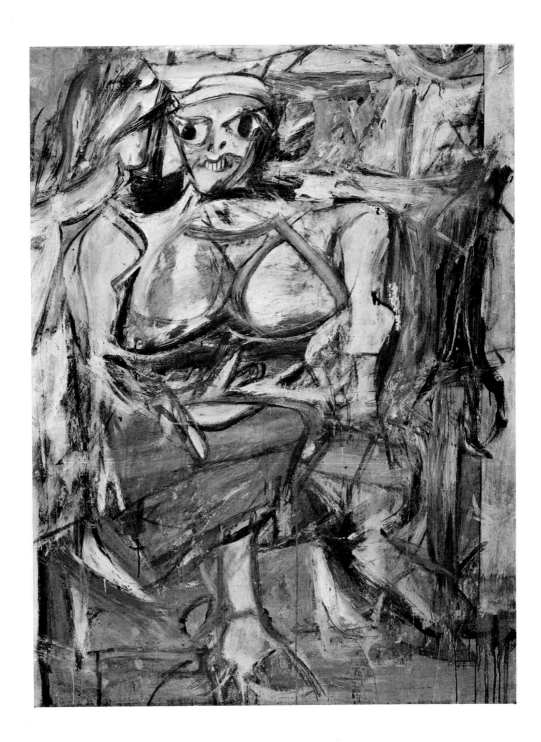

91

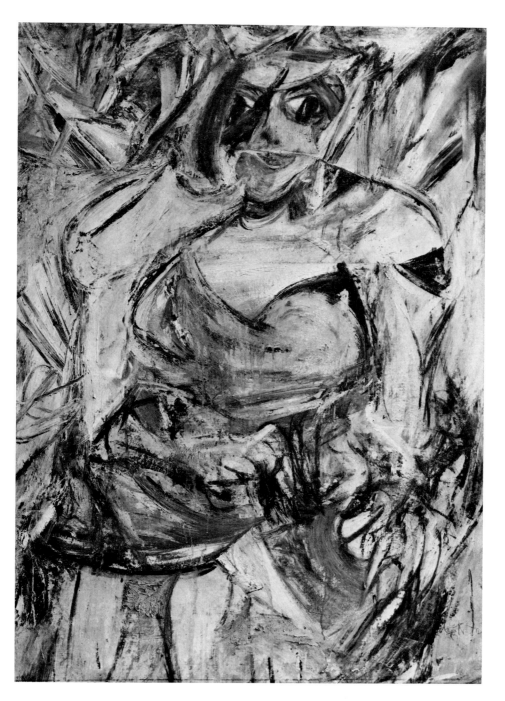

Woman, II. (1952).
Oil on canvas, 59 × 43 inches.
The Museum of Modern Art, New York. Gift of Mrs. John D. Rockefeller, 3rd.

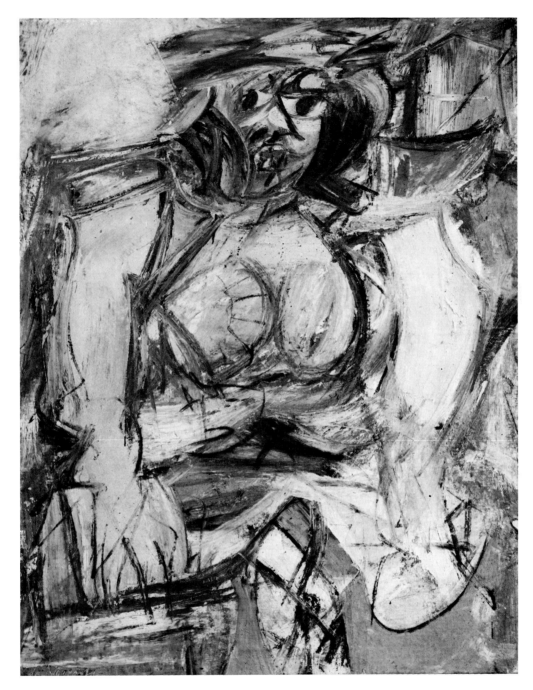

Woman, IV. (1952–1953).
Oil and enamel on canvas, 59 × 46¹/₄ inches.
Nelson Gallery–Atkins Museum, Kansas City, Missouri. Gift of William Inge

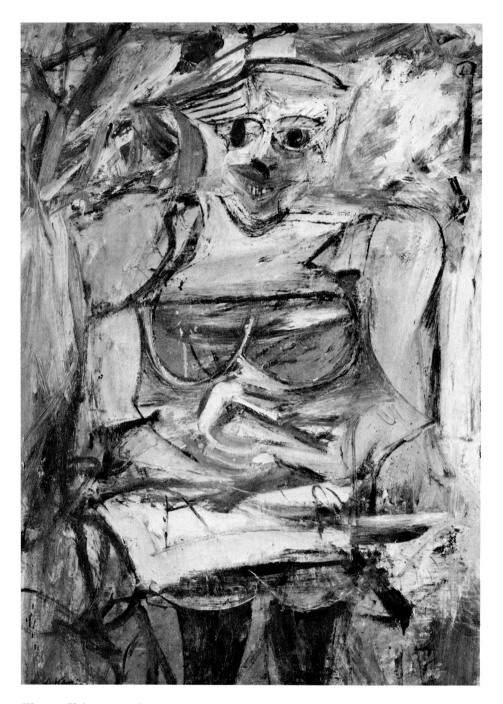

Woman, V. (1952–1953).
Oil on canvas, 61 × 45 inches.
Collection Mrs. Arthur C. Rosenberg, Chicago

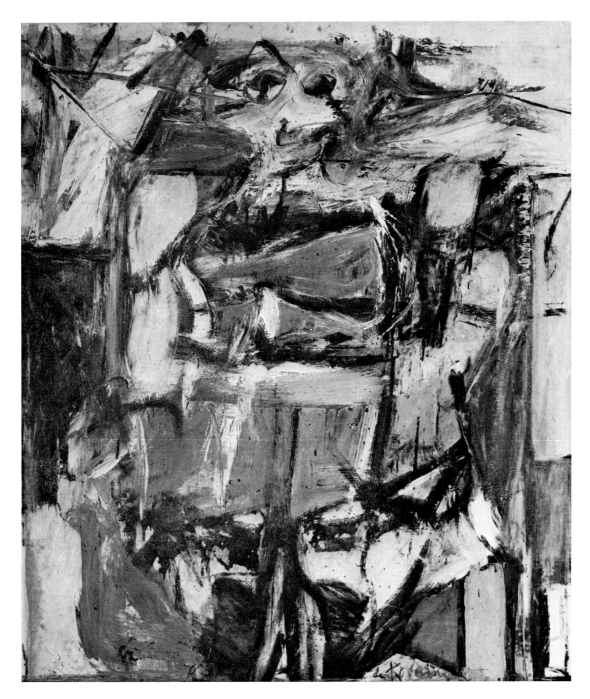

95

Woman, VI. (1953).
Oil and enamel on canvas, $68^1/_2 \times 58^1/_2$ inches.
Museum of Art, Carnegie Institute, Pittsburgh

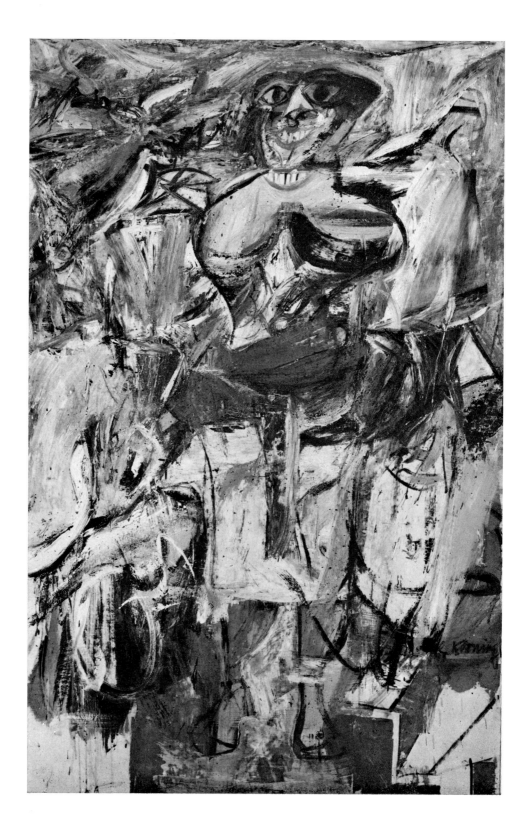

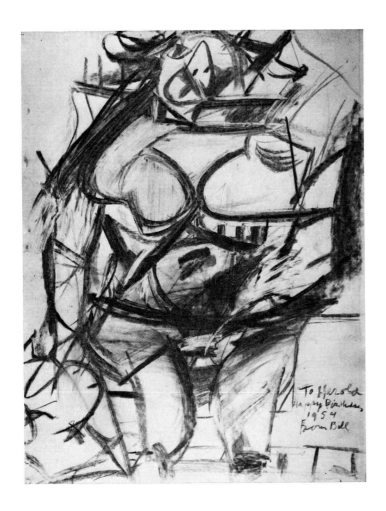

opposite: *Woman and Bicycle*. (1952–1953).
Oil, enamel, and charcoal on canvas, 76^1/$_2$ × 49 inches.
Whitney Museum of American Art, New York

97 above: *Monumental Woman*. 1954.
Charcoal, 28^1/$_2$ × 22^1/$_2$ inches.
Collection Mr. and Mrs. Harold Rosenberg, East Hampton, New York

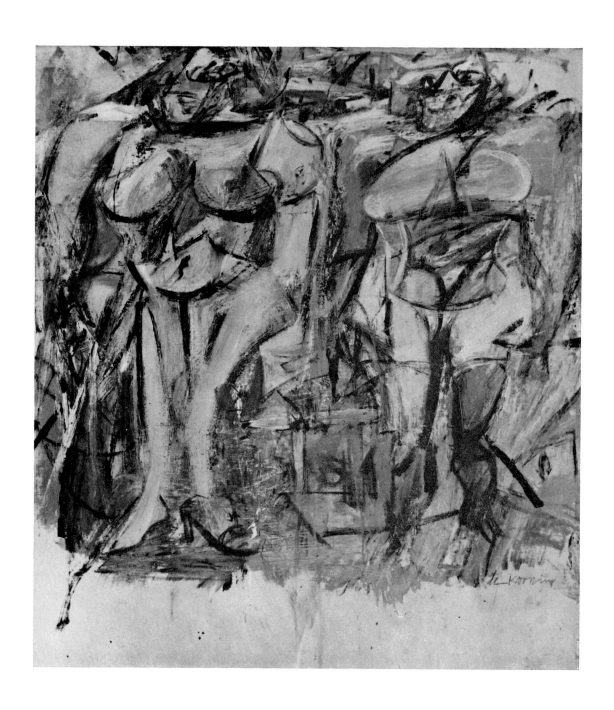

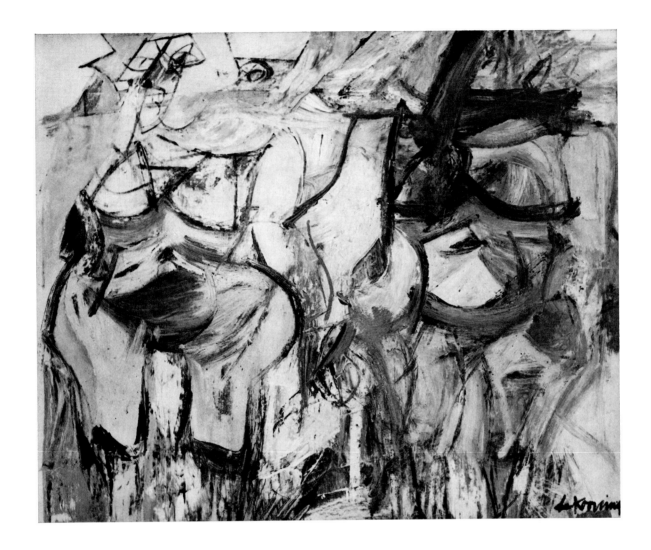

opposite: *Two Women in the Country.* (1954).
Oil, enamel, and charcoal on canvas, 46^1/$_8$ × 40^7/$_8$ inches.
Joseph H. Hirshhorn Collection

above: *Two Women.* (1954–1955).
Oil and charcoal on canvas, 40^1/$_8$ × 50 inches.
Collection Mrs. Samuel Weiner, New York

99

IV

In May 1955, almost every newspaper in America carried as a full-page advertisement a diatribe by millionaire Huntington Hartford titled "The Public Be Damned?": it was the usual Sanity-in-Art fanatic pitch, but with the difference that de Kooning was singled out for special attack. (Mr. Hartford's wife in those days was a painter. She had had a one-man exhibition that was a bit haughtily dismissed by an *Art News* reviewer in the same issue that carried a long article on the development of *Woman, I.*[15] Mr. Hartford seems to have fixed on this glaring injustice and, quoting liberally from the essay on de Kooning, proceeded to give him the kind of national publicity that politicians dream about.)

In 1955, after having painted about fifteen Women large and small, the image began to disappear from de Kooning's canvas. Abstract shapes with a "landscape" sense of light and space started to take over. "The landscape is in the Woman," de Kooning told me in 1953, "and there is Woman in the landscapes." But by the spring of 1955, the figure was engulfed in the new forms, as a jungle will obliterate a shrine. The following year, Sidney Janis, spurred by Martha Jackson's competition, gave de Kooning another exhibition, this time of abstractions in rich, heavy colors, based on urban and suburban landscape themes. Collectors, perhaps spurred by Huntington Hartford's advertisement, hurried to buy. At first the prices were modest. Later they rose as other dealers began to buy and sell de Koonings among each other and among collectors who owned or wanted earlier works. If a lack of money had been a problem for de Kooning, it was now solved. For example, as soon as his dealer became convinced that de Kooning's sales were not a flash in the pan, he advanced the artist money to buy materials, and for the first time in his life he was able to stock supplies of everything he wanted: rolls of canvas, pounds of paint, quires

of paper, boxes full of brushes. Around this time, too, most of the other first-generation Abstract Expressionists began to sell, and American modern art established a toe hold in what is laughingly called the international art market.

From 1956 until 1963, the year he moved to The Springs to live all year round in the country, de Kooning became increasingly famous.

He had been separated from his wife for some years. In 1956 his daughter Lisa was born; she has become his pride and joy.

He made two trips to Europe: first a brief jaunt to Venice in 1958; then he spent the winter months of 1959–1960 in Rome, where he borrowed his friend Afro's studio and executed some black enamel (mixed with pumice) drawings, tearing the paper and matching up the sections into new configurations, often with a wide-angled landscape effect – the torn edge of the paper is apt to read as a horizon.

He was elected to the National Institute of Arts and Letters; in 1963 he was awarded the President's Medal at the White House, and for a time he was on the official list of receptions at which the government wants to display some leading American intellectuals (but the last time he went to the White House, in 1965, he signed a petition against the war in Vietnam).

He fixed up a big loft at 831 Broadway with beautifully polished floors, painting-walls on casters so they could be moved to catch the best light, elegant modern chairs (the gift of a friend), and a telephone with a tape-recorded answering service (it never worked).

He had the leisure to visit friends ("The trouble with being poor," he once pointed out, "is that it takes up all your time."), going up to Bolton Landing to see David Smith's meadow full of sculpture and to New Haven to pay his respects to Albers' latest homage to the square.

In 1959 he exhibited thirteen large abstractions at Janis, plus a number of smaller works including some little painted rectangles made out of cut-up paintings on stiff paper. In his studio he kept these in a pack like a deck of cards and experimented with dealing out assemblages on his bedspread, fitting the little squares together into a large picture and studying how strokes would spurt and cut off at the edges.

Three movies were made of him at work, sections of which, plus some remarkable recent footage by Hans Namuth, were recently pieced together for a N.E.T. television show. At irregular intervals it still gets transmitted. In one sequence the artist is seen leaving his studio on Tenth Street, then he comes back into the room in The Springs a good five years older. Perhaps it is one of life's revenges on an artist who has spent so much energy cutting forms apart and putting the pieces back together in ways that can astonish him.

He was famous and, as he has said, for a moment he was "at the center of things." His friends were pleased for him, and all his old and new enemies noisily sharpened their knives.

There is no point in laboring an old morality, but the other side of fame is almost as bad as the dark side of poverty. In public de Kooning was his polite, punctilious, considerate self, which meant that at boring parties he would have to listen for hours to fools tell about their foolishness. He would become paralyzed with ennui.

At the Cedar bar, drinking a beer with some friends, a little episode that involved a stranger breaking his dentures on his own pipe suddenly made a splash in the newspapers. The *New York Post* saw fit to send a writer out to The Springs to report breathlessly that "all was quiet."

Free-lance interviewers, M.A. candidates, high-school art teachers, collectors wanting to brush up their name-dropping, kibitzers, long-forgotten

chance acquaintances, all would climb up the stairs at 831, pound on the door, and demand admittance. Once, when the pounding seemed a bit familiar, de Kooning peeked through the keyhole and saw it was a complete stranger. The man yelled, "I know you're there, I see you peeking through the keyhole!" "That's a very dirty trick," de Kooning shouted, and would not let him in, although the man felt he had as much right to visit him as Central Park. The landlord offered to put in an elevator. De Kooning said he would pay even more rent if the stairs were left alone: anything to discourage interruptions.

And where de Kooning used to have a few disciples – young artists who hung on his words and learned from his paintings – now he had followers. One day in 1959 he showed me his idea for placing two large pictures one flush on top of the other to make a third, vertical painting, using the arbitrary cut in the center as a kind of connecting jump. It did not work out very well, and de Kooning never finally joined the canvases, but it worked out very well for one of his followers who, I was astonished to see, in a few months had made a whole exhibition out of the device.

De Kooning worked his abstractions out of the Woman image in a few months in the spring of 1955. *Woman as Landscape* (page 104) is an unfinished picture that de Kooning permitted to leave his studio at the importunity of his dealer – he was having a great deal of trouble with it and probably felt it would never advance any further anyhow. *Police Gazette* (page 107), done at the same time, is similarly incomplete. If you imagine the former without the looming face, you have a landscape motif; if you examine *Police Gazette* upside down, you can see where the Woman had been positioned. After these tentative starts (which

will be highly appreciated as pictures by those who prefer de Kooning's expressionist side, still bearing as they do the integuments of the creative act), de Kooning moved into a new series of abstractions that relate to the earlier black-and-white pictures in the complication of their shapes, and to the Women in their heavy, rasping colors and textures. The surface is packed with forms, sometimes keyed to letters, often to jumps from texture to texture. There is a proliferation of images, a piling of ambiguity on top of ambiguity. Sometimes the paint is pushed into wrinkles and folds, like dead flesh. It is as if all the despair in *Woman, I* and in the black-and-white pictures was heaped together in a gesture of defiant exaltation. The titles refer to dates and places in the Tenth Street milieu: *The Time of the Fire* (page 110) to the Wanamaker fire, for which the artist and his friends had front-row seats on the roofs of their studios across the street. *Backyard on Tenth Street* refers to a sad little plot of earth that de Kooning could look at from his easel, watching the soot fall on a few sickly Trees of Heaven. The titles, of course, are not interpreted or even suggested in the paintings, which rather are named as you would name a child.

In the next year, 1957, and for the following six years, de Kooning simplified and clarified his images. This was a slow development, but a steady one. The forms became fewer, the surfaces bigger and less apt to be interrupted. In his exhibition of 1959, *Parc Rosenberg* and *Suburb in Havana* (pages 112, 113) are already highly simplified when compared to *Easter Monday* (page 109), from which they are separated by only some twenty months. From there to the untitled painting on page 117 is about two years, but now the shapes are reduced to wide smooth areas; the colors are keyed to white and the palest yellow makes a heavy accent.

In this evolution, de Kooning was responding

to, and in a sense leading, a general tendency in the later 1950's, in which forms became larger, more simple, and continuous; colors became fewer in number, cleaner, more intense, and more concentrated on primary contrasts; compositions became more frontal and simple; textures, smooth and even. The impact was big and direct, and nuances were sacrificed to this end. In an exhibition at the Guggenheim Museum in November 1961, Harvard Arnason tried to define this direction and proposed to call the artists "New Imagists," a name that never caught on, perhaps because it brought strong literary associations to this most unliterary of developments. A number of de Kooning's colleagues were having experiences similar to his, including David Smith, Adolph Gottlieb, and, just before his death, Franz Kline. Rothko, whose paintings were in this bare, open manner to begin with, refined them to an even narrower range of colors and values, within an even larger format.

It is probable that at this juncture many of Barnett Newman's old friends were taking a second, harder look at his art. But it was too general a movement to be attributed to any single influence, and it continues today, through color-field painting and minimal art to the solemn, blunt units of such young artists as Robert Morris and Peter Gourfain.

De Kooning's experience followed an inner logic, even as it moved in the van of a collective tendency. His 1956–1957 landscapes were urban in theme, of and in the city. The shapes were derived from ideas about what he saw as he walked through the Village streets or took a taxi to Times Square, and also from the elements out of which he had constructed his Women. A year later, his motif centered around the highway and the experience of driving along the bands of concrete to and from

New York. He had always been fascinated by connections – the shoulder, the planes of a collage, the jump from one shape to another. He saw the highway as an enormous connection, with an environment of its own. It moves through the "leftover" spaces of the city: the dumps and flats, industrial marshes, bituminized plains. And then it emerges into the neatly flowering suburbs where the forest on a hill looks as manicured as the lawns around the village funeral parlor.

By 1961, his image had moved to the countryside itself, the summer Long Island country: very flat and sunny – green grass, yellow beach, green water, blue sky, powdery brown earth.

"I am very happy to see that grass is green," de Kooning said to David Sylvester, "At one time, it was very daring to make a figure red or blue – I think now that it is just as daring to make it flesh-colored."

De Kooning mixes his colors in salad bowls. He starts out with a few basic tones, then "breeds" them with one another until he has some eighty possibilities – all from the same source and of the same chemistry, so the skin of the painting can be "all of one piece." He can make a blue-green, he explains, that, held up in front of the ocean, is an exact match – a kind of *trompe-l'œil*. But he cannot use this blue-green ocean color until he has "made it my own," through the same mysterious process that he made his own shapes for *Dark Pond* and his own ankles for *Woman, I*.

De Kooning's simplification of shape and format in the years 1957–1963 was the necessary discipline to arrive at his new colors. He could not have known that this was where he was going when he started out. In 1960 he said very firmly, "I'm no country dumpling!" and he was proud of being a city man. But he did finally arrive in the country and with the colors he needed to live there.

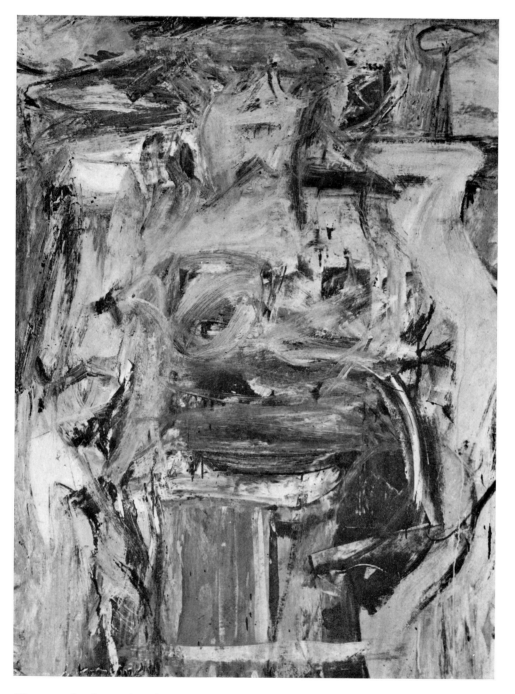

Woman as Landscape. (1955).
Oil on canvas, 45$^{1}/_{2}$ × 41 inches.
Private collection

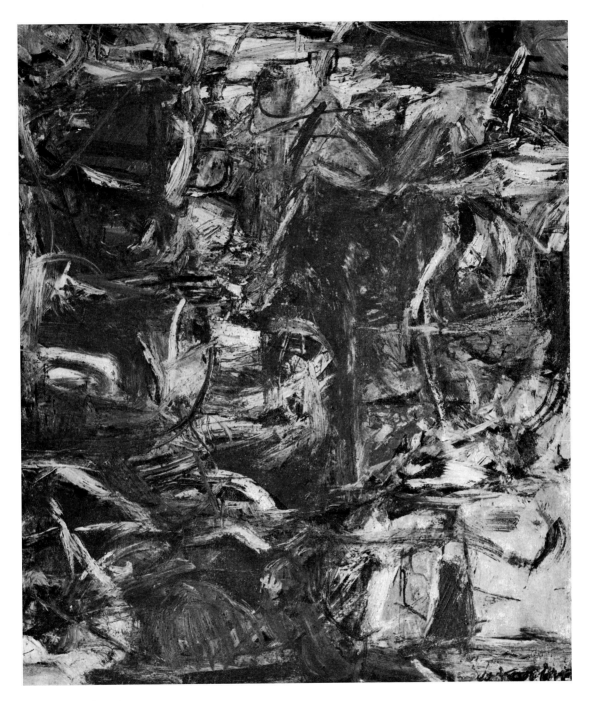

Composition. (1955).
Oil, enamel, and charcoal on canvas, 79$\frac{1}{4}$ × 69$\frac{1}{4}$ inches.
Solomon R. Guggenheim Museum, New York

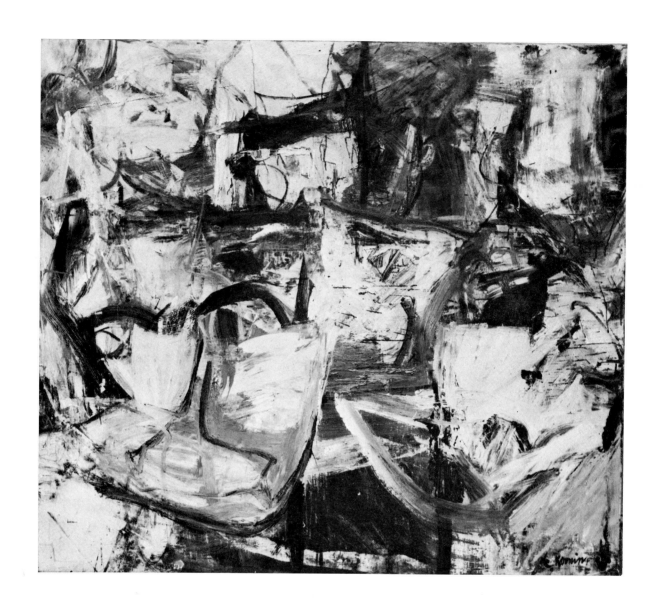

opposite: *Saturday Night*. (1955–1956).
Oil on canvas, 69 × 79 inches.
Washington University Gallery of Art, St. Louis

below: *Police Gazette*. (1954–1955).
Oil, enamel, and charcoal on canvas, 43¹/₄ × 50¹/₄ inches.
Collection Mr. and Mrs. Robert C. Scull, New York

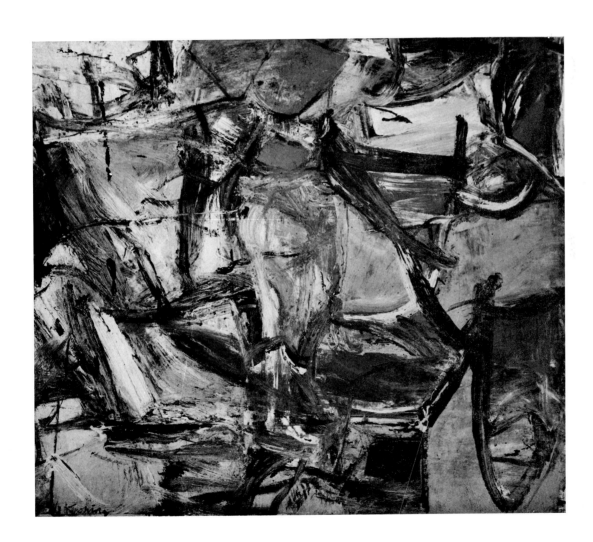

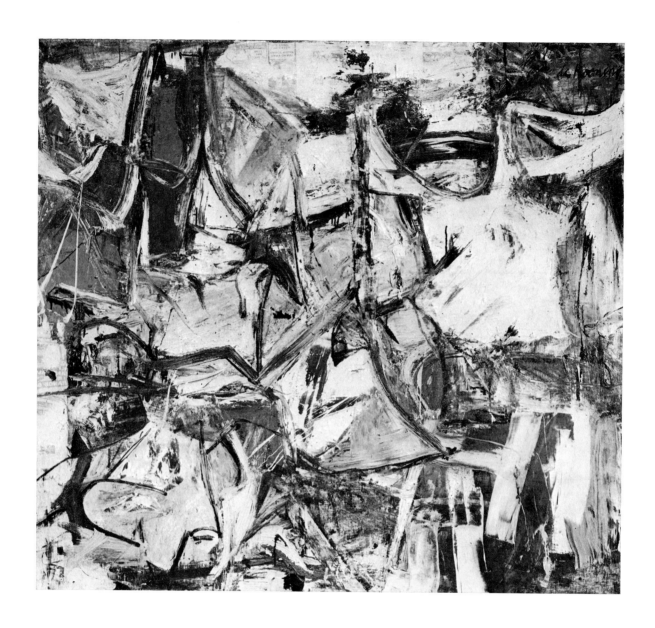

above: *Gotham News*. (1955–1956).
Oil, enamel, and charcoal on canvas, 69$^1/_2$ × 79$^3/_4$ inches.
Albright-Knox Art Gallery, Buffalo

opposite: *Easter Monday*. (1956).
Oil on canvas, 96$^1/_4$ × 73$^7/_8$ inches.
The Metropolitan Museum of Art, New York. Rogers Fund, 1956

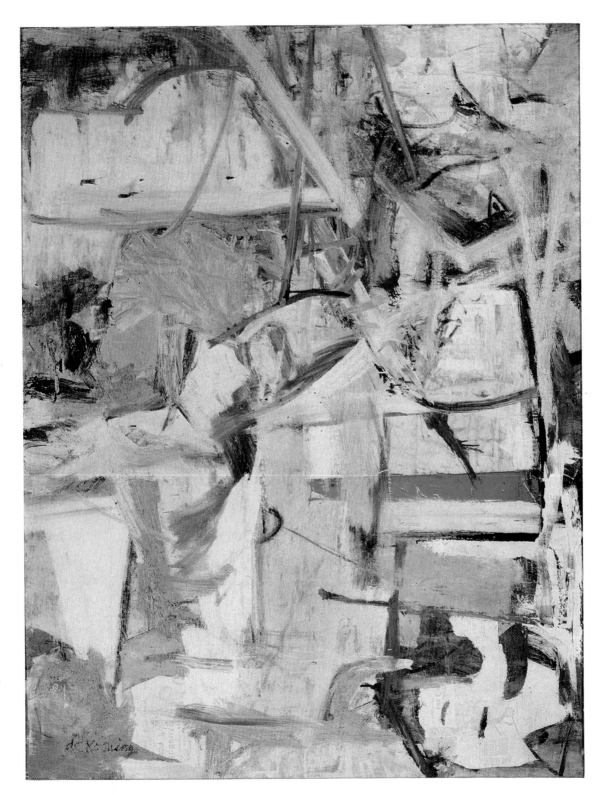

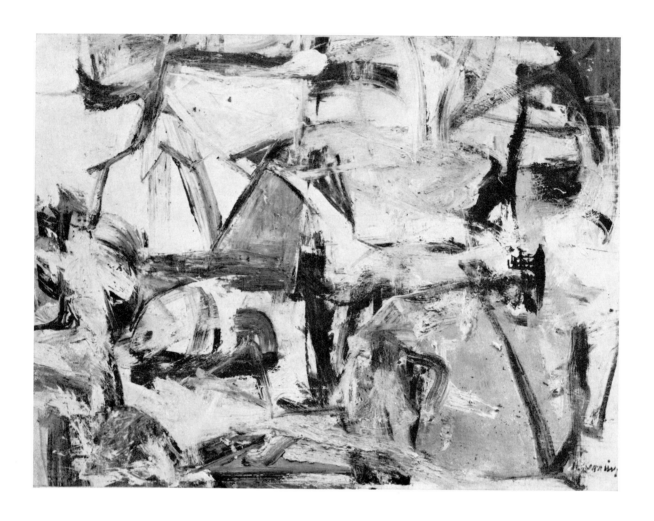

above: *The Time of the Fire*. (1956).
Oil and enamel on canvas, $59^{1}/_{4} \times 79$ inches.
Collection Dr. and Mrs. Israel Rosen, Baltimore

opposite: *Palisade*. (1957).
Oil on canvas, 79×69 inches.
Collection Mr. and Mrs. Milton A. Gordon, New York

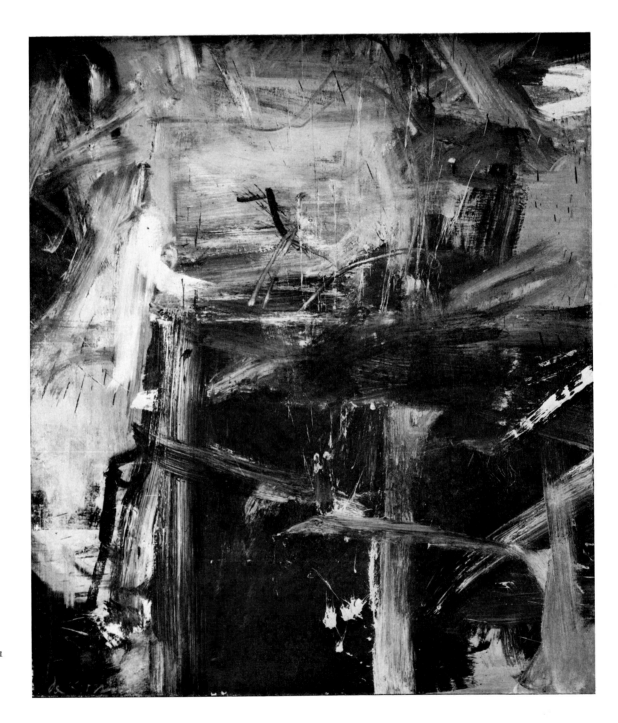

III

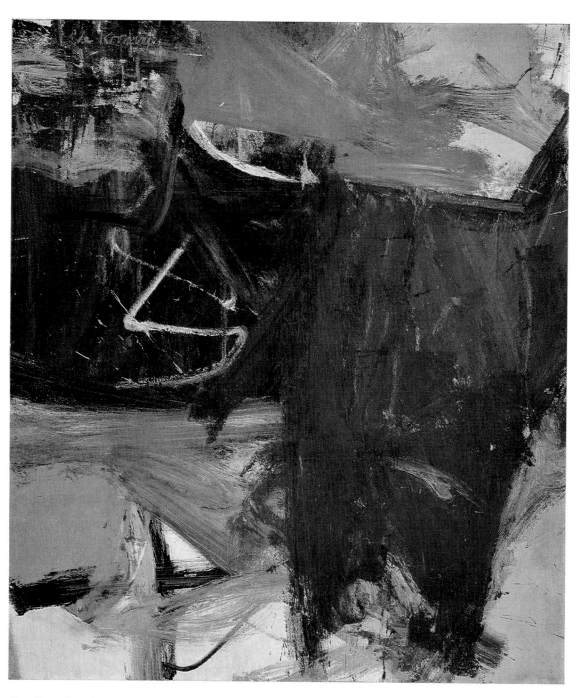

Parc Rosenberg. (1957).
Oil on canvas, 80 × 70 inches.
Isobel and Donald Grossman Collection, New York

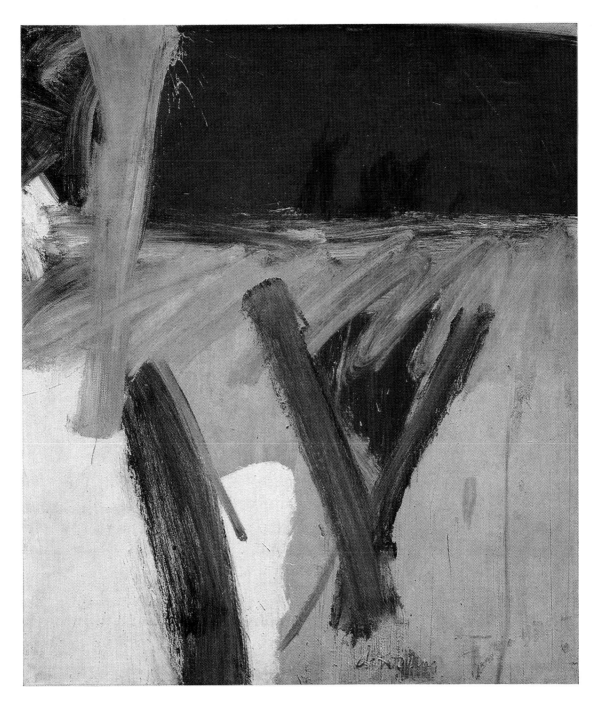

Suburb in Havana. (1958).
Oil on canvas, 80 × 70 inches.
Collection Mr. and Mrs. Lee V. Eastman, New York

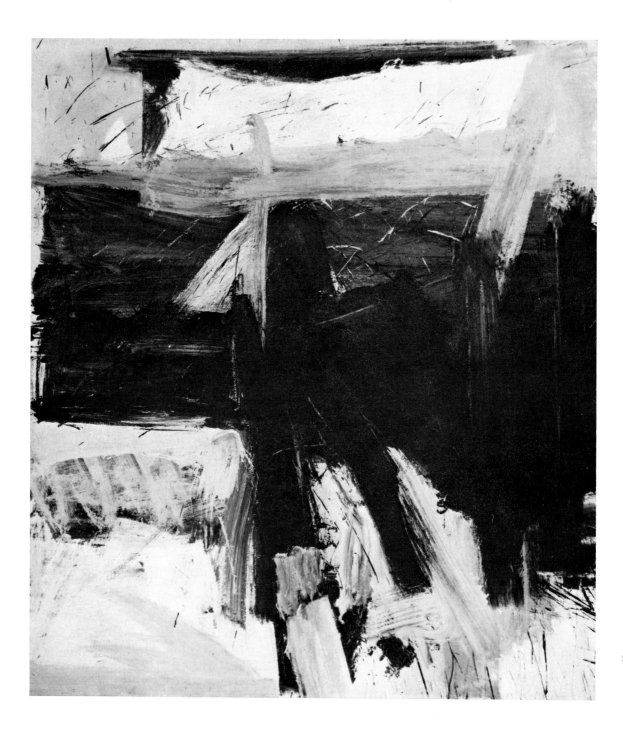

opposite: *Ruth's Zowie.* (1957).
Oil on canvas, $80^1/_4 \times 70^1/_8$ inches.
Collection Mr. and Mrs. Thomas B. Hess, New York

below: *Black and White, Rome D.* 1959.
Enamel on cut-and-pasted papers, mounted
 on canvas, $39^3/_8 \times 27^3/_4$ inches.
Collection Marie Christophe Thurman, New York

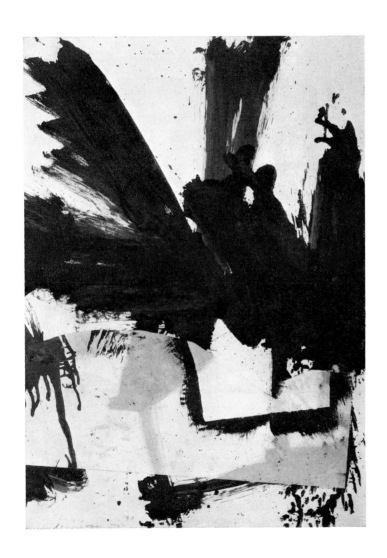

Rosy-Fingered Dawn at Louse Point. (1963).
Oil on canvas, 80 × 70 inches.
Stedelijk Museum, Amsterdam

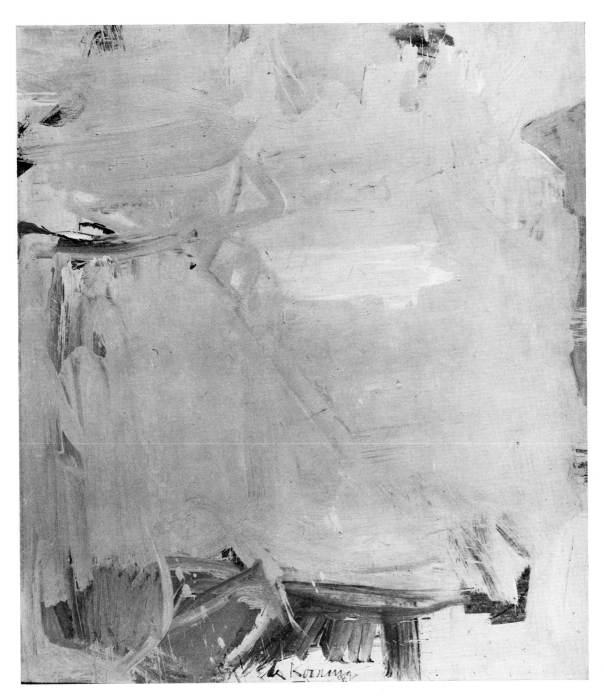

Untitled. (1961).
Oil on canvas, 80 × 70 inches.
Collection Virginia Dwan, New York

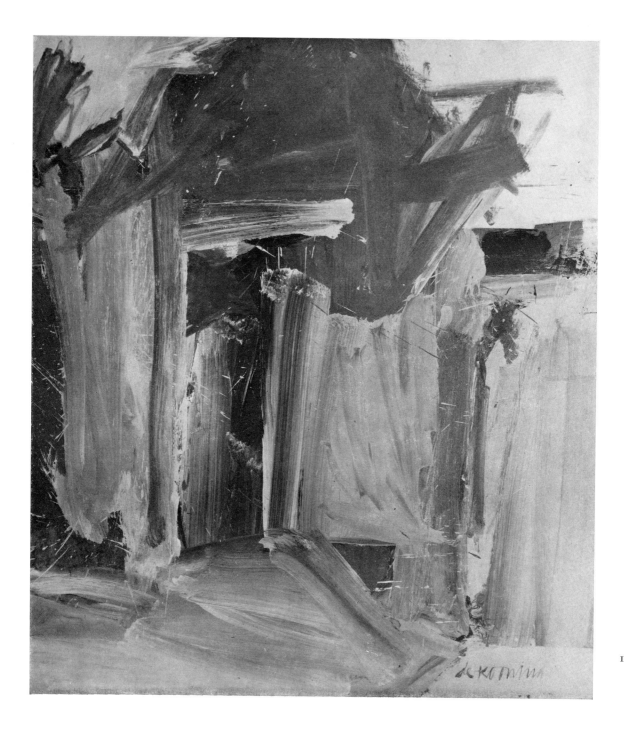

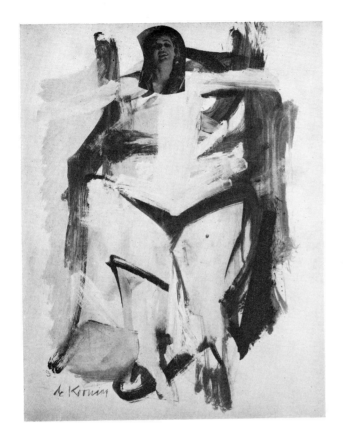 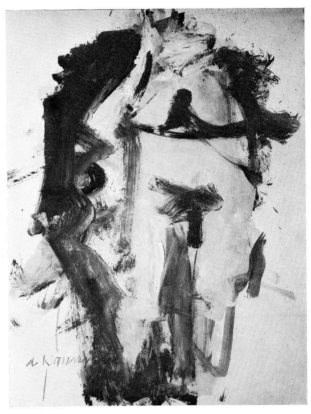

opposite: *Door to the River*. (1960).
Oil on canvas, 80 × 70 inches.
Whitney Museum of American Art, New York.
 Gift of the Friends of the Whitney Museum, and Purchase

above left: *Woman, I*. (1961).
Oil on paper, with pasted color photoengraving,
 mounted on canvas, 29 × 22³/₈ inches.
Private collection

above right: *Woman, VIII*. (1961).
Oil on paper, 29 × 22³/₈ inches.
National Collection of Fine Arts, Smithsonian Institution,
 Washington, D.C.

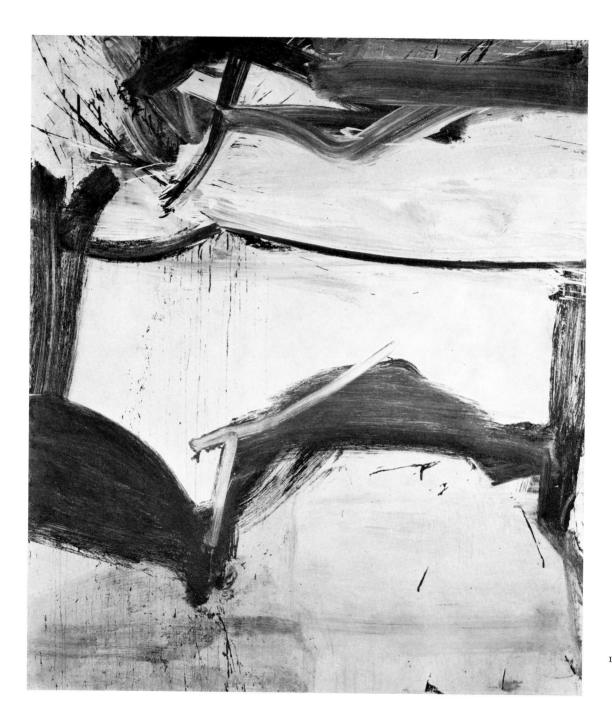

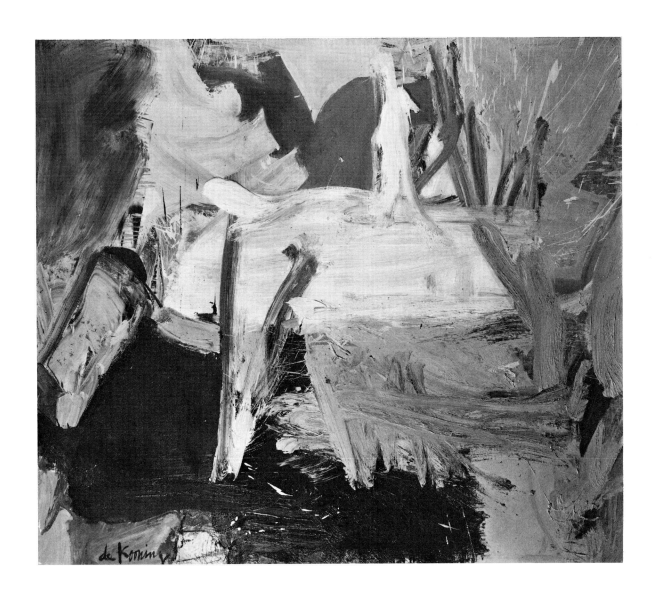

opposite: Untitled. (1963).
Oil on canvas, 80 × 70 inches.
Joseph H. Hirshhorn Foundation

121 above: *Pastorale*. (1963).
Oil on canvas, 70 × 80 inches.
Private collection

V

Around 1961 de Kooning began to spend less and less time in New York. That summer, at The Springs, in the house he later bought from his brother-in-law Peter Fried, he did a series of small Women on paper. But there was no room in the Fried house for doing large pictures, and he kept his loft in the city as his main studio.

The next winter he began plans for a large studio on some land he bought not far from the Fried house. He withdrew more and more from the art world, never answered his telephone, avoided all parties except those given by old friends.

In 1963, about February, he took one of his 80 by 70 inch stretched canvases and began a painting in pinks turning to golden yellow moving to a heavy white. The form developed evenly, smoothly across the picture, "all there in front of you"; there is an undulation which might be hills or waves or the landscape moving across the vision of a man coasting his bicycle down a road over the gently rolling scrub-oak landscape. He titled the painting *Pastorale* and a few months later moved out of his New York loft for good to live in Long Island and work in his partly completed studio. Turn *Pastorale* (page 121) 90 degrees clockwise, and you will see the emergent form of a Woman.

I telephoned de Kooning on a hot day last summer.

"Have you been to the beach?" I asked.

"Oh no, I never go to the beach, especially when there are lots of the people here."

"Watch out, you're turning into a farmer."

"I don't think so, but one thing – when I see a man of my own age with a bright scarf around his neck speeding by in one of those low-slung cars – I want to kill him!"

"Right," I said, "you're a farmer."

"Well, I know the people here, the ones in the winter; one family has a son in Vietnam. . . ."

And we discussed the war and Bertrand Russell.

De Kooning lives and paints in The Springs. He has never worked better or been more productive – of paintings, drawings, studies in all sizes; he threatens to take up sculpture. He still comes to New York, but it is as a visitor, to see a dentist, or an exhibition, or a friend. The rest of the time he paints, rebuilds his studio, rides his bicycle.

E. de Wilde, director of the Stedelijk Museum in Amsterdam, visited de Kooning in The Springs to make the first initiatives for this exhibition. He said he felt the light and terrain reminded him of the Lowlands, the wide horizons and tidy wilderness of Hobbema and the Ruysdaels. The artist grinned and said he didn't know; he hasn't been there in a long time.

Shortly after settling in Long Island, he left the Janis gallery – a parting that was unpleasant on both sides and resulted in a lawsuit and countersuit which, at this writing, are still proceeding. On his own, the artist sold pictures directly to a few collectors, especially to Joseph Hirshhorn – a dedicated and enthusiastic buyer of American art who plans a whole room for de Kooning in his projected museum in Washington, D.C. He sold pictures to private dealer Harold Diamond, who had arrangements with Los Angeles galleries to handle and exhibit some de Koonings, and who had contacts with many New York collectors, one of whom, John Powers, bought a number of works. Dealer Allan Stone also bought from the artist and carried on a brisk trade between buyers and sellers of earlier pictures. He exhibited a number of recent works in his gallery, and organized a handsome two-man show that joined de Kooning with his old friend Barnett Newman.

Like most first-rate artists, de Kooning has a keen understanding of the art market, such as it is, and of his place in it; but, again like most artists, he is a rotten accountant. Pictures went in and out of the studio very informally and records were kept even more informally. Some works disappeared others were stolen (most of them have been recovered). Whoever does the artist's catalogue raisonné at some future date will probably find his biggest headaches in the early 1960's.

In working on many of the larger pictures, de Kooning applied newspaper sheets to them, as he had to *Attic*, *Easter Monday*, etc., to slow the drying process or to cover up some section of the painting while he worked on an adjacent one. Pulling off these sheets, he would study the offset images of the paint on the paper and leave piles of them around the studio floor. Harold Diamond persuaded him to sell a number of these pictures, and a group of them were later shown in Los Angeles. It is hard to know what to call them. "Monotype" suggests that he was involved in a printmaking process. "Decal" is more accurately informal, but rather obscure. "Countertype" is another possibility; however, it generally describes drawings. Whatever these works may be labeled, some are of high interest in their own right – even though it should be remembered that most of them were never touched by the artist's brush. All of them are valuable documents of various stages in de Kooning's working process, in which destruction plays as important a role as creation.

In 1966, de Kooning signed a contract with M. Knoedler & Co., where accurate records now are kept of his work. In October 1967, he had a large show there of work of June 1963 to October 1967 – the last painting, *Two Figures in a Landscape* (page 137), arrived the day of the opening, still dripping wet. In June 1968, Knoedler exhibited many of these pictures in its Paris galleries – de Kooning's first one-man show in Europe. Its reception was obscured, to say the least, by the May uprisings and subsequent June elections.

His first pictures after moving out to The Springs were small oils and drawings of Women.

Any necessity to keep his shapes abstract disappeared at a moment when, in the fashionable world, abstract art was becoming a new rage. With Spinoza, de Kooning holds that, "the images of things are modifications of the human body." And the only reason not to paint the figure would be in obedience to some exterior historical or aesthetic imperative. And merely thinking about the possibility of such a directive would be sufficient to make de Kooning break it.

Kierkegaard is one of his favorite philosophers, but of his title, *Purity of Heart Is to Will One Thing*, de Kooning has said, "It makes me sick!"

The first Women of 1963 were set in one of de Kooning's characteristic "no-environment" places, in between the land and the ocean – wading off the beach, in a rowboat, sunbathing near the water. Shimmering reflections dapple their forms. As Harold Rosenberg pointed out, they are "not timeless icons but today's cuties."[16] A group of charcoal drawings analyzes the play of light bouncing off wavelets onto their plump bodies.

In 1964 de Kooning ordered some doors and used them as panels on which to paint a series of vertical Women: over life-size, hieratic, they have some of the violence and aggression of the 1953 subjects, especially the first one to be completed (page 130, left) the Women that followed marked a return to a more tranquil, bucolic manner.

In 1965–1967, he painted Women singly and in pairs, in more and more animated poses, the figures breaking free from the frontal stance to sit on the grass with their knees up to their chins, lie down on sofas, wave at friends – relax.

Along with these de Kooning did an enormous series of very free charcoal drawings (page 136) that represent a new departure for him – and for art history. Some of them were done with his eyes closed; some with a charcoal stick in both hands;

others using the left hand only; still others while watching television. It is as if he recognized that the brain that all great draftsmen have in their wrists becomes burdened with its own stereotypes and conventions. And to get rid of these neural intellectual constrictions, he had to change the physical nature of the act. This series of drawings still continues.

In small sketches and in some of the larger paintings, a new sense of landscape is apparent. It is no longer the "no environment" of the city and its suburbs; the place now seems specific, a certain "glimpse" of the country, a bush or a field under certain unique conditions instantaneously perceived. And in *Two Figures in a Landscape* (page 137), the figures are swallowed up by their environment.

To end the account here would be to close in a tidy circle: we would be back where we were in 1956, with the beginning of a new cycle of abstractions. However, after taking a few months off after his Knoedler exhibition, including a trip to Paris (where he saw the Ingres exhibition and, for the first time, visited the Louvre) and London (where he met Francis Bacon, whom he had admired since the screaming cardinal pictures), de Kooning started to work again in January 1968, aiming not at landscape abstractions, but at a large composition with two figures. The idea has obsessed him since the late 1930's (*Two Men*), but he has never been able to realize it. *Woman, I* began as two women. In small paintings from the mid-1940's to the early 1960's he achieved something of what he wanted, and he considered the possibility of a shortcut with the doors, by placing them flush with each other, like a Renaissance polyptych. But the latest, large pictures with two figures may indicate his new direction. And they may not. The story is unfinished.

124

The trouble with art history is that it oversimplifies its subject, reducing multitudes of interconnecting ideas, events, and haphazard circumstances to patterns and chronologies that because of their neatness often assume a false air of the correct and the factual. There is a certain professional rhetoric to such simplifications, which can reassure the reader that art is really quite a simple type of human endeavor when it is explained – and it can be explained.

Fortunately, art cannot be explained, only felt. The newer it is, the stronger we feel it, and the less able we are to account for its power. Thus, comment on de Kooning's pictures since 1963 must be tentative, even though they are among the most convincing of all his work.

It would be fairly easy to tie them up with the patterns of his past. For example, the curiously illuminated background of *Man* (page 33), in its pinks and ochers seems a direct prediction of de Kooning's abstractions of twenty-five years later. A coincidence? When a body of work is sufficiently varied, there are always ways to tie it up.

But the recent work itself is best seen as a heterogeneous group, involving many different concepts, many of them contradictory, being pushed along simultaneously.

In the little sketches of Women, such as the sun-drenched *Clam Diggers* (page 126), de Kooning seems to be looking back to Watteau and Rubens. He himself tells the story of Rubens instructing students not to start drawing from the model, but to work studiously from casts of the antique. Then, when they had understood the proportions, they could bring in the living nude and "scatter your own dimples."

Frenhofer also relaxed from his major work on Catherine Lescault to do smaller oils of girls. "I scattered over the contours," he said, "a cloud of blond, warm semi-tones so that you cannot tell where an edge meets the background." It could be a description of *Clam Diggers*.

De Kooning cites Courbet much more than Rubens and Watteau; the latter are apt to be dragged into the conversation by visitors. He sees Courbet as the artist who was able to go beyond style and mannerisms in order to paint things as they are: "dump a tree in front of you." De Kooning's colors are as things are, and the landscape motifs have a symbolizing verisimilitude that comes from thirty years of work, insight, and calculation ("symbolizing," obviously, because the brown is not made of earth nor the blue of sky but from a mixture of emulsified mineral pigments).

The late Women are distorted, which makes them seem Expressionist; just as I imagine Renoir's and Matisse's women looked Expressionist when they were new. But Expressionism includes an attitude about the outside world: its misery, pathos, brutality, or grandeur. De Kooning looks at his environment as coolly as Cézanne; his distortions come from inside, from his art.

Like all classical artists, he puts his insights (what he has called his "slipping glimpse") through an elaborate set of concepts about art and life (in his case a purposefully anti-systematic system), and he arrives where he began: home, himself.

Gertrude Stein wrote about it in 1934:

"Now about American painters. Today yesterday or any day. How do they do it.

"They do it like this.

"When they paint it does not make any difference what gets upon the canvas, they are they and they feel that they are going to be they. Oh yes. They. They are they. That is what they look like and that is what they feel." [17]

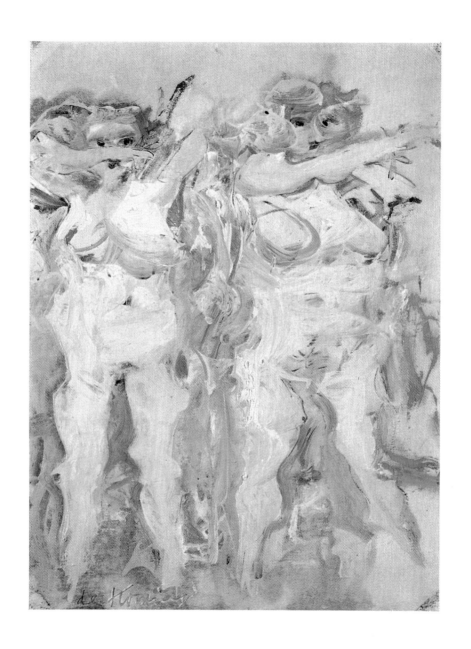

opposite: *Clam Diggers*. (1964).
Oil on paper, mounted on composition board, $20^1/_4 \times 14^1/_2$ inches.
Private collection. Courtesy Pasadena Art Museum

below: *Reclining Man*. (1964).
Oil on paper, mounted on composition board, 23×27 inches.
Joseph H. Hirshhorn Collection

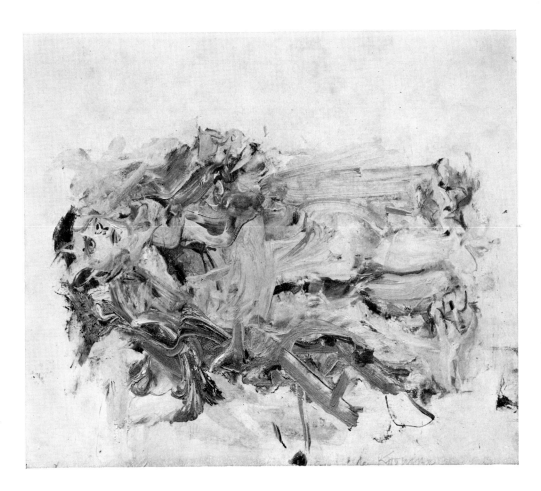

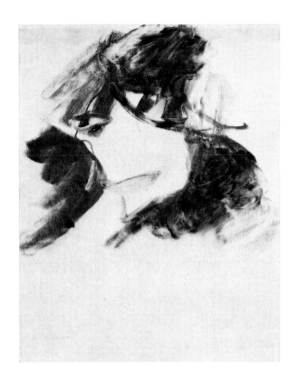

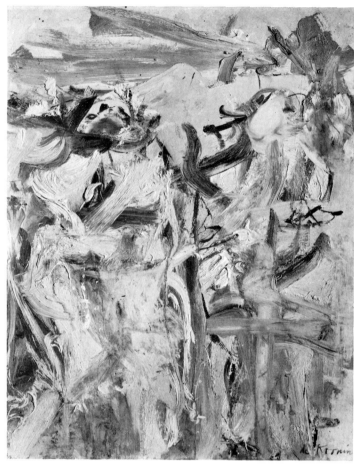

above left: *Head*. (1964–1965).
Charcoal and pastel, 23³/₄ × 19 inches.
Allan Stone Gallery, New York

above right: *Two Figures*. (1964).
Oil on paper, mounted on composition board,
 29³/₈ × 23³/₈ inches.
Joseph H. Hirshhorn Collection

opposite: *Two Women*. (1964).
Oil on paper, mounted on composition board, 60¹/₂ × 37 inches.
Joseph H. Hirshhorn Collection

128

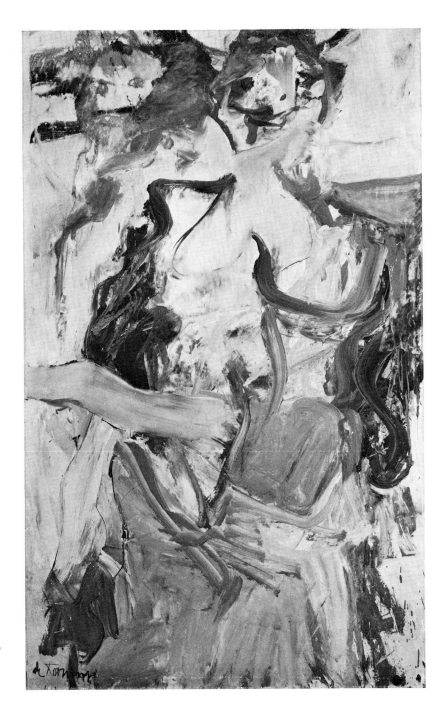

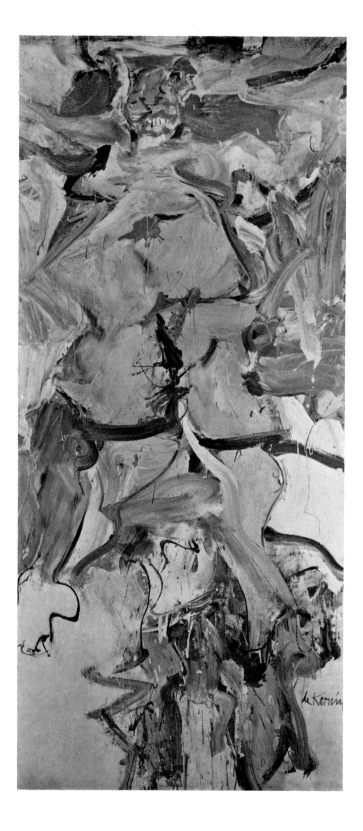

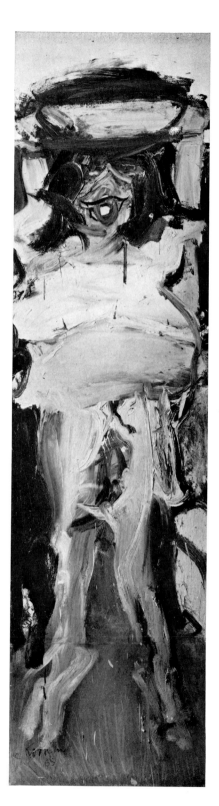

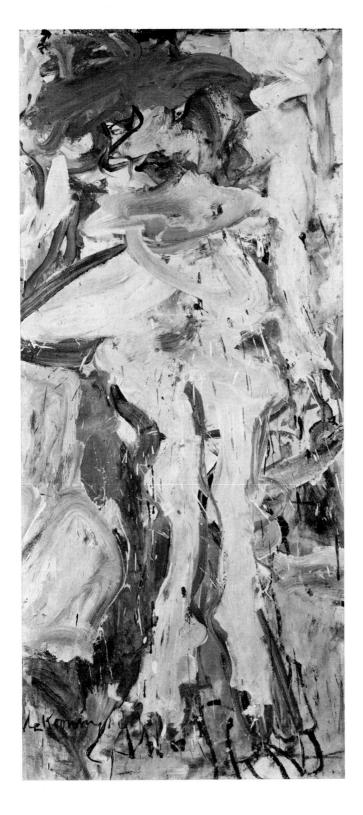

131

opposite left: *Woman, Sag Harbor*. (1964).
Oil on wood (door), 80 × 36 inches.
Joseph H. Hirshhorn Collection

opposite right: *Singing Woman*. 1965.
Oil on paper, mounted on canvas, $88^1/_4 \times 23^7/_8$ inches.
Collection John and Kimiko Powers, Aspen, Colorado

left: *Woman Acabonic*. (1966).
Oil on paper, mounted on canvas, $80^1/_2 \times 36$ inches.
Whitney Museum of American Art, New York.
 Gift of Mrs. Bernard F. Gimbel

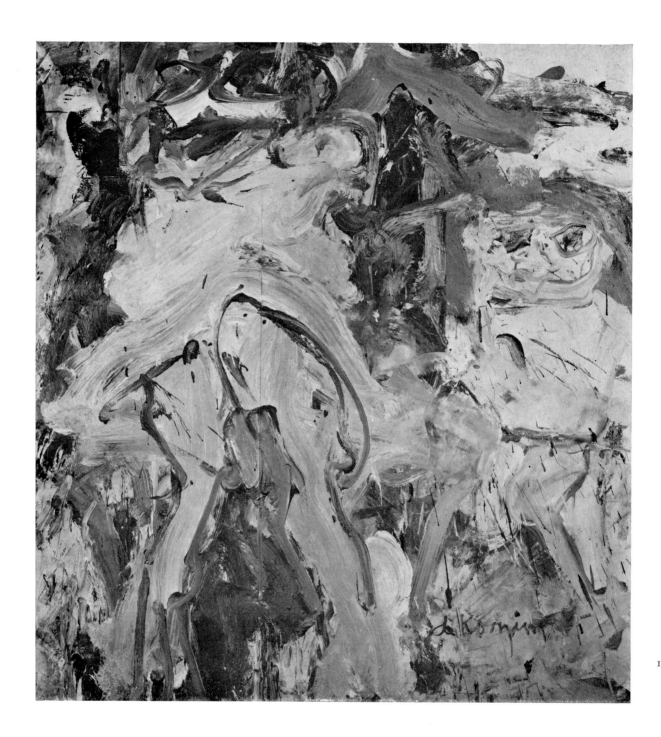

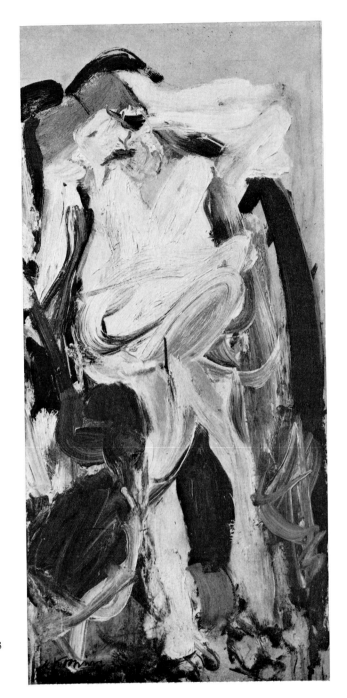

opposite: *Woman and Child.* (1967).
Oil on paper, 52$^{1}/_{2}$ × 47$^{5}/_{8}$ inches.
Collection Joseph and Mildred Gosman, Toledo, Ohio

left: *Woman in a Rowboat.* (1965).
Oil on paper, mounted on cardboard, 47$^{1}/_{2}$ × 22$^{1}/_{4}$ inches.
Martha Jackson Gallery, New York

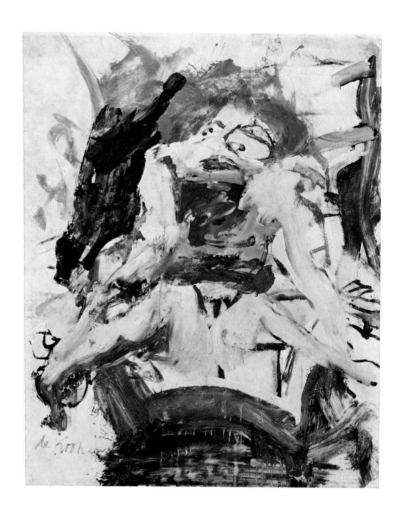

above: *Woman in the Water*. (1967).
Oil on paper, mounted on canvas, 23¹/₄ × 18¹/₂ inches.
James Goodman Gallery, New York

opposite: *The Visit*. (1967).
Oil on canvas, 60 × 48 inches.
M. Knoedler & Co., Inc., New York, Paris, London

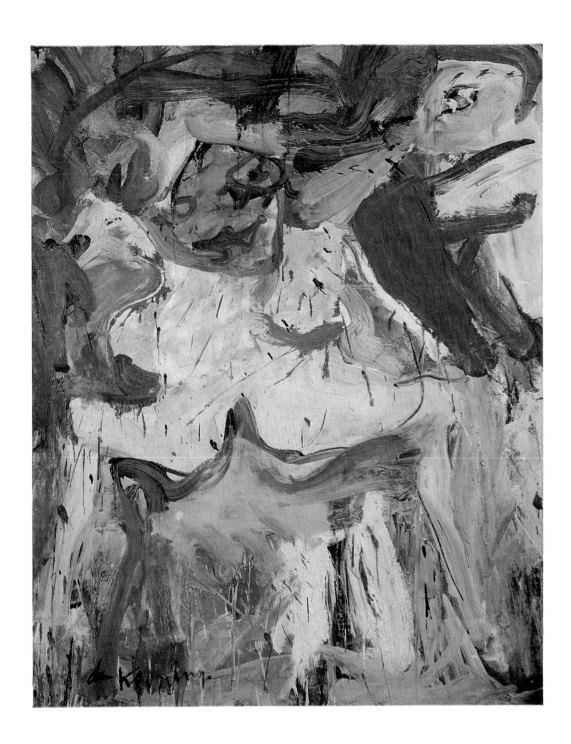

135

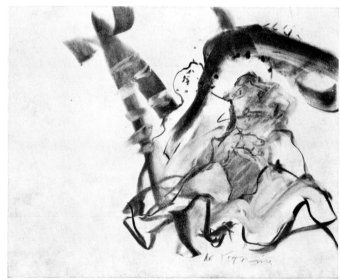

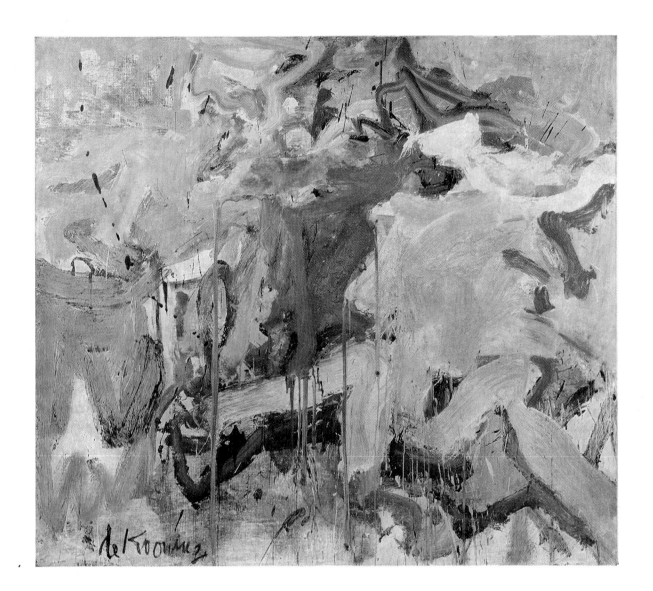

opposite above: Untitled (figures in landscape). (1967).
Charcoal, $18^5/_8 \times 23^3/_4$ inches.
Collection Susan Brockman, New York

137

opposite below: Untitled. (1967).
Charcoal, $18^3/_4 \times 24$ inches.
M. Knoedler & Co., Inc., New York, Paris, London

above: *Two Figures in a Landscape*. (1967).
Oil on canvas, 70×80 inches.
Stedelijk Museum, Amsterdam

Notes

1. Broadcast December 3, 1960. Edited version published as "Content Is a Glimpse," by Willem de Kooning. *Location* (New York), vol. I, no. 1, Spring 1963, pp. 45–48.

2. Published here for the first time, the paper was delivered at one of the Friday evenings of Subjects of the Artist: A New Art School, 35 East Eighth Street. The school was organized by William Baziotes, David Hare, Robert Motherwell, and Mark Rothko. Later Barnett Newman joined the group, initiated the Friday evening programs, and suggested the topics. De Kooning's paper begins: "I am surprised to be here this evening reading my piece, for I do not think I am up to it. Barney Newman decided it really, and he even gave the evening its name, *A Desperate View. . . .*"

3. Conversation with Martha Boudrez, published as an interview in *The Knickerbocker* (New York), May 1950, p. 3.

4. From an unpublished interview with Irving Sandler, assigned by *Art News* in the spring of 1959 to do an article on the French Line murals that Fernand Léger, with a number of American assistants, had undertaken in 1935. Because almost all the material had disappeared, the article could never be finished, but Mr. Sandler was kind enough to let me see his notes. Working with Léger were de Kooning, Harry Bowden, Mercedes Matter, George McNeil, Byron Browne, Balcomb Greene, and José de Rivera.

5. Clement Greenberg, *Matisse* (New York: Harry N. Abrams, 1953), n.p.

6. Friedrich Nietzsche, "article" 277, *Beyond Good and Evil*, translated by Marianne Cowan (Chicago: Henry Regnery, 1955), p. 244.

7. A distinction first made by Elaine de Kooning, "Kline and Rothko," *Art News Annual* (New York), XXVII, 1957–1958, pp. 89–96, 174–179.

8. Leon Trotsky, *My Life* (New York: Scribner's, 1930; Grosset and Dunlap, 1960), p. 260

9. Harold Rosenberg, "The American Action Painters," *Art News* (New York), December 1952, pp. 22–23; reprinted in *The Tradition of the New* (New York: Horizon Press, 1959), pp. 23–39.

10. Thomas B. Hess, *Willem de Kooning* (New York: George Braziller, 1959).

11. Clement Greenberg was one of the most enthusiastic champions of de Kooning at the time of his first exhibitions. Despite Greenberg's dire prediction about the artist's attempts to paint a Woman, he wrote a glowing foreword to an informal de Kooning retrospective held by the Workshop Art Center Gallery, Washington, D.C., June 14 – July 3, 1953. The show included 32 works, from a *Seated Woman*, 1937, to *Woman II*, as well as such abstractions as *Pink Angels*, Study for backdrop (*Labyrinth*), and *Asheville*. Greenberg wrote:

 "Modern art is not the sudden eruption out of nowhere that many people think it to be. To the extent that it is successful as art it flows from the past without break in continuity. One can find no better demonstration of this than in Willem de Kooning's painting, although – or rather, precisely because – it belongs to the most advanced in our time.

 "The supple line that does most of the work in de Kooning's pictures, whether these are representational or not, is never a completely abstract element but harks back to the contour, particu-

larly that of the human form. Though it is a disembodied contour, seldom closing back upon itself to suggest a solid object, it continues in the great tradition of sculptural draughtsmanship which runs from Leonardo through Michaelangelo, Raphael, Ingres and Picasso. The play of the planes whose edges this line creates – embedding them in the picture surface here, freeing them from it there – reminds one, however, of how nude forms in the big decorative canvases of the Venetians and Rubens undulate in and out of foreground light. De Kooning's restraint in the use of color serves but to let the rhythm of the undulation come through more clearly.

"De Kooning strives for synthesis, and in more ways than one. He wants to re-charge advanced painting, which has largely abandoned the illusion of depth and volume, with something of the old power of the sculptural contour. He wants also to make it accomodate bulging, twisting planes like those seen in Tintoretto and Rubens. And by these means he wants in the end to recover a distinct image of the human figure, yet without sacrificing anything of abstract painting's decorative and physical force. Obviously, this is highly ambitious art, and indeed de Kooning's ambition is perhaps the largest, or at least the most profoundly sophisticated, ever to be seen in a painter domiciled in this country.

"This is painting in the grand style, the grand style in the sense of tradition but not itself a traditional style, attempted by a man whose gifts amount to what I am not afraid to call genius (his ability as a colorist is larger than even his admirers ordinarily recognize). No wonder de Kooning has had such a tremendous impact on American painting in the last several years. He is one of the important reasons, moreover, why that painting has ceased to be a provincial one and become a factor in the mainstream of Western art today."

Three years later, Greenberg compared de Kooning's ambitions to Lucifer's, and found a cubist

substructure for the artist's "bulging and twisting planes." By the 1960's, he was engaged in an all-out attack on de Kooning's art, and several of his epigones have followed his lead, apparently unencumbered by any knowledge of their leader's old convictions.

12. Louis Finklestein, "Gotham News," *The Avant-Garde: Art News Annual* (New York), XXXIV, 1968, pp. 114–123.

13. Thomas B. Hess, "De Kooning Paints a Picture," *Art News* (New York), March 1953, p. 32.

14. *Ibid.*, pp. 30–33.

15. *Ibid.*, pp. 30–33, 64–67.

16. Harold Rosenberg, "De Kooning: on the Borders of the Act," *The Anxious Object* (New York: Horizon Press, 1964), pp. 123–129.

17. Gertrude Stein, *Four in America* (New Haven: Yale University Press, 1947), p. 87.

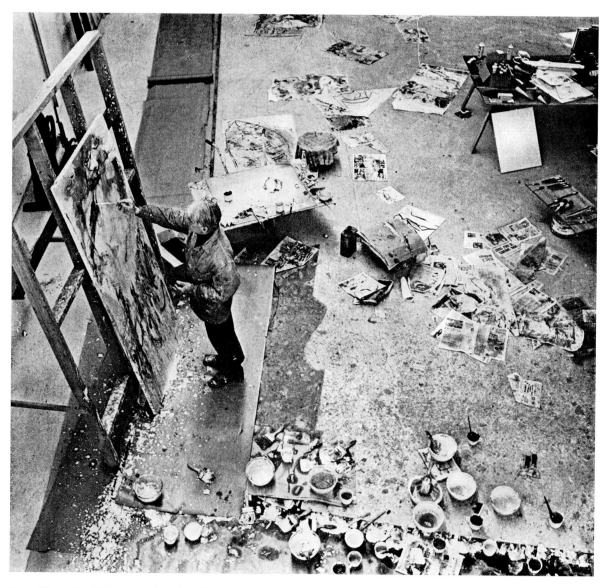

Hans Namuth: Willem de Kooning, East Hampton, 1964

Selections from the Writings of Willem de Kooning

THE RENAISSANCE AND ORDER

Written in 1950 for a lecture series at Studio 35 on Eighth Street in New York; reprinted from Trans/formation, *vol. 1, no. 2, 1951 (Courtesy of Harry Holtzman).*

In the Renaissance, when people – outside of being hung or crucified – couldn't die in the sky yet, the ideas a painter had always took place on earth. He had this large marvelous floor that he worked on. So if blood was on a sword, it was no accident. It meant that someone was dying or dead.

It was up to the artist to measure out the exact space for that person to die in or be dead already. The exactness of the space was determined or, rather, inspired by whatever reason the person was dying or being killed for. The space thus measured out on the original plane of the canvas surface became a "place" somewhere on that floor. If he were a good painter, he did not make the center of the end of that floor – the vanishing point on the horizon – the "content" (as the philosophers and educators of commercial art want to convince us nowadays that they did). The "content" was his way of making the happening on the floor measurable from as many angles as possible instead. The main interest was how deep the happening – and the floor itself – could be or ought to be. The concept he had about the so-called "subject" established the depth; and with that he eventually found how high it was and how wide. It was not the other way around. He wasn't Alice looking into the Looking Glass. The scene wasn't there yet. He still had to make it.

Perspective, then, to a competent painter, did not mean an illusionary trick. It wasn't as if he were standing in front of his canvas and needed to imagine how deep the world could be. The world was deep already.

As a matter-of-fact, it was depth which made it possible for the world to be there altogether. He wasn't so abstract as to take the hypotenuse of a two-dimensional universe. Painting was more intellectual than that. It was more intriguing to imagine himself busy on that floor of his – to *be*, so to speak, on the inside of his picture. He took it for granted that he could only measure things subjectively, and it was logical therefore that the best way was from the inside. It was the only way be could eventually project all the happenings on the frontmost plane. He became, in a way, the idea, the center, and the vanishing point himself – and all at the same time. He shifted, pushed, and arranged things in accordance with the way he felt about them. Sure they were not all the same to him. His idea of balance was a "wrought" one or a "woven" one. He loved something in one corner as much as he hated something in another. But he never became the things himself, as is usually said since Freud. If he wanted to, he could become one or two sometines, but he was the one that made the decision. As long as he kept the original idea in mind, he could both invent the phenomena and inspect them critically at the same time. Michelangelo invented Adam that way, and even God.

In those days, you were subjective to yourself, not to somebody else. If the artist was painting St. Sebastian, he knew very well he wasn't St. Sebastian – nor was he one of the torturers. He didn't understand the other fellow's face because he was painting his own: he understood it better because he himself had a face. He could never become completely detached. He could not get man out of his mind.

There must be something about us, he thought, that determines us to have a face, legs and arms, a belly, nose, eyes and mouth. He didn't even mind that people were flesh-colored. Flesh was very important to a painter then. Both the church and the state recog-

nized it. The interest in the difference of textures – between silk, wood, velvet, glass, marble – was there *only in relation to flesh*. Flesh was the reason why oil painting was invented. Never before in history had it taken such a place in painting. For the Egyptians, it was something that didn't last long enough; for the Greeks, it – and everything else – took on the texture of painted marble and plaster walls. But for the Renaissance artist, flesh was the stuff people were made of. It was because of man, and not in spite of him, that painting was considered an art.

Art was also tied up with effort. Man, and all the things around him, and all that possibly could happen to him – either going to heaven or hell – were not there because the artist was interested in designing. On the contrary, he was designing because all those things and himself too were in this world already. That was his great wonder. The marvel wasn't just what he made himself, but what was there already. He knew there was something more remarkable than his own ability. He wasn't continuously occupied with the petulant possibilities of what "mankind" ought to do. If they were beating something, it wasn't their own breasts all the time. You can see for yourself that he was completely astonished. Never a pose was taken. Everything was gesture. Everything in these paintings "behaved." The people were doing something; they looked, they talked to one another, they listened to one another, they buried someone, crucified someone else. The more painting developed, in that time, the more it started shaking with excitement. And very soon they saw that they needed thousands and thousands of brush-strokes for that – as you can see for yourself in Venetian painting.

The drawing started to tremble because it wanted to go places. The artist was too perplexed to be sure of himself. How do we know, he thought, that everything is really not still, and only starts moving when we begin to look at it? Actually there was no "subject-matter." What we call subject-matter now, was then painting itself. Subject matter came later on when parts of those works were taken out arbitrarily, when a man for no reason is sitting, standing or lying down. He be-

came a bather; she became a bather; she was reclining; he just stood there looking ahead. That is when the posing in painting began. When a man has no other meaning than that he is sitting, he is a *poseur*. That's what happened when the burghers got hold of art, and got hold of man, too, for that matter. For really, when you think of all the life and death problems in the art of the Renaissance, who cares if a Chevalier is laughing or that a young girl has a red blouse on.

It seems that so far, I have a chip on my shoulder. If I brought up Renaissance painting, it is not out of regret or because I think that we lost something. I do feel rather horrified when I hear people talk about Renaissance painting as if it were some kind of buck-eye painting good only for kitchen calendars. I did it also because it is impossible for me ever to come to the point. But when I think of painting today, I find myself always thinking of that part which is connected with the Renaissance. It is the vulgarity and fleshy part of it which seems to make it particularly Western. Well, you could say, "Why should it be Western?" Well, I'm not saying it should.

But, it is because of Western civilization that we can travel now all over the world and I, myself, am completely grateful for being able to sit in this ever-moving observation car, able to look in so many directions. But I also want to know where I'm going. I don't know exactly where it is, but I have my own track. I'm not always sure I'm on it, but sometimes I think I am.

In a recent issue of *Life* magazine (the half-century number), it is the pages on art which made it obvious that we are in the right direction. Everything else is dated. I mean this of course in relation to what was presented in that issue. Different directions in art were presented but, for my part, I picked Marcel Duchamp.

There is a train track in the history of art that goes way back to Mesopotamia. It skips the whole Orient, the Mayas and American Indians. Duchamp is on it. Cézanne is on it. Picasso and the Cubists are on it; Giacometti, Mondrian and so many, many more – whole civilizations. Like I say, it goes way in and back to

Mesopotamia for maybe 5,000 years, so there is no sense in calling out names. The reason I mention Duchamp is because he was one of the artists in *Life's* half-century number. But I have some feeling about all these people – millions of them – on this enormous track, way into history. They had a peculiar way of measuring. They seemed to measure with a length similar to their own height. For that reason they could imagine themselves in almost any proportions. That is why I think Giacometti's figures are like real people. The idea that the thing that the artist is making can come to know for itself, how high it is, how wide and how deep it is, is a historical one – a traditional one I think. It comes from man's own image.

I admit I know little of Oriental art. But that is because I cannot find in it what I am looking for, or what I am talking about. To me the Oriental idea of beauty is that "it isn't here." It is in a state of not being here. It is absent. That is why it is so good. It is the same thing I don't like in Suprematism, Purism and non-objectivity.

And, although I, myself, don't care for all the pots and pans in the paintings of the burghers – the genre scenes of goodly living which developed into the kind sun of Impressionism later on – I do like the idea that they – the pots and pans, I mean – are always in relation to man. They have no soul of their own, like they seem to have in the Orient. For us, they have no character; we can do anything we please with them. There is this perpetual irritability. Nature, then, is just nature. I admit I am very impressed with it.

The attitude that nature is chaotic and that the artist puts order into it is a very absurd point of view, I think. All that we can hope for is to put some order into ourselves. When a man ploughs his field at the right time, it means just that.

Insofar as we understand the universe – if it can be understood – our doings must have some desire for order in them; but from the point of view of the universe, they must be very grotesque. As a matter-of-fact, the idea of "order" reminds me of something Jack Tworkov was telling me that he remembered of his childhood.

There was the village idiot. His name was Plank and he measured everything. He measured roads, toads, and his own feet; fences, his nose and windows, trees, saws and caterpillars. Everything was there already to be measured by him. Because he was an idiot, it is difficult to think in terms of how happy he was. Jack says he walked around with a very satisfied expression on his face. He had no nostalgia, neither a memory nor a sense of time. All that he noticed about himself was that his length changed!

WHAT ABSTRACT ART MEANS TO ME

Written for a symposium held at The Museum of Modern Art on February 5, 1951; reprinted from THE MUSEUM OF MODERN ART BULLETIN, *vol. XVIII, no. 3, Spring 1951.*

The first man who began to speak, whoever he was, must have intended it. For surely it is talking that has put "Art" into painting. Nothing is positive about art except that it is a word. Right from there to here all art became literary. We are not yet living in a world where everything is self-evident. It is very interesting to notice that a lot of people who want to take the talking out of painting, for instance, do nothing else but talk about it. That is no contradiction, however. The art in it is the forever mute part you can talk about forever.

For me, only one point comes into my field of vision. This narrow, biased point gets very clear sometimes. I didn't invent it. It was already here. Everything that passes me I can see only a little of, but I am always looking. And I see an awful lot sometimes.

The word "abstract" comes from the light-tower of the philosophers, and it seems to be one of their spotlights that they have particularly focussed on "Art." So the artist is always lighted up by it. As soon as it – I mean the "abstract" – comes into painting, it ceases to be what it is as it is written. It changes into a feeling which could be explained by some other words, probably. But one day, some painter used "Abstraction"

143

as a title for one of his paintings. It was a still life. And it was a very tricky title. And it wasn't really a very good one. From then on the idea of abstraction became something extra. Immediately it gave some people the idea that they could free art from itself. Until then, Art meant everything that was in it – not what you could take out of it. There was only one thing you could take out of it sometime when you were in the right mood – that abstract and indefinable sensation, the esthetic part – and still leave it where it was. For the painter to come to the "abstract" or the "nothing," he needed many things. Those things were always things in life – a horse, a flower, a milkmaid, the light in a room through a window made of diamond shapes maybe, tables, chairs, and so forth. The painter, it is true, was not always completely free. The things were not always of his own choice, but because of that he often got some new ideas. Some painters liked to paint things already chosen by others, and after being abstract about them, were called Classicists. Others wanted to select the things themselves and, after being abstract about them, were called Romanticists. Of course, they got mixed up with one another a lot too. Anyhow, at that time, they were not abstract about something which was already abstract. They freed the shapes, the light, the color, the space, by putting them into concrete things in a given situation. They *did* think about the possibility that the things – the horse, the chair, the man – were abstractions, but they let that go, because if they kept thinking about it, they would have been led to give up painting altogether, and would probably have ended up in the philosopher's tower. When they got those strange, deep ideas, they got rid of them by painting a particular smile on one of the faces in the picture they were working on.

The esthetics of painting were always in a state of development parallel to the development of painting itself. They influenced each other and vice versa. But all of a sudden, in that famous turn of the century, a few people thought they could take the bull by the horns and invent an esthetic beforehand. After immediately disagreeing with each other, they began to form all kinds of groups, each with the idea of freeing art, and each demanding that you should obey them. Most of these theories have finally dwindled away into politics or strange forms of spiritualism. The question, as they saw it, was not so much what you *could* paint but rather what you could *not* paint. You could *not* paint a house or a tree or a mountain. It was then that subject matter came into existence as something you ought *not* to have.

In the old days, when artists were very much wanted, if they got to thinking about their usefulness in the world, it could only lead them to believe that painting was too worldly an occupation and some of them went to church instead or stood in front of it and begged. So what was considered too worldly from a spiritual point of view then, became later – for those who were inventing the new esthetics – a spiritual smoke-screen and not worldly enough. These latter-day artists were bothered by their apparent uselessness. Nobody really seemed to pay any attention to them. And they did not trust that freedom of indifference. They knew that they were relatively freer than ever before *because* of that indifference, but in spite of all their talking about freeing art, they really didn't mean it that way. Freedom to them meant to be useful in society. And that is really a wonderful idea. To achieve that, they didn't need *things* like tables and chairs or a horse. They needed ideas instead, social ideas, to make their objects with, their constructions – the "pure plastic phenomena" – which were used to illustrate their convictions. Their point was that until they came along with their theories, Man's own form in space – his body – was a private prison; and that it was because of this imprisoning misery – because he was hungry and overworked and went to a horrid place called home late at night in the rain, and his bones ached and his head was heavy – because of this very consciousness of his own body, this sense of pathos, they suggest, he was overcome by the drama of a crucifixion in a painting or the lyricism of a group of people sitting quietly around a table drinking wine. In other words, these estheticians proposed that people had up to now understood painting in terms of their own private misery. Their own sentiment of form instead was one

of comfort. The beauty of comfort. The great curve of a bridge was beautiful because people could go across the river in comfort. To compose with curves like that, and angles, and make works of art with them could only make people happy, they maintained, for the only association was one of comfort. That millions of people have died in war since then, because of that idea of comfort, is something else.

This pure form of comfort became the comfort of "pure form." The "nothing" part in a painting until then – the part that was not painted but that was there because of the things in the picture which were painted – had a lot of descriptive labels attached to it like "beauty," "lyric," "form," "profound," "space," "expression," "classic," "feeling," "epic," "romantic," "pure," "balance," etc. Anyhow that "nothing" which was always recognized as a particular something – and as something particular – they generalized, with their book-keeping minds, into circles and squares. They had the innocent idea that the "something" existed "in spite of" and not "because of" and that this something was the only thing that truly mattered. They had hold of it, they thought, once and for all. But this idea made them go backward in spite of the fact that they wanted to go forward. That "something" which was not measurable, they lost by trying to make it measurable; and thus all the old words which, according to their ideas, ought to be done away with got into art again: pure, supreme, balance, sensitivity, etc.

Kandinsky understood "Form" as *a* form, like an object in the real world; and an object, he said, was a narrative – and so, of course, he disapproved of it. He wanted his "music without words." He wanted to be "simple as a child." He intended, with his "inner-self," to rid himself of "philosophical barricades" (he sat down and wrote something about all this). But in turn his own writing has become a philosophical barricade, even if it is a barricade full of holes. It offers a kind of Middle-European idea of Buddhism or, anyhow, something too theosophic for me.

145 The sentiment of the Futurists was simpler. No space. Everything ought to keep on going! That's probably the reason they went themselves. Either a man

was a machine or else a sacrifice to make machines with.

The moral attitude of Neo-Plasticism is very much like that of Constructivism, except that the Constructivists wanted to bring things out in the open and the Neo-Plasticists didn't want anything left over.

I have learned a lot from all of them and they have confused me plenty too. One thing is certain, they didn't give me my natural aptitude for drawing. I am completely weary of their ideas now.

The only way I still think of these ideas is in terms of the individual artists who came from them or invented them. I still think that Boccioni was a great artist and a passionate man. I like Lissitzky, Rodchenko, Tatlin and Gabo; and I admire some of Kandinsky's painting very much. But Mondrian, that great merciless artist, is the only one who had nothing left over.

The point they all had in common was to be both inside and outside at the same time. A new kind of likeness! The likeness of the group instinct. All that it has produced is more glass and an hysteria for new materials which you can look through. A sympton of love-sickness, I guess. For me, to be inside and outside is to be in an unheated studio with broken windows in the winter, or taking a nap on somebody's porch in the summer.

Spiritually I am wherever my spirit allows me to be, and that is not necessarily in the future. I have no nostalgia, however. If I am confronted with one of those small Mesopotamian figures, I have no nostalgia for it but, instead, I may get into a state of anxiety. Art never seems to make me peaceful or pure. I always seem to be wrapped in the melodrama of vulgarity. I do not think of inside or outside – or of art in general– as a situation of comfort. I know there is a terrific idea there somewhere, but whenever I want to get into it, I get a feeling of apathy and want to lie down and go to sleep. Some painters, including myself, do not care what chair they are sitting on. It does not even have to be a comfortable one. They are too nervous to find out where they ought to sit. They do not want to "sit in style." Rather, they have found that painting -- any kind of painting, any style of painting – to be painting

at all, in fact – is a way of living today, a style of living so to speak. That is where the form of it lies. It is exactly in its uselessness that it is free. Those artists do not want to conform. They only want to be inspired.

The group instinct could be a good idea, but there is always some little dictator who wants to make his instinct the group instinct. There *is* no style of painting now. There are as many naturalists among the abstract painters as there are abstract painters in the so-called subject-matter school.

The argument often used that science is really abstract, and that painting could be like music and, for this reason, that you cannot paint a man leaning against a lamp-post, is utterly ridiculous. That space of science – the space of the physicists – I am truly bored with by now. Their lenses are so thick that seen through them, the space gets more and more melancholy. There seems to be no end to the misery of the scientists' space. All that it contains is billions and billions of hunks of matter, hot or cold, floating around in darkness according to a great design of aimlessness. The stars *I* think about, if I could fly, I could reach in a few old-fashioned days. But physicists' stars I use as buttons, buttoning up curtains of emptiness. If I stretch my arms next to the rest of myself and wonder where my fingers are – that is all the space I need as a painter.

Today, some people think that the light of the atom bomb will change the concept of painting once and for all. The eyes that actually saw the light melted out of sheer ecstasy. For one instant, everybody was the same color. It made angels out of everybody. A truly Christian light, painful but forgiving.

Personally, I do not need a movement. What was given to me, I take for granted. Of all movements, I like Cubism most. It had that wonderful unsure atmosphere of reflection – a poetic frame where something could be possible, where an artist could practise his intuition. It didn't want to get rid of what went before. Instead it added something to it. The parts that I can appreciate in other movements came out of Cubism. Cubism *became* a movement, it didn't set out to be one. It has force in it, but it was no "force-move-

ment." And then there is that one-man movement, Marcel Duchamp – for me a truly modern movement because it implies that each artist can do what he thinks he ought to – a movement for each person and open for everybody.

If I *do* paint abstract art, that's what abstract art means to me. I frankly do not understand the question. About twenty-four years ago, I knew a man in Hoboken, a German who used to visit us in the Dutch Seamen's Home. As far as he could remember, he was always hungry in Europe. He found a place in Hoboken where bread was sold a few days old – all kinds of bread: French bread, German bread, Italian bread, Dutch bread, Greek bread, American bread and particularly Russian black bread. He bought big stacks of it for very little money, and let it get good and hard and then he crumpled it and spread it on the floor in his flat and walked on it as on a soft carpet. I lost sight of him, but found out many years later that one of the other fellows met him again around 86th street. He had become some kind of a Jugend Bund leader and took boys and girls to Bear Mountain on Sundays. He is still alive but quite old and is now a Communist. I could never figure him out, but now when I think of him, all that I can remember is that he had a very abstract look on his face.

CONTENT IS A GLIMPSE...

Excerpts from an interview with David Sylvester (B.B.C.); reprinted from LOCATION, *vol. 1, no. 1, Spring 1963.*

When we went to the Academy [in Rotterdam, in the early 1920s] – doing painting, decorating, making a living – young artists were not interested in painting *per se.* We used to call that "good for men with beards." And the idea of a palette, with colors on it, was rather silly. At that time we were influenced by the de Stijl group. The idea of being a modern person wasn't really being an artist in the sense of being a painter. So it wasn't illogical to come to America [instead of

going to Paris]. Also, being young, I really didn't understand the nature of painting. I really intended to become an applied artist. I mean, it was more logical to be a designer or a commercial artist. I didn't intend to become a painter – that came later.

I didn't expect that there were any artists here. We never heard in Holland that there were artists in America. There was still the feeling that this was where an individual could get places and become well off, if he worked hard; while art, naturally, was in Europe. When I had been here for about six months or a year I found out that there were a lot of artists here too. There was Greenwich Village; there was a whole tradition in painting and in poetry. I just didn't know about it, and it must have directed me back to interests I had when I was fourteen, fifteen, sixteen years old. When you're about nineteen and twenty, you really want to go up in the world and you don't mind giving up art.

I was here only about three days when I got a job in Hoboken as a house painter. I made nine dollars a day, which was quite a large salary, and after being around four or five months doing that, I started looking for a job doing applied art-work. I made some samples and I was hired immediately. I didn't even ask them the salary because I thought if I made twelve dollars a day as a house painter, I would make at least twenty dollars a day being an artist. Then at the end of two weeks, the man gave me twenty-five dollars and I was so astonished I asked him if that was a day's pay. He said, "No, that's for the whole week." And I immediately quit and went back to house painting. It took quite a while for me to make the shift from being a Sunday painter, working most of the time and painting once in a while, to painting for longer periods and taking odd jobs here and there on the side. It was a gradual development and it was really more of a psychological attitude: that it was better to say, "No. I'm an artist. I have to do something on the side to make a living." So I styled myself an artist and it was very difficult. But it was a much better state of mind.

Then, when the Depression came, I got on the WPA, and I met all kinds of other painters and sculptors and writers and poets and architects, all in the same boat, because America never really cared much for people who do those things. I was on the Project about a year or a year and a half, and that really made it stick, this attitude, because the amount of money we made on the Project was rather fair; in the Depression days one could live modestly and nicely. So I felt, well, I have to just keep doing that. The decision to take was: was it worth it to put all my eggs in one basket, that kind of basket of art. I didn't know if I really was competent enough, if I felt it enough.

I met a lot of artists – but then I met Gorky. I had some training in Holland, quite a training, the Academy. Gorky didn't have that at all. He came from no place; he came here when he was sixteen, from Tiflis in Georgia, with an Armenian upbringing. And for some mysterious reason, he knew lots more about painting and art – he just knew it by nature – things I was supposed to know and feel and understand – he really did it better. He had an extraordinary gift for hitting the nail on the head; very remarkable. So I immediately attached myself to him and we became very good friends. It was nice to be foreigners meeting in some new place. Of course, New York is really like a Byzantine city – it is very natural too. I mean, that is probably one of the reasons why I came myself, without knowing. When I was a child I was very interested in America; it was romantic... cowboys and Indians. Even the shield, the medieval shield they have with the stars on top and the stripes on the bottom, was almost like the heraldic period of the Crusaders, with the eagle; as a child I used to be absolutely fascinated by this image.

Now that is all over. It's not so much that I'm an American: I'm a New Yorker. I think we have gone back to the cities, and I feel much more in common with artists in London or Paris. It is a certain burden, this American-ness. If you come from a small nation, you don't have that. When I went to the Academy and I was drawing from the nude, *I* was making the drawing, not Holland. I feel sometimes an American artist must feel, like a baseball player or something – a member of a team writing American history... I think it is kind of nice that at least part of the public is

proud that they have their own sports and things like that – and why not their own art? I think it's wonderful that you know where you came from – I mean you know, if you are American, you are an American.

Certain artists and critics attacked me for painting the *Women*, but I felt that this was their problem, not mine. I don't really feel like a non-objective painter at all. Today, some artists feel they have to go back to the figure, and that word "figure" becomes such a ridiculous omen – if you pick up some paint with your brush and make somebody's nose with it, this is rather ridiculous when you think of it, theoretically or philosophically. It's really absurd to make an image, like a human image, with paint, today, when you think about it, since we have this problem of doing or not doing it. But then all of a sudden it was even more absurd not to do it. So I fear that I have to follow my desires.

The *Women* had to do with the female painted through all the ages, all those idols, and maybe I was stuck to a certain extent; I couldn't go on. It did one thing for me: it eliminated composition, arrangement, relationships, light – all this silly talk about line, color and form – because that was the thing I wanted to get hold of. I put it in the center of the canvas because there was no reason to put it a bit on the side. So I thought I might as well stick to the idea that it's got two eyes, a nose and mouth and neck. I got to the anatomy and I felt myself almost getting flustered. I really could never get hold of it. It almost petered out. I never could complete it and when I think of it now, it wasn't such a bright idea. But I don't think artists have particularly bright ideas. Matisse's *Woman in a Red Blouse* – what an idea that is! Or the Cubists – when you think about it now, it is so silly to look at an object from many angles. Constructivism – open, not closed. It's very silly. It's good that they got those ideas because it was enough to make some of them great artists.

Painting the *Women* is a thing in art that has been done over and over – the idol, Venus, the nude. Rembrandt wanted to paint an old man, a wrinkled old guy – that was painting to him. Today artists are in a belated age of reason. They want to get hold of things. Take Mondrian; he was a fantastic artist. But when we read his ideas and his idea of Neo-Plasticism – pure plasticity – it's kind of silly. Not for him, but I think one could spend one's life having this desire to be in and outside at the same time. He could see a future life and a future city – not like me, who am absolutely not interested in seeing the future city. I'm perfectly happy to be alive now.

The *Woman* became compulsive in the sense of not being able to get hold of it – it really is very funny to get stuck with a woman's knees, for instance. You say, "What the hell am I going to do with that now?"; it's really ridiculous. It may be that it fascinates me, that it isn't supposed to be done. A lot of people paint a figure because they feel it ought to be done, because since they're human beings themselves, they feel they ought to make another one, a substitute. I haven't got that interest at all. I really think it's sort of silly to do it. But the moment you take this attitude it's just as silly not to do it.

It became a problem of picture painting, because the very fact that it had words connected with it – "figure of a woman" – made it more precise. Perhaps I am more of a novelist than a poet, but I always like the word in painting. Forms ought to have the emotion of a concrete experience. For instance, I am very happy to see that grass is green. At one time, it was very daring to make a figure red or blue – I think now that it is just as daring to make it flesh-colored.

Content is a glimpse of something, an encounter like a flash. It's very tiny – very tiny, content. When I was painting those figures, I was thinking about Gertrude Stein, as if they were ladies of Gertrude Stein – as if one of them would say, "How do you like me?" Then I could sustain this thing all the time because it could change all the time; she could almost get upside down, or not be there, or come back again, she could be any size. Because this content could take care of almost anything that could happen.

I still have it now from fleeting things – like when one passes something, and it makes an impression, a simple stuff.

I wasn't concerned to get a particular kind of feeling. I look at them now and they seem vociferous and ferocious. I think it had to do with the idea of the idol, the oracle, and above all the hilariousness of it. I do think that if I don't look upon life that way, I won't know how to keep on being around.

I cut out a lot of mouths. First of all, I thought everything ought to have a mouth. Maybe it was like a pun. Maybe it's sexual. But whatever it is, I used to cut out a lot of mouths and then I painted those figures and then I put the mouth more or less in the place where it was supposed to be. It always turned out to be very beautiful and it helped me immensely to have this real thing. I don't know why I did it with the mouth. Maybe the grin – it's rather like the Mesopotamian idols, they always stand up straight, looking to the sky with this smile, like they were just astonished about the forces of nature you feel, not about problems they had with one another. That I was very conscious of – the smile was something to hang onto.

I wouldn't know what to do with the rest, with the hands, maybe, or some gesture, and then in the end I failed. But it didn't bother me because I had, in the end, given it up; I felt it was really an accomplishment. I took the attitude that I was going to succeed, and I also knew that this was just an illusion. I never was interested in how to make a good painting. For many years I was not interested in making a good painting – as one might say, "Now this is really a good painting" or a "perfect work." I didn't want to pin it down at all. I was interested in that before, but I found out it was not my nature. I didn't work on it with the idea of perfection, but to see how far one could go – but not with the idea of really doing it. With anxiousness and dedication to fright maybe, or ecstasy, like the *Divine Comedy*, to be like a performer: to see how long you can stay on the stage with that imaginary audience.

The pictures done since the *Women*, they're emotions, most of them. Most of them are landscapes and highways and sensations of that, outside the city – with the feeling of going to the city or coming from it. I'm not a pastoral character. I'm not a – how do you say that? – "country dumpling." I am here, and I like New York City. But I love to go out in a car. I'm crazy about weekend drives, even if I drive in the middle of the week. I'm just crazy about going over the roads and highways... They are really not very pretty, the big embankments and the shoulders of the roads and the curves are flawless – the lawning of it, the grass. This I don't particularly like or dislike, but I wholly approve of it. Like the signs. Some people want to take the signs away, but it would break my heart. All those different big billboards. There are places in New England where they are not allowed to put those signs, and that's nice too, but I love those grotesque signs. I mean, I am not undertaking any social... I'm no lover of the new – it's a personal thing.

When I was working on this *Merritt Parkway* picture, this thing came to me: it's just like the Merritt Parkway. I don't think I set out to do anything, but I find because of modern painting that things which couldn't be seen in terms of painting, things you couldn't paint, for instance, are now – it's not that you paint them but it is the connection.

I imagine that Cézanne, when he painted a ginger pot and apples and ordinary everyday wine bottles, must have been very grotesque in his day, because a still-life was something set up of beautiful things. It may be very difficult, for instance, to put a Rheingold bottled beer on the table and a couple of glasses and a package of Lucky Strikes. There are certain things you cannot paint at a particular time; and it takes a certain attitude, how to see those things in terms of art. You feel those things and inasmuch as I should set out to paint Merritt Parkway years ago, it seems I must have liked it so much I must have subconsciously found a way of setting it down on paper, on canvas. It could be that – I'm not sure.

Now I can make some highways, maybe. Of course, there will be something else. Now I can set out to do it, and then it will be, maybe it will be a painting of something else. Because if you know the measure of something – for yourself there's no absolute measure – you can find the size of something. You say now that's just this length and immediately with that length you

can paint, well, a cat. If you understand one thing, you can use it for something else. That is the way I work. I get hold of a certain kind of area or measure or size and then I can use it. I mean, I have an attitude. I have to have an attitude.

I feel now if I think of it, it will come out in the painting. In other words, if I want to make the whole painting look like a bottle, like a lot of bottles, for instance – maybe the end of the day, when everything is very light, but not in sunlight necessarily – and so if I have this image of this bottle and if I really think about it, it will come out in the painting. That doesn't mean that people notice a bottle, but I know when I succeed in it – then the painting would have this. They can interpret it their ways.

I get freer. I feel I am getting more to myself in the sense of, I have all my forces. I hope so, anyhow. I have this sort of feeling that I am all there now. It's not even thinking in terms of one's limitations because they have to come naturally. I think whatever you have, you can do wonders with it, if you accept it, and I feel with the help of all the other artists around me doing all these different things – I wouldn't know how to pin it down. But I have some feelings now – a bigger feeling of freedom. I am more convinced about picking up the paint and the brush and drumming it out.

I make a little mystique for myself. Since I have no preference or so-called sense of color, I could take almost anything that could be some accident of a previous painting. Or I set out to make a series. I take, for instance, some pictures where I take a color, some arbitrary color I took from some place. Well, this is gray maybe, and I mix the color for that, and then I find out that when I am through with getting the color the way I want it, I have six other colors in it, to get that color; and then I take those six colors and I use them also with this color. It is probably like a composer does a variation on a certain theme. But it isn't technical. It isn't just like fun because if I am interested in this bottle, I'm not going to find it in any place.

I have this measure, so it's no contradiction really.

All these things are already in art and if you can – even if you go to the Academy and you really can do it and you get the point – well, you know how to draw a basket, you see.

I read somewhere that Rubens said students should not draw from life, but draw from all the great classic casts. Then you really get the measure of them, you really know what to do. And *then*, put in your own dimples.

Isn't that marvelous!

Now, of course, we don't do that. You've developed a little culture for yourself, like yoghurt; as long as you keep something of the original microbes, the original thing in it will grow out. So I had – like most artists – this original little sensation, so I don't have to worry about getting stuck. As to the painting being finished. I always have a miserable time over that. But it is getting better now. I just stop. I sometimes get rather hysterial and because of that I find sometimes a terrific picture. As a matter of fact, that's probably the real thing, but I couldn't set out to do that. I set out keeping in mind that this thing will be a flop in all probability, and it sometimes turns out very good.

Bibliography

It is hoped that the following provides a balanced review of the sources. Additional documentation may be found in: *Willem de Kooning* by T. B. Hess, 1959 (bibl. 10); *De Kooning* by H. Janis and R. Blesh, 1960 (bibl. 11); *American Abstract Expressionists and Imagists*, The Solomon R. Guggenheim Museum, 1961 (bibl. 145); *Willem de Kooning*, Smith College Museum of Art, 1965 (bibl. 163); *New York School*, Los Angeles County Museum of Art, 1965 (bibl. 164); and *Willem de Kooning*, Stedelijk Museum, 1968 (bibl. 176). (*Note*: The artist is catalogued variously under de Kooning, deKooning, De Kooning, and alphabetically under K.)

Bernard Karpel
Librarian of the Museum

DE KOONING STATEMENTS, WRITINGS, INTERVIEWS, AND LETTERS

(arranged chronologically)

1 [Letter to the editor on Arshile Gorky.] *Art News* (New York), January 1949, p. 6.
Reprinted in bibl. 141.

2 "Artists' Sessions at Studio 35 (1950)." In Motherwell, Robert and Reinhardt, Ad (eds.). *Modern Artists in America*. First series. New York: Wittenborn, Schultz, 1951, pp. 12–22, 69.
Edited excerpts of round-table discussions, April 1950.

3 "The Renaissance and Order," *Trans/formation* (New York), vol. 1, no. 2, 1951, pp. 85–87.
Reprinted in bibl. 163, 176. Published in French in bibl. 175; in Dutch in bibl. 176.

4 "What Abstract Art Means to Me," *The Museum of Modern Art Bulletin* (New York), Spring 1951, pp. 4–8.

Reprinted in bibl. 54, 176. Published in French in bibl. 175; in Dutch in bibl. 176; in Danish in *Aarstiderne* (Copenhagen), November 1951, pp. 21–25.

5 [Interview by Storm de Hirsch.] *Intro Bulletin*, October 1955, pp. 1, 3.

6 "Is today's artist with or against the past?" *Art News* (New York), Summer 1958, pp. 27, 56.
Interview by T. B. Hess.

7 [Film script.] In *Sketchbook No. 1: Three Americans*. New York: Time, 1960, pp. 1–20.
Written by M. C. Sonnabend; produced and directed by Robert Snyder.

8 "Content is a glimpse...," *Location* (New York), Spring 1963, pp. 45–53.
Excerpts from B.B.C. interview by David Sylvester. Broadcast December 30, 1960.

See also bibl. 15, 21, 50, 51, 109, 142, 164.

MONOGRAPHS

9 Hess, Thomas B. *De Kooning: Recent Paintings*. New York: Walker, 1967.
Issued on occasion of exhibition at M. Knoedler, New York, November 14 – December 2.

10 ———. *Willem de Kooning*. ("The Great American Artists Series") New York: George Braziller, 1959. Chron., bibl.

11 Janis, Harriet, and Blesh, Rudi. *De Kooning*. New York: Grove Press and London: Evergreen Books, 1960. Bibl.

GENERAL WORKS

12 Ashton, Dore. *The Unknown Shore: A View of Contemporary Art*. Boston and Toronto: Little, Brown, 1962.

13 BARR, ALFRED H., JR. (ed.). *Masters of Modern Art.* 3rd ed. rev. New York: The Museum of Modern Art, 1958.

BAUR, JOHN I. H., see bibl. 23.

14 BAYL, FRIEDRICH. *Bilder unserer Tage.* Cologne: DuMont Schauberg, 1960.

BLESH, RUDI, see bibl. 35.

15 CELENTANO, FRANCIS. "The Origins and Development of Abstract Expressionism in the United States." Unpublished M.A. thesis, New York University, New York, 1957.
 Includes statement by the artist dated November 16, 1955.

16 CUMMINGS, PAUL. *A Dictionary of Contemporary American Artists.* New York: St. Martin's Press, 1966.

17 *Current Biography Yearbook.* New York: H. W. Wilson, 1955.

18 DENBY, EDWIN. *In Public In Private.* Prairie City, Ill.: Decker, 1948.
 Includes *The Shoulder*, poem based on de Kooning's conversations and painting, *Glazier*.

19 DIEHL, GASTON. *The Moderns: A Treasury of Painting Throughout the World.* New York: Crown, 1961.

20 FELDMAN, EDMUND BURKE. *Art as Image and Idea.* Englewood Cliffs, N. J.: Prentice-Hall, 1967.

FLIEGEL, NORRIS, see bibl. 55.

21 FRIEDMAN, B. H. *School of New York: Some Younger Artists.* New York: Grove Press, 1959.
 Statement by the artist.

22 GELDZAHLER, HENRY. *American Painting in the Twentieth Century.* New York: The Metropolitan Museum of Art, 1965.

GOLDMAN, MARVIN, see bibl. 27.

23 GOODRICH, LLOYD, and BAUR, JOHN I. H. *American Art of Our Century.* New York: Frederick A. Praeger, 1961.

24 GREENBERG, CLEMENT. *Art and Culture: Critical Essays.* Boston: Beacon Press, 1961.
 Includes re-edited version of bibl. 87.

25 GRÜNIGEN, B. VON. *Vom Impressionismus zum Tachismus.* Basel: Birkhauser, 1964.

26 HAFTMANN, WERNER. *Painting in the Twentieth Century.* 2 vols. New York: Frederick A. Praeger, 1961.
 Translated from German eds. (Munich: Prestel Verlag, 1954–1955; rev. ed., 1957).

27 HANTMAN, SIDNEY, GOLDMAN, MARVIN, and SANDLER, IRVING. [Documentary film on de Kooning.] One reel, April 1956. Undistributed.

28 HENNING, EDWARD B. *Fifty Years of Modern Art, 1916–1966.* Cleveland: Cleveland Museum of Art, 1966.
 Book edition of exhibition catalogue.

29 ——. *Paths of Abstract Art.* Cleveland: Cleveland Museum of Art, 1960.

30 HESS, THOMAS B. *Abstract Painting: Background and American Phase.* New York: Viking, 1951.

31 HUNTER, SAM. "American Art since 1945." In *New Art Around the World: Painting and Sculpture.* New York: Harry N. Abrams, 1966, pp. 9–58.

32 ——. *Modern American Painting and Sculpture.* New York: Dell, 1959.

33 ——. "USA." In *Art Since 1945.* New York: Harry N. Abrams, 1958, pp. 283–332.

34 HUYGHE, RENÉ (ed.). *Larousse Encyclopedia of Modern Art.* New York: Prometheus Press, 1965.
 Translated from *L'art et l'homme*, Paris: Librairie Larousse, 1961.

35 JANIS, HARRIET, and BLESH, RUDI. *Collage: Personalities, Concepts, Techniques.* Philadelphia and New York: Chilton, 1962.

36 JANIS, SIDNEY. *Abstract and Surrealist Art in America.* New York: Reynal & Hitchcock, 1944.

37 JANIS, SIDNEY, GALLERY. [Scrapbooks of press notices.] New York, 1953–1963.

38 KOZLOFF, MAX. "The Impact of de Kooning." In *Arts Yearbook 7*. New York: Arts Magazine, 1964, pp. 77–88.

39 ——. "The New American Painting". In KOSTELANETZ, R. (ed.). *The New American Arts*. New York: Horizon, 1965, pp. 88–116.

40 LARKIN, OLIVER W. *Art and Life in America*. rev. ed. New York: Holt, Rinehart and Winston, 1960.

41 McDARRAH, FRED W. *The Artist's World in Pictures*. New York: Dutton, 1961.
 Introduction by T. B. Hess.

42 MENDELOWITZ, DANIEL M. *A History of American Art*. New York: Holt, Rinehart and Winston, 1960.

43 *Metro. International Directory of Contemporary Art, 1964*. Milan: Editoriale Metro, 1964.
 Brief text in French, Italian, and English.

44 MURRAY, PETER, and LINDA. *Dictionary of Art and Artists*. London: Thames and Hudson, 1965.

45 NORDNESS, LEE (ed.). *Art:USA:Now*. Vol. 1. New York: Viking, 1963.
 Introduction by Allen S. Weller; text by Daniel Abramson.

46 O'HARA, FRANK. "Ode to Willem de Kooning," *Odes*. New York: Tiber Press, 1960.
 Reprinted in *Metro* (Milan), No. 3, 1961, pp. 18–21; *In Memory of My Feelings*. Bill Berkson (ed.). New York: The Museum of Modern Art, 1967.

47 PELLEGRINI, ALDO. *New Tendencies in Art*. New York: Crown, 1966.

48 *The Picture Encyclopaedia of Art*. London: Thames and Hudson, 1958.

49 PONENTE, NELLO, *Modern Painting: Contemporary Trends*. Lausanne: Albert Skira, 1960.

50 PROTTER, ERIC (ed.). *Painters on Painting*. New York: Grosset and Dunlap, 1963.
 Two extracts, dated 1951 and 1956.

51 RODMAN, SELDEN. *Conservations with Artists*. New York: Devin-Adair, 1957.

Describes the artist's studio. Reviewed by Herman Cherry, "U.S. art confidential," *Art News* (New York), April 1957, pp. 36–37, 61–62.

52 ——. *The Insiders*. Baton Rouge: Lousiana State University Press, 1960.

53 ROSE, BARBARA, *American Art Since 1900: A Critical History*. New York and Washington: Frederick A. Praeger, 1967.

54 —— (ed.). *Readings in American Art Since 1900: A Documentary Survey*. New York and Washington: Frederick A. Praeger, 1968.

55 ROSENBERG, BERNARD, and FLIEGEL, NORRIS. *The Vanguard Artist: Portrait and Self-Portrait*. Chicago: Quadrangle, 1965.

56 ROSENBERG, HAROLD. *The Anxious Object: Art Today and Its Audience*. New York: Horizon, 1964.
 Reprints bibl. 114, 115.

57 ——. *The Tradition of the New*. New York: Horizon, 1959.
 SANDLER, IRVING, see bibl. 27.

58 SEDGWICK, JOHN P., JR. *Discovering Modern Art*. New York: Random House, 1966.

59 SEITZ, WILLIAM C. "Abstract Expressionist Painting in America." Unpublished Ph.D. dissertation, Princeton University, Princeton, N. J., 1955.

60 SEUPHOR, MICHEL, *Abstract Painting*. New York: Harry N. Abrams, 1961.

61 ——. *Dictionary of Abstract Painting*. New York: Paris Book Center, 1957.
 Translated from French edition (Paris: Hazan, 1957).

62 SOBY, JAMES THRALL. "Willem de Kooning." In BAUR, JOHN I. H. (ed.). *New Art in America*. Greenwich, Conn.: New York Graphic Society and New York: Frederick A. Praeger, 1957, pp. 232–235.

63 SYLVESTER, David. *Modern Art: From Fauvism to Abstract Expressionism*. New York: Franklin Watts, 1965.

64 ———. *Ten Modern Artists: An Introduction to Twentieth-Century Painting and Sculpture*. London: British Broadcasting Corporation, 1964.

65 TUCHMAN, MAURICE. *Van Gogh and Expressionism* New York: The Solomon R. Guggenheim Museum, 1964.

66 *21 Etchings and Poems*. New York: Morris Gallery, 1960.

 Limited portfolio edition of 50 copies; includes de Kooning etching for Harold Rosenberg poem, *Revenge*.

67 *USA: Artists*. Film produced by Lane Slate; directed by Robert Snyder, 1966.

 30 minutes. Shown on National Educational Television, July 19, 1966. Kinescope in TV Archive, The Museum of Modern Art, New York.

68 VOLLMER, HANS, *Allgemeines Lexikon der bildenden Künstler des XX. Jahrhunderts*. Vol. 3. Leipzig: E. A. Seeman Verlag, 1956.

69 WESTON, NEVILLE, *Kaleidoscope of Modern Art*. London: George G. Harrap, 1968.

70 WRIGHT, CLIFFORD. *Helten i den nye verden*. Copenhagen: Borgens Forlag, 1963.

 Danish text on American art.

ARTICLES AND REVIEWS

71 ALLOWAY, LAWRENCE. "Iconography Wreckers and Maenad Hunters," *Art International* (Zurich), April 1961, pp. 32–34, 47.

 Includes review of bibl. 10.

72 ———. "Sign and Surface: Notes on Black and White Painting in New York," *Quadrum* (Brussels), No. 9, 1960, pp. 49–62.

73 A[RB], R[ENÉE]. "Spotlight on: de Kooning," *Art News* (New York), April 1948, p. 33.

74 ARMSTRONG, RICHARD. "Abstract Expressionism Was an American Revolution," *Canadian Art* (Ottawa), September–October 1964, pp. 262–265.

 Revised version of "The American Revolution," *USA-1*, May 1962.

75 ASHTON, DORE. "New York Commentary: de Kooning's Verve," *Studio* (London), June 1962, pp. 216–217, 224.

76 ———. "Perspective de la peinture américaine," *Cahiers d'Art* (Paris), No. 33–35, 1960, pp. 203–220.

77 ———. "Willem de Kooning," *Paletten* (Stockholm), No. 3, 1961, pp. 94–97.

78 BARR, ALFRED H., JR. "7 Americans Open in Venice. De Kooning," *Art News* (New York), June 1950, pp. 22–23, 60.

 Reprint of text for XXV Biennale catalogue (see bibl. 129).

79 BATTCOCK, GREGORY. "Willem de Kooning," *Arts Magazine* (New York), November 1967, pp. 34–37.

80 "Big Splash," *Time* (New York), May 18, 1959, p. 72.

81 DENBY, EDWIN. "My Friend De Kooning," *Art News Annual*, No. XXIX, November 1963, pp. 82–99.

 Unabridged version in Denby's *Dancers, Buildings and People in the Streets*, New York: Horizon, 1965.

82 FINKLESTEIN, LOUIS. "The Light of de Kooning," *Art News* (New York), November 1967, pp. 28–31, 70–71.

83 ———. "Marin and de Kooning," *Magazine of Art* (Washington), October 1950, pp. 202–206.

84 GOLDWATER, ROBERT. "Masters of the New," *Partisan Review* (Brunswick, N. J.), Summer 1962, pp. 416–418.

85 ———. "Reflections on the New York School," *Quadrum* (Brussels), No. 8, 1960, pp. 17–36.

86 GREENBERG, CLEMENT. "After Abstract Expressionism," *Art International* (Zurich), October 1962, pp. 24–32.

87 ———. "'American-Type' Painting," *Partisan Review* (Brunswick, N. J.), Spring 1955, pp. 179–196.

 Reprinted in revised form in bibl. 24.

88 ——. "New York Painting Only Yesterday," *Art News* (New York), Summer 1957, pp. 38–39, 84–86.
Review of exhibition at Poindexter Gallery (see bibl. 137).

89 ——. "Poetry of Vision," *Artforum* (New York), April 1968, p. 18.
Review of exhibition at National Museum, Dublin.

90 HAMMACHER, A. M. "Mondrian and de Kooning: A Contrast in Transformation," *Delta* (Amsterdam), September 1959, pp. 67–71.

91 HARTFORD, HUNTINGTON. "The Public be Damned?" *New York Times*, May 16, 1955, p. 48.
Originally published in *American Mercury* (Los Angeles); Reprinted in Hartford's *Art or Anarchy*? Garden City, N. Y.: Doubleday, 1964.

92 HELLER, BEN. "The Roots of Abstract Expressionism," *Art in America* (New York), No. 4, 1961, pp. 40–49.

93 HESS, THOMAS B. "De Kooning Paints a Picture," *Art News* (New York), March 1953, pp. 30–33, 64–67.

94 ——. "De Kooning's New Women," *Art News* (New York), March 1965, pp. 36–38, 63–65.

95 ——. "Introduction to Abstract," *Art News Annual*, No. XX, 1950–1951, pp. 127–158, 186–187.

96 ——. "Willem de Kooning," *Art News* (New York) March 1962, pp. 40–51, 60–61.
Review of exhibition at the Sidney Janis Gallery (see bibl. 148).

97 "How They Got that Way," *Time* (New York), April 13, 1962, pp. 94–99.
Review of exhibition at the Wadsworth Atheneum (see bibl. 149).

98 HUNTER, SAM. "Abstract Expressionism Then – and Now," *Canadian Art* (Ottawa), No. 93, September – October 1964, pp. 266–269.

99 HUTCHINSON, PETER. "Willem de Kooning: The Painter in Times of Changing Belief," *Program Guide 13* (Channel 13, WNDT, New York), November 1967, pp. 36–40.

100 KOZLOFF, MAX. "The Critical Reception of Abstract-Expressionism," *Arts Magazine* (New York), December 1965, pp. 27–32.

101 ——. "New York Letter," *Art International* (Zurich), May 1962, pp. 75–83.

102 KRAMER, HILTON, "Critics of American Painting," *Arts Magazine* (New York), October 1959, pp. 26–31.

103 KRAUSS, ROSALIND. "The New de Koonings," *Artforum* (New York), January 1968, pp. 44–47.

104 KROLL, JACK. "American Painting and the Convertible Spiral," *Art News* (New York), November 1961, pp. 34–37, 66–68.
Review of exhibition at the Guggenheim Museum (see bibl. 145).

105 LINDE, ULF. "Rosenberg och action painting," *Konstrevy* (Stockholm), No. 5–6, 1960, pp. 204–207.

106 "Living Art and the People's Choice," *Horizon* (New York), September 1958, pp. 108–113.

107 McMULLEN, ROY. "L'école de New York: des concurrents dangereux," *Connaissance des Arts* (Paris), September 1961, pp. 30–37.

108 NAMUTH, HANS. "Willem de Kooning, East Hampton, Spring 1964," *Location* (New York), Summer 1964, pp. 27–34.
Photographic essay.

109 O'DOHERTY, BRIAN. "De Kooning: Grand Style," *Newsweek* (New York), January 4, 1965, pp. 56–57.

110 "Prisoner of the Seraglio," *Time* (New York), February 26, 1965, pp. 74–75.

111 "Recent Acquisitions," *City Art Museum of Saint Louis Bulletin*, September – October 1966, pp. 4–5, 10.

112 ROSENBERG, HAROLD. "Action Painting: A Decade of Distortion," *Art News* (New York), December 1962, pp. 42–44, 62–63.

113 ——. "Art of Bad Conscience," *New Yorker*, December 16, 1967, pp. 138–149.

114 ——. "De Kooning," *Vogue* (New York), September 15, 1964, pp. 146–149.
 Reprinted in bibl. 56.

115 ——. "Painting is a Way of Living," *New Yorker*, February 16, 1963, pp. 126, 128, 130–137.
 Reprinted in bibl. 56.

116 ——. "Tenth Street: A Geography of Modern Art." *Art News Annual*, No. XXVIII, 1959, pp. 120–143, 184–192.

117 RUBIN, WILLIAM. "Arshile Gorky, Surrealism and the New American Painting," *Art International* (Zurich), February 1963, pp. 27–38.

118 SAWYER, KENNETH B. "A Backyard on Tenth Street," *Baltimore Museum of Art News*, December 1956, pp. 3–7.

119 ——. "Three Phases of Willem de Kooning," *Art News and Review* (London), November 22, 1958, pp. 4, 16.

120 SEIBERLING, DOROTHY. "The Varied Art of Four Pioneers," *Life* (Chicago), November 16, 1959, pp. 80–81.
 Part II of series on Abstract Expressionism.

121 STEINBERG, LEO. "Month in Review," *Arts Magazine* (New York), November 1955, pp. 46–47.

122 "Talk of the Town," *New Yorker*, April 18, 1959, p. 34.
 Quotes the artist.

123 TALPHIR, GABRIEL. "Modern Art in U.S.A.," *Gazith* (Tel Aviv), No. 200, December 1959 – March 1960.
 Hebrew text; summary in English pp. 1–2.

124 TONO, YOSHIAKI. "De Kooning's Metamorphosis of 'Woman,'" *Mizue* (Tokyo), No. 679, November 1961, pp. 56–62.
 Japanese text; summary in English.

125 ——. "Willem de Kooning," *Mizue* (Tokyo), No. 676, August 1961, pp. 1–18.
 Japanese text; summary in English.

126 "William DeKooning," *Magazine of Art* (Washington), February 1948, p. 54.

EXHIBITION CATALOGUES

(arranged chronologically)

127 NEW YORK. THE MUSEUM OF MODERN ART. *New Horizons in American Art*. September 14–October 16, 1936. 1 work.
 Introduction by Holger Cahill.

128 NEW YORK. WORLD'S FAIR 1939. *Painting and Sculpture in the World of Tomorrow*. Summer – Fall 1939. 1 work. Biog.

129 VENICE. XXV BIENNALE. *Catalogo*. 1950, pp. 383–386.
 Text in Italian. Comment by Alfred H. Barr, Jr.; reprinted in English in bibl. 78.

130 NEW YORK. THE MUSEUM OF MODERN ART. *Abstract Painting and Sculpture in America*. January 23 – March 25, 1951. 2 works.
 Text by Andrew Carnduff Ritchie.

131 CHICAGO. ARTS CLUB OF CHICAGO. *Exhibition: Ben Shahn, Willem de Kooning, Jackson Pollock*. October 2–27, 1951. 14 works.

132 CHICAGO. ART INSTITUTE. *60th Annual of American Painting and Sculpture*. 1951.
 Excavation won First Prize and Logan Medal.

133 BOSTON. MUSEUM SCHOOL. [*De Kooning Retrospective*]. April 21 – May 8, 1953. 20 works.
 Foreword by Clement Greenberg. Exhibition also shown at Workshop Art Center, Washington, D. C. (June 13 – July 3).

134 NEW YORK. THE SOLOMON R. GUGGENHEIM MUSEUM. *Younger American Painters*. May 12 – July 25, 1954. 1 work. Biog.

135 VENICE. XXVII BIENNALE. AMERICAN PAVILION. *2 Pittori: de Kooning, Shahn. 3 Scultori: Lachaise, Lassaw, Smith*. June 1954. 26 works.
 Text in Italian and English. Comment by A. C. Ritchie; statement by the artist, from bibl. 4; biog. Exhibition organized by The Museum of Modern Art, New York.

156

136 NEW YORK. MARTHA JACKSON GALLERY. *De Kooning.* November 9 – December 3, 1955. 21 works.

137 NEW YORK. POINDEXTER GALLERY. *The 30's: Painting in New York.* June 3–29, 1957.
Edited by Patricia Passloff. Memoir by Edwin Denby. Reviewed in bibl. 88.

138 NEW YORK. WHITNEY MUSEUM OF AMERICAN ART. *Nature in Abstraction.* January 14 – March 16, 1958.
Introduction by I. H. Baur. Biog.

139 LONDON. INSTITUTE OF CONTEMPORARY ARTS. *Some Paintings from the E. J. Power Collection.* March 13 – April 19, 1958.
Text by Lawrence Alloway.

140 NEW YORK. WHITNEY MUSEUM OF AMERICAN ART. *The Museum and Its Friends.* March 5 – April 12, 1959.
Statement by the artist, from bibl. 4. Biog.

141 NEW YORK. THE MUSEUM OF MODERN ART. International Council. *The New American Painting As Shown in Eight European Countries, 1958–1959.* May 28 – September 8, 1959.
Introduction by Alfred H. Barr, Jr. Biog. Circulated in Europe; variant catalogues issued.

142 NEW YORK. THE MUSEUM OF MODERN ART. *New Images of Man.* September 30 – November 29, 1959. 5 works.
Text by Peter Selz; statement by the artist. Biog., bibl.

143 BEVERLY HILLS. PAUL KANTOR GALLERY. *William de Kooning.* April 3–29, 1961.
Text by Clifford Odets.

144 SARASOTA, FLA. JOHN AND MABLE RINGLING MUSEUM OF ART. *The Sidney Janis Painters.* April 8 – May 7, 1961. 2 works.
Catalogue issued as museum bulletin (vol. 1, no. 3, April 1961). Texts by Kenneth Donahue and Dore Ashton. Chron., bibl.

145 NEW YORK. THE SOLOMON R. GUGGENHEIM MUSEUM. *American Abstract Expressionists and Imagists.* October – December 1961. 1 work.
Introduction by H. H. Arnason. Biog., bibl. Reviewed in bibl. 104.

146 NEW YORK. THE MUSEUM OF MODERN ART. *The Art of Assemblage.* October 2 – November 12, 1961. 2 works.
Text by William C. Seitz. Exhibition also shown in Dallas (January 9 – February 11, 1962) and San Francisco (March 5 – April 15, 1962).

147 LONDON. AMERICAN EMBASSY. U.S.I.S. GALLERY. *Vanguard American Painting.* February 28 – March 30, 1962. 3 works.
Introduction by H. H. Arnason.

148 NEW YORK. SIDNEY JANIS GALLERY. *Recent Paintings by Willem de Kooning.* March 5 – 31, 1962. 41 works.
Introduction by T. B. Hess. Reviewed in bibl. 96. (For exhibitions held in 1953, 1956, and 1959, no catalogues were issued.)

149 HARTFORD. WADSWORTH ATHENEUM. *Continuity and Change.* April 12 – May 27, 1962. 4 works. Biog. Reviewed in bibl. 97.

150 SEATTLE. WORLD'S FAIR 1962. *Art Since 1950.* April 21 – October 21, 1962.
American section later shown at Rose Art Museum, Brandeis University.

151 AMSTERDAM. STEDELIJK MUSEUM. *Nederlands bijdrage: tot de internationale ontwikkeling sedert 1945.* June 29 – September 17, 1962. 9 works.
Exhibition later shown in Montreal (October 5 – November 4) and Ottawa (November 15 – December 31).

152 MILWAUKEE. MILWAUKEE ART CENTER. *Art: USA: The Johnson Collection of Contemporary American Painting.* September 20 – October 21, 1962. 1 work.
Text by Lee Nordness (see also bibl. 45). Exhibition circulated for two years in eighteen cities.

153 NEW YORK. ALLAN STONE GALLERY. *De Kooning*

—*Newman*. October 23 – November 17, 1962. 15 works.

Comment by Allan Stone.

154 NEW YORK. SIDNEY JANIS GALLERY. *11 Abstract Expressionist Painters*. October 7 – November 2, 1963. 2 works.

155 NEW YORK. THE SOLOMON R. GUGGENHEIM MUSEUM. *Guggenheim International Award*. January – March 1964. 1 work.

Introduction by Lawrence Alloway. Bibl.

156 BUFFALO. JAMES GOODMAN GALLERY. *"Woman" Drawings by Willem de Kooning*. January 10–25, 1964.

Preface by Merle Goodman.

157 NEW YORK. ALLAN STONE GALLERY. *Willem de Kooning Retrospective: Drawings 1936–1963*. February 1–29, 1964.

158 ST. LOUIS. CITY ART MUSEUM. *200 Years of American Painting*. April 1 – May 31, 1964.

Introduction by M. C. Rueppel.

159 LONDON. TATE GALLERY. *Painting & Sculpture of a Decade: 54-64*. April 22 – June 28, 1964. 5 works.

160 CAMBRIDGE, MASS. HARVARD UNIVERSITY. FOGG MUSEUM. *Within the Easel Convention: Sources of Abstract Expressionism*. May 7 – June 7, 1964.

Text on de Kooning by Rosalind Krauss.

161 NEW YORK. THE SOLOMON R. GUGGENHEIM MUSEUM. *American Drawings*. September – October 1964. 4 works.

Introduction by Lawrence Alloway. Bibl.

162 BEVERLY HILLS. PAUL KANTOR GALLERY. *Willem de Kooning*. March 22 – April 30, 1965.

Preface by William Inge.

163 NORTHAMPTON, MASS. SMITH COLLEGE MUSEUM OF ART. *Willem de Kooning*. April 8 – May 2, 1965.

Text by Dore Ashton. Reprints bibl. 3. Chron., bibl. Exhibition also shown at Massachusetts Institute of Technology (May 10 – June 16).

164 LOS ANGELES. COUNTY MUSEUM OF ART. *New York School. The First Generation. Paintings of the 1940s and 1950s*. July 16 – August 1, 1965.

Edited by Maurice Tuchman. Statements by the artist. Bibl.

165 AUSTIN. UNIVERSITY OF TEXAS. *Drawings &*. February 6 – March 15, 1966. 4 works.

Text by D. B. Goodall and M. Matter. Biog.

166 RIDGEFIELD, CONN. LARRY ALDRICH MUSEUM. *Selections from the John G. Powers Collection*. September 25 – December 11, 1966. 21 works.

167 HOUSTON. UNIVERSITY OF ST. THOMAS. *Six Painters*. February – April 1967. 8 works.

Texts by T. B. Hess and Morton Feldman.

168 URBANA. UNIVERSITY OF ILLINOIS. *Contemporary American Painting and Sculpture 1967*. March 5 – April 9, 1967.

Introduction by Allen S. Weller. Biog.

169 IRVINE. UNIVERSITY OF CALIFORNIA. *Selection of 19th and 20th Century Works from the Hunt Foods and Industries Museum of Art Collection*. March 7 – 22, 1967. 1 work.

Text by Marc H. Muller. Exhibition later shown at University of California, Riverside and Fine Arts Gallery, San Diego.

170 VICTORIA, AUSTRALIA. NATIONAL GALLERY. *Two Decades of American Painting*. June 6 – July 9, 1967. 3 works.

Essays by Irving Sandler, Lucy Lippard, Gene Swenson. Exhibition organized by the International Council of The Museum of Modern Art, New York; also shown in Tokyo (October 15 – November 27, 1966), Kyoto (December 10, 1966 – January 22, 1967), New Delhi (March 28 – April 26, 1967), New South Wales (July 26 – August 20, 1967). Variant catalogues issued: Japanese version contains insert with essays in English; Indian publication in English

171 BERKELEY. UNIVERSITY OF CALIFORNIA. ART MUSEUM. *Selection 1967: Recent Acquisitions in Modern Art*. June 20 – September 10, 1967.

Critique by Susan King. Biog.

172 PARIS. M. KNOEDLER & CIE, *Six peintres améri-cains: Gorky, Kline, de Kooning, Newman, Pollock, Rothko*. October 1967. 2 works.

173 FRANKFORT. FRANKFURTER KUNSTVEREIN. *Kompass New York*. December 30, 1967 – February 11, 1968. 2 works.
 Introduction by Jean Leering, in German and English. Biog. Exhibition organized by the Van Abbe Museum, Eindhoven, The Netherlands, and the Museum of Krefeld, Germany.

174 LONDON. INSTITUTE OF CONTEMPORARY ARTS. *The Obsessive Image, 1960–1968*. April 10 – May 29, 1968. 2 works.
 Introduction by Mario Amaya.

175 PARIS. M. KNOEDLER & CIE. *de Kooning: peintures récentes*. June 4 – 29, 1968. 56 works.
 Texts in French from bibl. 3, 4, 9.

176 AMSTERDAM. STEDELIJK MUSEUM. *Willem de Kooning*. September 19 – November 17, 1968. 134 works.
 Introduction by T. B. Hess. Statements by the artist, from bibl. 3,4. Texts in Dutch and English. Exhibition also shown at the Tate Gallery, London (December 5, 1968 – January 26, 1969); The Museum of Modern Art, New York (March 6 – April 27, 1969); the Art Institute of Chicago (May 17 – July 6, 1969); Los Angeles County Museum of Art (July 29 – September 14, 1969).

Catalogue of the Exhibition

Dimensions are given in feet and inches, height preceding width. For drawings, pastels, and collages, sheet size is given; composition size (comp.) is also given in some cases. A date is enclosed in parentheses when it does not appear on the work. A picture not included in all showings of the exhibition has the notation (A), (L), (NY), (C), or (LA), indicating that it is shown in Amsterdam, London, New York, Chicago, or Los Angeles.

SCHEDULE OF THE EXHIBITION

Stedelijk Museum, Amsterdam
September 19 – November 17, 1968

The Tate Gallery, London
December 5, 1968 – January 26, 1969

The Museum of Modern Art, New York
March 6 – April 27, 1969

The Art Institute of Chicago
May 17 – July 6, 1969

Los Angeles County Museum of Art
July 29 – September 14, 1969

PAINTINGS (listed by categories)

EARLY ABSTRACTIONS

1 Untitled. (*ca.* 1934). Oil on canvas, $36 \times 45^1/_8$ inches. Collection John Becker, London. Ill. p. 27

2 *Abstract Still Life*. (*ca.* 1938). Oil on canvas, 30×36 inches. Collection Mr. and Mrs. Daniel Brustlein, Paris. Ill. p. 28

3 *Pink Landscape*. (*ca.* 1938). Oil on composition board, 24×36 inches. Collection Mr. and Mrs. Reuben Tam, New York. Ill. p. 28

4 *Elegy*. (*ca.* 1939). Oil and charcoal on composition board, $40^1/_4 \times 47^7/_8$ inches. Private collection. Courtesy Pasadena Art Museum. Ill. p. 29

5 Untitled. (1941–1942). Oil on paper, $5^5/_8 \times 7^3/_8$ inches. Allan Stone Gallery, New York. Ill. p. 30

6 Untitled (*Matchbook*). (*ca.* 1942). Oil and pencil on paper, $5^1/_2 \times 7^1/_2$ inches. Collection Mr. and Mrs. Stephen D. Paine, Boston. Ill. p. 30

7 Untitled. (1943). Oil on composition board, $31^1/_4 \times 53^1/_2$ inches. Collection Mr. and Mrs. Frederick R. Weisman, Beverly Hills, California. (NY, C, LA)

8 Untitled. (*ca.* 1944). Oil and charcoal on paper, mounted on composition board, $13^1/_2 \times 21^1/_4$ inches. Collection Mr. and Mrs. Lee V. Eastman, New York. Ill. p. 31

EARLY FIGURES (MEN) 1938–1942

9 *Two Men Standing*. (*ca.* 1938). Oil on canvas, $61^1/_8 \times 45^1/_8$ inches. Private collection. Ill. p. 32

10 *Man*. (*ca.* 1939). Oil on paper, mounted on composition board, $11^1/_4 \times 9^3/_4$ inches. Private collection. Ill. p. 33

11 *Glazier*. (*ca.* 1940). Oil on canvas, 54×44 inches. Private collection. Ill. p. 34

12 *Seated Figure (Classic Male)*. (*ca.* 1940). Oil and charcoal on plywood, $54^3/_8 \times 36$ inches. Private collection. Ill. p. 35

13 *Standing Man*. (*ca.* 1942). Oil on canvas, $41^1/_8 \times 34^1/_8$ inches. Wadsworth Atheneum, Hartford. The Ella Gallup Sumner and Mary Catlin Sumner Collection. Ill. p. 19

EARLY FIGURES (WOMEN) 1940–1944

14 *Seated Woman.* (*ca.* 1940). Oil and charcoal on composition board, 54 × 36 inches. Collection Mrs. Albert M. Greenfield, Philadelphia. Ill. p. 38

15 *Woman Sitting.* (1943–1944). Oil and charcoal on composition board, 48$^1/_4$ × 42 inches. Collection Mr. and Mrs. Daniel Brustlein, Paris. Ill. p. 40

16 *Queen of Hearts.* (1943–1946). Oil and charcoal on composition board, 46 × 27$^1/_2$ inches. Joseph H. Hirshhorn Foundation. Ill. p. 41

17 *Woman.* (*ca.* 1944). Oil and charcoal on canvas, 46 × 32 inches. Private collection. (A, L, NY). Ill. p. 43

18 *Pink Lady.* (*ca.* 1944). Oil and charcoal on composition board, 48$^3/_8$ × 35$^5/_8$ inches. Collection Mr. and Mrs. Stanley K. Sheinbaum, Santa Barbara, California. Ill. p. 42

ABSTRACTIONS 1945–1950

19 *Pink Angels.* (*ca.* 1945). Oil and charcoal on canvas, 52 × 40 inches. Collection Mr. and Mrs. Frederick R. Weisman, Beverly Hills, California. Ill. p. 52

20 Study for backdrop (*Labyrinth*). (1946). Oil and charcoal on paper, 22$^1/_8$ × 28$^1/_2$ inches. Private collection. Ill. p. 49

21 Backdrop for *Labyrinth*. (1946). Calcimine and charcoal on canvas, 16 feet 10 inches × 17 feet. Allan Stone Gallery, New York. (NY, C, LA). Ill. p. 48

22 *Special Delivery.* 1946. Oil, enamel, and charcoal on cardboard, 23$^3/_8$ × 30 inches. Joseph H. Hirshhorn Foundation

23 *Light in August.* (*ca.* 1946). Oil and enamel on paper, mounted on canvas, 55 × 41$^1/_2$ inches. Collection Elise C. Dixon, Scottsdale, Arizona. Ill. p. 54

24 *Valentine.* (1947). Oil and enamel on paper, mounted on composition board, 36$^3/_8$ × 24$^1/_4$ inches.

Collection Mr. and Mrs. Gifford Phillips, Santa Monica, California

25 *Orestes.* (1947). Enamel on paper, mounted on plywood, 24$^1/_8$ × 36$^1/_8$ inches. Collection Ruth Stephan Franklin, New York. Ill. p. 56

26 *Black Friday.* (1948). Enamel and oil on composition board, 48 × 38 inches. Collection Mrs. H. Gates Lloyd, Haverford, Pennsylvania. Ill. p. 55

27 *Dark Pond.* (1948). Enamel on composition board, 46$^3/_4$ × 55$^3/_4$ inches. Collection Mr. and Mrs. Richard L. Weisman, New York. Ill. p. 59

28 *Painting.* (1948). Enamel and oil on canvas, 42$^5/_8$ × 56$^1/_8$ inches. The Museum of Modern Art, New York. Purchase. Ill. p. 57

29 Untitled. (1948). Enamel and oil on paper, mounted on composition board, 30 × 40 inches. Collection Mr. and Mrs. Thomas B. Hess, New York. Ill. p. 60

30 Untitled ("*D*"). (*ca.* 1946–1948). Oil on paper, 14 × 11$^1/_2$ inches. Collection Mr. and Mrs. David M. Solinger, New York. (NY)

31 Untitled. (1948). Oil and enamel on paper, 13$^1/_2$ × 12 inches. Collection Carol Bettman Lazar, New York

32 *Secretary.* (1948). Oil and charcoal on composition board, 24$^1/_2$ × 36$^1/_2$ inches. Joseph H. Hirshhorn Collection

33 *Mailbox.* (1948). Oil, enamel, and charcoal on paper, mounted on cardboard, 23$^1/_4$ × 30 inches. Collection Nelson A. Rockefeller, New York. (A, L, NY). Ill. p. 63

34 *Town Square.* (1948). Oil and enamel on paper, mounted on compositon board, 17$^3/_8$ × 23$^3/_4$ inches. Collection Mr. and Mrs. Ben Heller, New York. Ill. p. 62

35 Untitled. (1948). Oil and enamel on paper, 18$^7/_8$ × 23 inches. Collection Mary Abbott, New York. Ill. p. 62

36 *Night Square.* (*ca.* 1949). Enamel on cardboard, mounted on composition board, 30×40 inches. Collection Martha Jackson, New York. Ill. p. 58

37 *Attic Study.* (1949). Oil and enamel on buff paper, mounted on composition board, $18^7/_8 \times 23^7/_8$ inches. D. and J. de Menil Collection. Ill. p. 64

38 *Attic.* (1949). Oil on canvas, $61^3/_8 \times 80^1/_4$ inches. Collection Muriel Newman, Chicago. Ill. p. 65, detail p. 77

39 *Asheville.* (1949). Oil and enamel on cardboard, mounted on composition board, $25^5/_8 \times 32$ inches. The Phillips Collection, Washington, D.C. Ill. p. 68

40 *Warehouse Manikins.* (1949). Oil and enamel on buff paper, mounted on cardboard, $24^1/_4 \times 34^5/_8$ inches. Collection Mr. and Mrs. Bagley Wright, Seattle, Washington. Ill. p. 67

41 *Collage.* (1950). Oil, enamel, and metal (thumbtacks) on cut papers, 22×30 inches. Collection Mr. and Mrs. David M. Solinger, New York. (A, L, NY). Ill. p. 69

42 *Painting.* (*ca.* 1950). Oil and enamel on cardboard, mounted on composition board, $30^1/_8 \times 40$ inches. Collection Mrs. H. Gates Lloyd, Haverford, Pennsylvania. Frontispiece

43 *Boudoir.* (1950). Oil and enamel on paper, $15 \times 20^3/_4$ inches. Collection Mr. and Mrs. Allan Stone, New York. Ill. p. 66

44 Untitled (*Woman, Wind, and Window*). (1950). Oil and enamel on paper, $16^1/_2 \times 20$ inches. Collection Alfonso A. Ossorio, East Hampton, New York. Ill. p. 66

45 *Woman, Wind, and Window.* (1950). Oil and enamel on buff paper, mounted on composition board, $24^1/_8 \times 36$ inches. Collection Mr. and Mrs. Ben Heller, New York. Ill. p. 67

46 *Excavation.* (1950). Oil and enamel on canvas, 6 feet $8^1/_8$ inches × 8 feet $4^1/_8$ inches. The Art Institute of Chicago. Mr. and Mrs. Frank G. Logan Purchase Prize; Gift of Mr. Edgar Kauf- mann, Jr. and Mr. and Mrs. Noah Goldowsky. Ill. pp. 70–71

WOMEN 1947–1955

47 Untitled. (*ca.* 1947). Oil on paper, 20×16 inches. Private collection. (NY). Ill. p. 80

48 *Woman.* (*ca.* 1947). Oil on paper, mounted on composition board, $16 \times 15^1/_2$ inches. American Broadcasting Company, New York. (NY)

49 *Pink Lady* (study). (*ca.* 1948). Oil on paper, $18^1/_2 \times 18^1/_2$ inches. Collection Mr. and Mrs. Donald M. Blinken, New York. (NY). Ill. p. 80

50 *Woman.* 1948. Oil and enamel on composition board, $53^1/_2 \times 44^1/_2$ inches. Joseph H. Hirshhorn Foundation. Ill. p. 81

51 *Woman.* (1949). Oil, enamel, and charcoal on canvas, $60^1/_2 \times 47^7/_8$ inches. Collection Mr. and Mrs. Boris Leavitt, Hanover, Pennsylvania. (NY, C, LA). Ill. p. 82

52 *Two Standing Women.* (1949). Oil, charcoal, and enamel on paper, mounted on composition board, $29^1/_2 \times 26^1/_4$ inches. Norton Simon Foundation. Ill. p. 84

53 *Two Women on a Wharf.* (1949). Oil, enamel, and pencil on cut-and-pasted papers, $24^1/_4 \times 24^1/_4$ inches. Collection Edward F. Dragon, East Hampton, New York. Ill. p. 84

54 *Figure and Landscape, II.* (*ca.* 1950). Oil and enamel on cardboard, mounted on composition board, $32^3/_4 \times 15^1/_4$ inches. Joseph H. Hirshhorn Collection. Ill. p. 85

55 Study for *Woman.* (1950). Oil and enamel on paper, with pasted color photoengraving, $14^5/_8 \times 11^5/_8$ inches (sight). Collection Mr. and Mrs. Thomas B. Hess, New York. Ill. p. 83, detail p. 78

56 *Woman, I.* (1950–1952). Oil on canvas, $75^7/_8 \times 58$ inches. The Museum of Modern Art, New York. Purchase. Ill. p. 91, detail p. 90

57 *Woman, II.* (1952). Oil on canvas, 59 × 43 inches. The Museum of Modern Art, New York. Gift of Mrs. John D. Rockefeller, 3rd. Ill. p. 92

58 *Woman, IV.* (1952–1953). Oil and enamel on canvas, 59 × 46¹/₄ inches. Nelson Gallery–Atkins Museum, Kansas City, Missouri. Gift of William Inge. Ill. p. 93

59 *Woman, V.* (1952–1953). Oil on canvas, 61 × 45 inches. Collection Mrs. Arthur C. Rosenberg, Chicago. (NY, C). Ill. p. 94

60 *Woman and Bicycle.* (1952–1953). Oil, enamel, and charcoal on canvas, 76¹/₂ × 49 inches. Whitney Museum of American Art, New York. Ill. p. 96

61 *Woman, VI.* (1953). Oil and enamel on canvas, 68¹/₂ × 58¹/₂ inches. Museum of Art, Carnegie Institute, Pittsburgh. Ill. p. 95

62 *Woman.* (1953). Oil and charcoal on paper, mounted on canvas, 25¹/₂ × 19³/₄ inches. Joseph H. Hirshhorn Collection. Ill. p. 88

63 *Marilyn Monroe.* (1954). Oil on canvas, 50 × 30 inches. Collection Mr. and Mrs. Roy R. Neuberger, New York. (NY, C, LA)

64 *Two Women in the Country.* (1954). Oil, enamel, and charcoal on canvas, 46¹/₈ × 40⁷/₈ inches. Joseph H. Hirshhorn Collection. Ill. p. 98

65 *Two Women.* (1954–1955). Oil and charcoal on canvas, 40¹/₈ × 50 inches. Collection Mrs. Samuel Weiner, New York. Ill. p. 99

66 *Woman as Landscape.* (1955). Oil on canvas, 45¹/₂ × 41 inches. Private collection. (NY, C, LA). Ill. p. 104

ABSTRACTIONS 1955–1963

67 *Police Gazette.* (1954–1955). Oil, enamel, and charcoal on canvas, 43¹/₄ × 50¹/₄ inches. Collection Mr. and Mrs. Robert C. Scull, New York. Ill. p. 107

68 *Composition.* (1955). Oil, enamel, and charcoal on canvas, 79¹/₄ × 69¹/₄ inches. Solomon R. Guggenheim Museum, New York. (A, L, NY). Ill. p. 105

69 *Gotham News.* (1955–1956). Oil, enamel, and charcoal on canvas, 69¹/₂ × 79³/₄ inches. Albright-Knox Art Gallery, Buffalo. (A, L, NY). Ill. p. 108

70 *Saturday Night.* (1955–1956). Oil on canvas, 69 × 79 inches. Washington University Gallery of Art, St. Louis. (NY, C, LA). Ill. p. 106

71 *Backyard on Tenth Street.* (1956). Oil on canvas, mounted on composition board, 47⁷/₈ × 58¹/₈ inches. The Baltimore Museum of Art. Frederic Cone Fund

72 *Easter Monday.* (1956). Oil on canvas, 96¹/₄ × 73⁷/₈ inches. The Metropolitan Museum of Art, New York. Rogers Fund, 1956. Ill. p. 109

73 *The Time of the Fire.* (1956). Oil and enamel on canvas, 59¹/₄ × 79 inches. Collection Dr. and Mrs. Israel Rosen, Baltimore. (A, L, NY). Ill. p. 110

74 *Bolton Landing.* (1957). Oil on canvas, 83³/₄ × 74 inches. Inland Steel Company, Chicago. (C)

75 *July 4th.* 1957. Oil on cut-and-pasted papers, 26³/₄ × 22 inches. Collection Elaine de Kooning, New York

76 *Palisade.* (1957). Oil on canvas, 79 × 69 inches. Collection Mr. and Mrs. Milton A. Gordon, New York. (A, L, NY). Ill. p. 111

77 *Parc Rosenberg.* (1957). Oil on canvas, 80 × 70 inches. Isobel and Donald Grossman Collection, New York. (A, L, NY, C). Ill. p. 112

78 *Ruth's Zowie.* (1957). Oil on canvas, 80¹/₄ × 70¹/₈ inches. Collection Mr. and Mrs. Thomas B. Hess, New York. Ill. p. 114

79 *Suburb in Havana.* (1958). Oil on canvas, 80 × 70 inches. Collection Mr. and Mrs. Lee V. Eastman, New York. Ill. p. 113

80 *Yellow River.* (1958). Oil on canvas, 62¹/₂ × 49¹/₂ inches. Collection Mr. and Mrs. David M. Solinger, New York. (NY)

81 *Door to the River.* (1960). Oil on canvas, 80×70 inches. Whitney Museum of American Art, New York. Gift of the Friends of the Whitney Museum, and Purchase. (NY, C, LA). Ill. p. 118

82 Untitled. (1961). Oil on canvas, 80×70 inches. Collection Virginia Dwan, New York. Ill. p. 117

83 *Rosy-Fingered Dawn at Louse Point.* (1963). Oil on canvas, 80×70 inches. Stedelijk Museum, Amsterdam. Ill. p. 116

84 Untitled. (1963). Oil on canvas, 80×70 inches. Joseph H. Hirshhorn Foundation. Ill. p. 120

85 *Pastorale.* (1963). Oil on canvas, 70×80 inches. Private collection. Ill. p. 121

FIGURES 1961–1967

86 *Woman, I.* (1961). Oil on paper, with pasted color photoengraving, mounted on canvas, 29×22³/₈ inches. Private collection. Ill. p. 119

87 *Woman, VIII.* (1961). Oil on paper, 29×22³/₈ inches. National Collection of Fine Arts, Smithsonian Institution, Washington, D.C. Ill. p. 119

88 *Clam Diggers.* (1964). Oil on paper, mounted on composition board, 20¹/₄×14¹/₂ inches. Private collection. Courtesy Pasadena Art Museum. Ill. p. 126

89 *Male Figure.* (1964). Oil on paper, mounted on composition board, 29¹/₂×23¹/₂ inches. Collection Peter Fried, Freeport, New York

90 *Reclining Man.* (1964). Oil on paper, mounted on composition board, 23×27 inches. Joseph H. Hirshhorn Collection. Ill. p. 127

91 *Two Standing Women.* (1964). Oil on paper, mounted on canvas, 29¹/₂×23¹/₂ inches. Joseph H. Hirshhorn Collection

92 *Two Figures.* (1964). Oil on paper, mounted on composition board, 29³/₈×23³/₈ inches. Joseph H. Hirshhorn Collection. Ill. p. 128

93 *Two Women.* (1964). Oil on paper, mounted on composition board, 60¹/₂×37 inches. Joseph H. Hirshhorn Collection. Ill. p. 129

94 *Woman, Sag Harbor.* (1964). Oil on wood (door), 80×36 inches. Joseph H. Hirshhorn Collection. Ill. p. 130

95 *Woman in a Rowboat.* (1965). Oil on paper, mounted on cardboard, 47¹/₂×22¹/₄ inches. Martha Jackson Gallery, New York. Ill. p. 133

96 *Singing Woman.* 1965. Oil on paper, mounted on canvas, 88¹/₄×23⁷/₈ inches. Collection John and Kimiko Powers, Aspen, Colorado. (A, L, NY). Ill. p. 130

97 *Woman.* (1965–1966). Oil on paper, mounted on canvas, 48⁷/₈×36³/₈ inches. Allan Stone Gallery, New York

98 *Women Singing, I.* (1966). Oil on paper, 36¹/₈×24¹/₄ inches. Collection Mr. and Mrs. Gianluigi Gabetti, New York

99 *Woman Acabonic.* (1966). Oil on paper, mounted on canvas, 80¹/₂×36 inches. Whitney Museum of American Art, New York. Gift of Mrs. Bernard F. Gimbel. Ill. p. 131

100 *The Visit.* (1967). Oil on canvas, 60×48 inches. M. Knoedler & Co., Inc., New York, Paris, London. Ill. p. 135

101 *Woman and Child.* (1967). Oil on paper, 52¹/₂×47⁵/₈ inches. Collection Joseph and Mildred Gosman, Toledo, Ohio. Ill. p. 132

102 *Woman in the Water.* (1967). Oil on paper, mounted on canvas, 23¹/₄×18¹/₂ inches. James Goodman Gallery, New York. Ill. p. 134

103 *Woman on a Sign, II.* (1967). Oil on paper, mounted on canvas, 56×41¹/₄ inches. M. Knoedler & Co., Inc., New York, Paris, London

104 *Two Figures in a Landscape.* (1967). Oil on canvas, 70×80 inches. Stedelijk Museum, Amsterdam. Ill. p. 137

DRAWINGS, PASTELS, COLLAGES

(listed chronologically)

105 *Dish with Jugs.* (*ca.* 1921). Charcoal on gray paper, $19^3/_4 \times 25^3/_8$ inches. Private collection. Ill. p. 14

106 *Self-Portrait with Imaginary Brother.* (*ca.* 1938). Pencil, $13^1/_8 \times 10^1/_4$ inches. Collection Saul Steinberg, New York. Ill. p. 36

107 *Reclining Nude.* (*ca.* 1938). Pencil, $10^1/_2 \times 13$ inches; $7^3/_8 \times 10^5/_8$ inches (comp.). Owned by the artist. Ill. p. 39

108 Study for *Glazier* (Self-Portrait?). (*ca.* 1940). Pencil, $14^1/_8 \times 11$ inches. Owned by the artist. Ill. p. 20

109 *Portrait.* (*ca.* 1940). Pencil, $16^1/_2 \times 11$ inches; $10^1/_2 \times 8^3/_8$ inches (comp.). Owned by the artist. Ill. p. 21

110 *Elaine de Kooning.* (*ca.* 1940–1941). Pencil, $12^1/_4 \times 11^7/_8$ inches; $9 \times 8^7/_8$ inches (comp.). Collection Hermine T. Moskowitz, New York. Ill. p. 37

111 *Manikins.* (*ca.* 1942). Pencil, $13^7/_8 \times 16^7/_8$ inches. Owned by the artist. Ill. p. 76

112 *Still Life.* (*ca.* 1945). Pastel and charcoal, $13^3/_8 \times 16^1/_4$ inches (sight). Collection Betty Parsons, New York. Ill. p. 53

113 Untitled. (1945). Pastel and pencil, $12 \times 13^7/_8$ inches (irregular). Allan Stone Gallery, New York. Ill. p. 51

114 Untitled. (1949). Enamel on graph paper, $21^1/_2 \times 29^1/_2$ inches. Collection Mr. and Mrs. Harold Rosenberg, East Hampton, New York. Ill. p. 61

115 Untitled. (1949). Enamel, 22×30 inches. Joseph H. Hirshhorn Collection

116 Untitled. (1950). Enamel, $18^7/_8 \times 25^1/_2$ inches. Joseph H. Hirshhorn Collection. Ill. p. 61

117 *Two Women.* (*ca.* 1950). Pencil, $10 \times 7^7/_8$ inches. Owned by the artist

118 *Two Women.* (1950). Pencil, $8 \times 8^7/_8$ inches (irregular); $5^3/_4 \times 6^1/_2$ inches (comp.). Owned by the artist

119 *Reclining Woman.* (1951). Pencil, $8^7/_8 \times 11^3/_4$ inches. Collection Wilder Green, New York

120 *Woman.* 1951. Charcoal, pastel, and crayon, $21^1/_2 \times 16$ inches. Paul and Ruth Tishman Collection, New York. (NY, C, LA). Ill. p. 86

121 *Two Women.* (*ca.* 1951–1952). Pencil, $14^3/_8 \times 16^1/_8$ inches; $10^1/_2 \times 11^1/_8$ inches (comp.). Owned by the artist

122 *Woman.* (*ca.* 1951–1952). Pencil, $17^7/_8 \times 12$ inches; $9^7/_8 \times 5^7/_8$ inches (comp.). Owned by the artist

123 *Woman.* (1952). Pastel and pencil, 21×14 inches. Collection Mr. and Mrs. Stephen D. Paine, Boston. Ill. p. 86

124 *Woman.* (*ca.* 1952). Charcoal and crayon on cut-and-pasted papers, mounted on canvas, $29^1/_2 \times 19^3/_4$ inches. Collection Elaine de Kooning, New York. Ill. p. 88

125 *Two Women.* (*ca.* 1952). Pencil, $8^5/_8 \times 12$ inches; $5 \times 6^3/_8$ inches (comp.). Owned by the artist

126 *Two Women.* (*ca.* 1952). Pencil, $11^1/_8 \times 13$ inches (irregular); $10^1/_2 \times 10$ inches (comp.). Owned by the artist

127 *Two Women.* (1952). Pastel and charcoal, $18^1/_2 \times 24^5/_8$ inches. The Art Institute of Chicago

128 *Two Women, IV.* (1952). Charcoal and pastel, $16^1/_2 \times 20^1/_4$ inches; $15^1/_2 \times 17^1/_2$ inches (comp.). Private collection. Ill. p. 87

129 *Two Women.* 1952. Charcoal, 22×29 inches. Robert and Jane Meyerhoff Collection, Baltimore. Ill. p. 89

130 *Woman.* (1952). Pastel and pencil, $16^3/_4 \times 14$ inches. Collection Mr. and Mrs. Seymour Propp, New York

131 *Woman.* (1953). Charcoal, $36 \times 23^5/_8$ inches. Collection Mr. and Mrs. Robert C. Scull, New York

132 *Dog.* (*ca.* 1953). Pencil, 6×9 inches. Owned by the artist

133 *Monumental Woman.* 1954. Charcoal, 28$^1/_2$ × 22$^1/_2$ inches. Collection Mr. and Mrs. Harold Rosenberg, East Hampton, New York. Ill. p. 97

134 *Three Women.* (1953–1954). Pencil, 9$^3/_4$ × 26$^1/_8$ inches. Owned by the artist

135 *Figure in Interior.* (1955). Pastel, 26$^1/_2$ × 33$^1/_4$ inches. Collection Mr. and Mrs. Stephen D. Paine, Boston

136 *Folded Shirt on Laundry Paper.* (1958). Brush and ink, 16$^7/_8$ × 13$^7/_8$ inches. Owned by the artist

137 *Folded Shirt on Laundry Paper.* (1958). Brush and ink, 16$^7/_8$ × 13$^7/_8$ inches. Owned by the artist

138 *Black and White, Rome D.* 1959. Enamel on cut-and-pasted papers, mounted on canvas, 39$^3/_8$ × 27$^3/_4$ inches. Collection Marie Christophe Thurman, New York. Ill. p. 115

139 *Rome Drawing.* 1959. Brush and ink on cut-and-folded papers, 14$^1/_2$ × 13$^5/_8$ inches (irregular). Collection Susan Brockman, New York

140 *Woman* (study). (1959). Brush and ink, 23 × 18$^3/_4$ inches. The J. L. Hudson Gallery, Detroit

141 *Head.* (1964–1965). Charcoal and pastel, 23$^3/_4$ × 19 inches. Allan Stone Gallery, New York. Ill. p. 128

142 *Woman.* (1965). Charcoal, 85$^1/_2$ × 45$^1/_2$ inches. Collection John and Kimiko Powers, Aspen, Colorado.

143 Untitled (figures in landscape). (1967). Charcoal, 18$^5/_8$ × 23$^3/_4$ inches. Collection Susan Brockman, New York. Ill. p. 136

144 Untitled. (1967). Charcoal, 18$^3/_4$ × 24 inches. M. Knoedler & Co., Inc., New York, Paris, London. Ill. p. 136

145 Untitled. (1967). Charcoal, 18$^3/_4$ × 24 inches. M. Knoedler & Co., Inc., New York, Paris, London

146 Untitled. (1967). Charcoal, 18$^3/_4$ × 24 inches. M. Knoedler & Co., Inc., New York, Paris, London

147 Untitled. (1967). Charcoal, 24 × 18$^3/_4$ inches. M. Knoedler & Co., Inc., New York, Paris, London

Photograph Credits

Oliver Baker, New York: 41, 53, 62 bottom, 67 top, 68, 69, 85, 86 right, 92, 93, 95, 96, 98, 99, 104, 106, 110, 111, 114; Maurice Berezov, New York: 61 top, 97; Rudolph Burckhardt, New York: 28 bottom, 29, 30 bottom, 32, 33, 34, 36, 54, 56, 60, 62 top, 64, 66 top, 80 bottom, 82, 84 right, 89; Geoffrey Clements, New York: 28 top, 118; Leonard de Caro, New York: 128 left, 133 right; Peter Hujar, New York: 136 top; Paulus Leesser, New York: 120, 121, 127, 128 right, 129, 130 left, 130 right, 131, 132, 134, 136 bottom; James Mathews, New York: 21, 27, 35, 37, 59, 76; Herbert Matter, New York: 48; Peter Moore, New York: 51; Hans Namuth, New York, 10, 140; O. E. Nelson, New York: 133; Eric Pollitzer, New York: 31, 40, 88 right, 107, 119 left, 119 right; Len Provato, Norwalk, Conn.: 80 top; Walter Rosenblum, New York: 42; John D. Schiff, New York: 58, 84 left; I. Serisawa, Los Angeles: 117; Adolph Studly, New York: 66 bottom, 67 bottom, 83; Soichi Sunami, New York: 55, 57, 63, 91; Taylor & Dull, New York: 86 left, 115; Alfred J. Wyatt, Philadelphia: 24; Malcolm Varon, New York: 38, 43, 49, 52, 87, 90, 109, 112, 113, 116, 126, frontispiece.

Stedelijk Museum, Amsterdam: 65, 116, 137; Albright-Knox Art Gallery, Buffalo: 108; The Art Institute of Chicago: 70–71, 94; Wadsworth Atheneum, Hartford, Conn.: 19; M. Knoedler & Co., New York: 135; Solomon R. Guggenheim Museum, New York: 105.

Index

168